Robert Motherwell

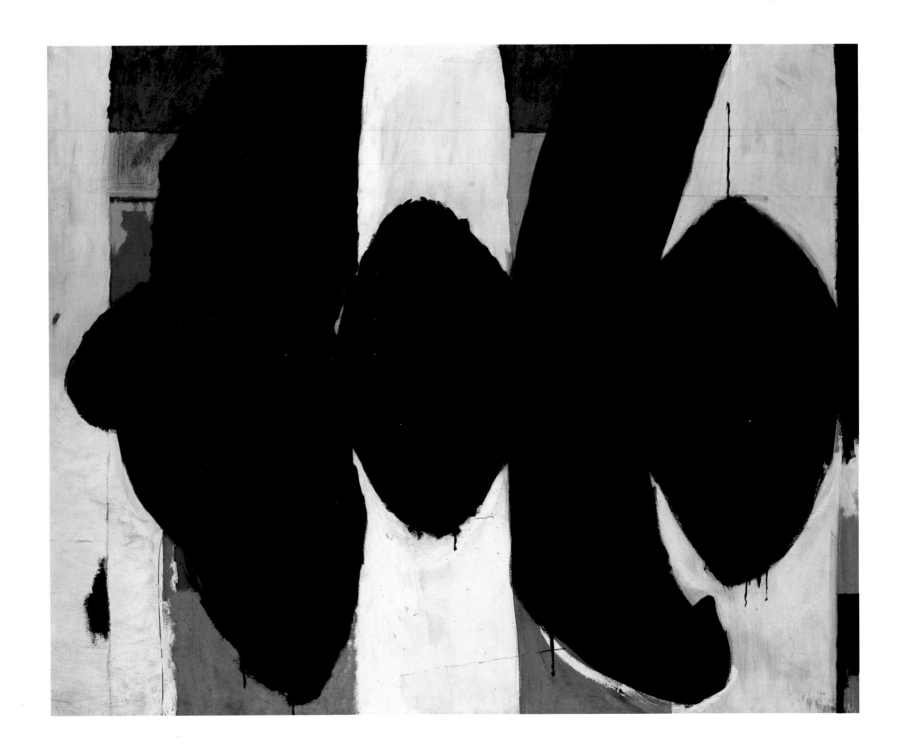

Robert Motherwell

Essays by Dore Ashton and Jack D. Flam
with an introduction by Robert T. Buck

Albright-Knox Art Gallery
Abbeville Press • Publishers • New York

This publication was prepared on the occasion of the exhibition, *Robert Motherwell*, organized by Douglas G. Schultz, Chief Curator, Albright-Knox Art Gallery, under the direction of Robert T. Buck. The exhibition was made possible by grants from the IBM Corporation and the National Endowment for the Arts.

October 1–November 27, 1983
Albright-Knox Art Gallery

January 5–March 4, 1984
Los Angeles County Museum of Art

April 12–June 3, 1984
San Francisco Museum of Modern Art

June 21–August 5, 1984
Seattle Art Museum

September 15–November 4, 1984
Corcoran Gallery of Art

December 7, 1984–February 3, 1985
The Solomon R. Guggenheim Museum

First edition

Editor: Josephine Novak
Designer: Robert Jensen

Library of Congress Cataloging in Publication Data
Main entry under title:

Robert Motherwell.

 Bibliography: p.143
 Includes index.
 1. Motherwell, Robert. 2. Artists—United States—Biography. I. Buck, Robert T.
N6537.M67R6 1983 709′.2′4 83-3859
ISBN 0-89659-387-8
ISBN 0-89659-388-6 (pbk.)

cover
Red Open No. 1, 1970
acrylic on canvas, 59½ x 71¾″
See page 94

frontispiece
*Elegy to the Spanish Republic
No. 34*, 1953–54
oil on canvas, 80 x 100″

Contents

Introduction

"Peindre, non la chose, mais l'effet qu'elle produit." [1]
—Stéphane Mallarmé

Robert Motherwell, the youngest of a burgeoning generation of abstract American artists, came to maturity on the threshold of a new, historic era during World War II. This war for freedom, the events leading up to it, and the eventual global defeat of fascism, deeply marked the artistic development of that generation. Recurring themes in Motherwell's work, most notably in the *Elegy* series, remind one continuously of this international conflict of unsurpassed magnitude.

Motherwell remains one of the most accomplished of this prophetic group of American painters generally referred to as the Abstract Expressionists and is, today, one of only a handful of survivors. From the intellectual viewpoint, his philosophical and moral concerns cause him to be most aptly compared to the postwar generation of French philosophers and writers known as the Existentialists.

It was the Existentialists who underscored the single, dominating conviction continually evident in their works, and in that of Motherwell, that modern man retains only the act of choosing as his moral and ethical statement. So far had society been transformed, departing from hitherto unquestioned ethical and religious convictions, that choice had been relegated to the individual alone. And, in turn, the individual was left with little or no moral and ethical suasion.

Motherwell's work in its entirety becomes a superb and beautiful litany or evocation of the existence of modern man, and in particular the struggle to infuse meaning into life. Time and again, his art makes us feel as if we are poised at the edge of the chasm between meaning and futility. Unlike the paintings of his fellow Abstract Expressionists, his works are veined with rich references to modern literary and philosophical concerns. In every way, his work is a timely, seasoned and poignant pursuance of modern life.

Motherwell's own consistent and insistent emphasis on "internationalism" in his work can only be fully understood when one recalls what it meant to be an artist in America when he was a young man. Regionalism, social realism and the always present academic, figurative styles, were dominant tastes of the period. Unlike most of the other painters of the New York School, he determined to transfer modern European artistic values into the very fabric of the new American art.

Because of his extraordinary skills as a writer and editor, Motherwell has been considered the unofficial American spokesman for his artistic times. This sometimes unwanted mantle has led him to achieve an eloquence greater than that of others who, by word or pen, have investigated the accomplishments of the American painters of the immediate post–World War II period. For example:

. . . 'tragic' art—which is what some of us have been able to create at certain privileged moments of our existence—a 'heroic' art. A twentieth-century American artist is closer to Goya than to the impressionists. [2]

or

That painting and sculpture are not skills, that can be taught in reference to pre-established criteria, whether academic or modern, but a process, whose content is found, subtle and deeply felt; that no true artist ends with the style that he expected to have when he began, anymore than anyone's life unrolls in the particular manner that one expected when young; that it is only by giving oneself up completely to the painting medium that one finds oneself and one's own style . . . such is the experience of the School of New York. [3]

Finally, as a draftsman, collagist, printmaker and painter, Motherwell is unsurpassed today for his contributions to the maturation and international importance of American contemporary art. To him, I express my greatest gratitude for his many lessons both painted and spoken, which seem, though I am sure unintentionally, to be directed at me.

This foreword would not be complete without my acknowledgment of the invaluable contribution of Douglas G. Schultz, Chief Curator, who has faithfully and efficiently overseen the entire organization of the exhibition. I am also most grateful to the IBM Corporation for its generous support. The National Endowment for the Arts awarded important grant support to this exhibition. Finally, and above all, I am thankful for the privilege of having had a part in forming this exhibition for Bob Motherwell.

Robert T. Buck

1. "To paint, not the thing, but the effect it produces."
Stéphane Mallarmé, *Correspondance, 1862–1871*, ed. Henri Mondor (Paris: Librairie Gallimard, 1959), p. 137.
2. Princeton: Art Museum, Princeton University
Robert Motherwell: Recent Work
January 5–February 17, 1973. Exhibition catalogue.
3. Dusseldorf: Stadtische Kunsthalle
Robert Motherwell
September 3–October 10, 1976. Exhibition catalogue.

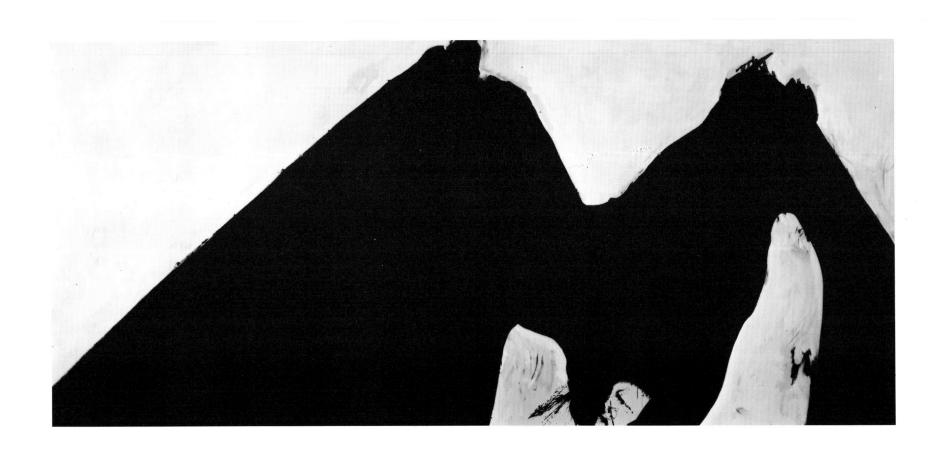

In Black and White No. 2, 1975
acrylic on canvas, 72 x 160″

With Robert Motherwell

Jack D. Flam

Robert Motherwell has been producing significant paintings for over forty years now, and during that time he has not only sustained a very high level of quality in his work, but has also created an oeuvre that contains a remarkably broad range of abstract imagery and pictorial modes. The formal inventiveness and force of his work, which made him an important influence on other artists four decades ago, have continued to the present, and he remains an important influence on many of the younger painters today.

Unlike most of the other painters of his generation, Motherwell has not developed in a steady, straight-line progression toward a single, characteristic image. Instead, he has constantly been involved with the invention of new motifs and pictorial modes, and with the reworking of old ones. In fact, it is not unusual for Motherwell to work in two or three different modes at once, as if trying to register every nuance of his sensibility, in order to work, as he has said, "as rapidly as one's mind envisions."[1] As a result, Motherwell's formal repertory is very broad, ranging from simple Zen-like calligraphs to elaborately worked fugal compositions; from complex networks of angular and biomorphic shapes to severe rectilinear geometry; and across a range of feeling that moves from the lyrical to the violent to the austerely serene.

Motherwell's oeuvre is united not so much by consistency of image as by consistency of touch

1. Robert Motherwell
Robert Motherwell Prints, 1977–1979
(New York: Brooke Alexander, Inc., 1979), n.p.

and color. A heterogeneous range of imagery is made "his" by a characteristic physical touch and a carefully delimited, highly personal range of hues; especially ochers, blues, and reds. And underlying these characteristic hues, which seem to have been chosen with the rigor of a man inventing his own musical scale, is the dialogue of the ultimate bass line, the unifying polarity of black and white—or rather of blacks and whites—for few painters have invested these two supposedly noncolors with as much coloristic nuance as has Motherwell.

Black and white have been Robert Motherwell's main colors for over thirty years now, the chromatic bedrock of his image-making. And this underlying dialectic of black and white—graphic, stark, and reductive—has allowed Motherwell to achieve an art of absolutes without having had to limit the play of his inventive mind to a single (absolute) image, and an art of pure abstraction without having had to reject the notion of subject matter. It has permitted him to choose, over a long period of time, many of his own constraints and freedoms, in a way that might have been closed to him had he opted, around 1950, for a schematic rather than chromatic framework for his art. The dialogue of black and white forms the basis not only of Motherwell's pictorial structure, but also of the implied subject matter that he, unlike most abstract artists, has continuously been willing to accept. "Black is death, anxiety; white is life, éclat,"[2] Motherwell has said of his *Spanish Elegies*. An astonishing remark, it would seem, from a man who is not only one of the leading abstractionists of our era, but also one of our most important theorists. Yet the statement is arresting in its forthrightness, and in the willingness it shows to confront the fact that

abstract pictures and the component elements of abstract pictures are richer in their evocations and affective implications than any single orthodoxy might want to allow. "It would be very difficult to formulate a position in which there were no external relations," Motherwell wrote in 1951. "I cannot imagine any structure being defined as though it only has internal meaning."[3]

And since, in order to avoid narrative or anecdote, shapes must be kept more or less purely abstract, while colors can be allowed a certain range of external associations without imposing narrative, much of the explicit symbolism of Motherwell's imagery has been stated chromatically. "Mainly I use each color as simply symbolic: ocher for the earth, green for the grass, blue for the sea and sky. I guess that black and white, which I use most often, tend to be the protagonists."[4] Not black and white separately, but in combination— the polarity of black and white, the dialogue of absolutes, which, like Motherwell's other colors, functions primarily as an autonomous formal element, but is also unavoidably rooted to our experience of the real world.

What we call the real world is itself composed of more realms than we can keep track of: sensations, feelings, ideas, memories. Black and white, for example, may evoke the abstract idea of death

2. Robert Motherwell
"A Conversation at Lunch"
in *An Exhibition of the Work of Robert Motherwell*
(Northampton, Mass.: Smith College Museum of Art, 1963), n.p.
3. Robert Motherwell and Ad Reinhardt, eds.,
Modern Artists in America
(New York: Wittenborn, Schultz, 1951), p. 20.
4. "A Conversation at Lunch," n.p.

and life, but they also recall Mallarmé's white paper awaiting the excruciating appearance of a word; or the matter-of-factness of any printed words or music; or the extremes of darkness and light; or other kinds of art, from Japanese brush painting to Goya's etchings and Picasso's *Guernica*. And, as Motherwell uses them, black and white even evoke the specific stark flat light of certain southern lands; the whitewashed walls and brilliant shadows of Mexican, Greek or Spanish villages, punctuated by the black garb of priests and perpetually mourning women. And at the same time, somewhere in his work—sometimes at the edge, and sometimes at the center of our attention—appear the colors of sky, blood, and sand, and perhaps of bright pink scarves—vivid emblems of the fleeting moments of which eternity itself is composed. Together, these other colors and black and white, all colors and none, evoke (finally) time beyond events or hours or years.

Perhaps the underlying metaphor of much of Motherwell's black and white imagery lies somewhere in this direction, and has something to do with time lived and felt, moment by moment, tragically set against a consciousness that, in the larger scheme of things, these wonderfully vivid moments may count for little or nothing—and in any case always lead back to Nothing.

• • •

The language of discourse is linear, and in using it we find ourselves hard pressed to talk about more than one thing at a time; pictures, on the other hand, are tabular, and colors and forms can have meaning in several often seemingly contradictory ways at once. A strong painting or drawing means more than the sum of its parts, yet part of its meaning is always only that of its merest parts.

At the same time that one is led to speculation about symbols and absolutes—and at times the sheer force of Motherwell's imagery seems to demand it—it is important not to lose sight of the simple physical presence of Motherwell's work. The works themselves are ultimately so much more complex than it would appear from the examination of any single aspect. This is apparent in the various interpretations of Motherwell's *Spanish Elegies*: the forms are said to be like architecture, or megaliths, or phalluses and wombs, or bull's testicles, or metaphors for sexual intercourse. Each interpretation is surely inherent in the shapes of the forms, but each, *taken singly*, can focus attention too intensely on only one implication or part at the expense of the whole. Sometimes we forget that a strong painting or drawing is an essay in a silent medium, and that the very essence of that medium is lodged in the ambiguity of its silences. When looking at one of the *Spanish Elegies*, the viewer may feel its particular urgency and mood, acknowledge its architecture, sense the overtones of death and love and physical anguish—but at the same time he remains constantly aware that these feelings are all brought about by the medium of mute black and white paint, which has been applied to canvas in a certain way. The harsh music of the oblongs and ovals, the interaction between areas, shapes, and edges, the denseness or fluidity of the forms, are all imbedded in the black and white paint that the painter's confrontation with his medium has left, like quivering skin, on the surface of the canvas. And ultimately this signal of surface is the matrix for all the other signals, the physical context that absorbs them and gives them back to us again in transfigured form, their ideas irradiating, but also inseparable from the movement of the brush that put them there.

11

In Motherwell's work this sense of the physical act is always of great importance, and it cannot be detached from the meaning of the image itself. The hand moves, feeling is transmitted. In the now quick, now light, now violent, now probing movement of the brush or pen or pencil, a gesture makes feeling intelligible. Some of Motherwell's images, such as the calligraphic brush drawings, isolate a single gesture; others incorporate thousands of gestures, small, large, broad, linear —always integral to both the structure and the feeling of the forms themselves. Historically, Motherwell has made an enormous contribution to the development of the language of abstract painting. He has explored a remarkably broad range of pictorial possibilities, with a remarkable degree of eloquence. Yet his technical means have been surprisingly simple: the hand moves, a mark is made. The act that lies behind all of his forms is the act of painting itself. Or perhaps one might call it the act of drawing since, in Motherwell's work, the acts of painting and drawing are simultaneous. Because of this, even Motherwell's largest paintings often have the spontaneity of his drawings, and his smallest drawings can have some of the richness of the largest paintings. In either case, meaning is inseparable from the act of making.

2.

A few years ago, I was standing next to one of my huge black and white pictures (In Black and White No. 2 *[ill. p. 8]) in a museum gallery, and a middle-aged man approached me and asked what the picture was about, what it "meant." Because we happened to be standing in front of the actual painting, I was able to look at it directly, instead of using an after-image inside my head. I realized that that picture had been painted over several times and radically changed, in shape, balances, and weights. At one time it was too black, at one time the rhythm of it was too regular, at one time there was not enough variation in the geometry of the shapes. I realized there were about ten thousand brush strokes in it, and that each brush stroke is a decision. It is not only a decision of aesthetics—will this look more beautiful?—but a decision that concerns one's inner I: is it getting too heavy, or too light? It has to do with one's sense of sensuality: the surface is getting too coarse, or is not fluid enough. It has to do with one's sense of life: is it airy enough, or is it leaden? It has to do with one's own inner sense of weights: I happen to be a heavy, clumsy, awkward man, and if something gets too airy, even though I might admire it very much, it doesn't feel like my self, my I.*

In the end I realize that whatever "meaning" that picture has is just the accumulated "meaning" of ten thousand brush strokes, each one being decided as it was painted. In that sense, to ask "what does this painting mean?" is essentially unanswerable, except as the accumulation of hundreds of decisions with the brush. On a single day, or during a few hours, I might be in a very particular state, and make something much lighter, much heavier, much smaller, much bigger than I normally would. But when you steadily work at something over a period of time, your whole being must emerge.

In a sense, all of my pictures are slices cut out of a continuum whose duration is my whole life, and hopefully will continue until the day I die.

3.

Robert Motherwell and I are sitting in his studio, looking at a miniature model that has been made of all the works in this exhibition. Some of the paintings that are represented in the maquette are actually hanging on the wall a few yards away from us and serve as particularly vivid points of reference as the conversation wanders. When I ask him about the variety of his imagery, he replies:

As the paintings were being chosen for this show, I came to realize how different the spatial conceptions are in my paintings—something that I was not conscious of before. I have been conscious of the Oriental concept of a painting representing a void, and that anything that happens on a painting plane is happening against an ultimate, metaphysical void. Some of my pictures are conceived that way, such as In Beige with Charcoal *(ill. p. 100) or* A View No. 1 *(ill. p. 74). Another group of pictures, I consciously conceived of as walls, such as the Janss picture [Jour la maison, nuit la rue] (ill. p. 71), or some of the* Elegies, *or the ones literally called* Wall Paintings *(see ill. p. 66). Others are conceived of traditionally in terms of figures and background, such as* The Persian No. I *(ill. p. 105), or* The Homely Protestant *(ill. p. 32), or* Fishes with Red Stripes *(ill. p. 14). But these categories are not mutually exclusive. For example, the* Plato's Cave *paintings (see ills. pp. 49, 98) were originally conceived of (as the* Opens *in general are) as walls. Because of the* Caves' *liquidity and their darkness, they became literally "caves"; and that was unexpected and unintentional on my part. The sense of a "voyage" is crucial to the process of such works.* Fishes with Red Stripes *involves the void as well as figuration; it also involves both spontaneity and correction in equal measure. In a way, it is close to what I have been after all my painting life.*

My paintings also cluster in terms of colors. Many are built on black and white; some on black and white and yellow ocher; some on sky blues; some on scarlet. I am not a "colorist" in the sense that Bonnard or Matisse or the Impressionists are, orchestrating many colors; but nevertheless (although it seems a contradiction) I think that specific hue is more important to me than to most artists, even those who orchestrate colors. Not only in art but in everyday life, I recognize color before shape.

I use hues somewhat the way small children do. They use bright colors very naturally; they rarely muddy them or work tonally. Practically all professional painters work essentially tonally, not primarily with color. This is especially true of painters who "model" forms. In Henri Rousseau's sense of the term, I am deliberately an "Egyptian" painter; I use flat, linear, local hue. One of the deepest influences of my early days as a painter was a three-volume set of rotogravure photos of the antiquities in the Louvre, especially the Ancient Near Eastern and Egyptian bas-reliefs, even more than old paintings, probably because of the incisiveness and clarity of lines and shapes in low relief.

My images are determined by a combination of vectors. A subject emerges out of an interaction between my self, my I, and my medium. It is determined by what dominant hues I am using, by the format, by whether the spatial concept is of a void, or a wall, or a figure (or, very rarely, of a landscape).

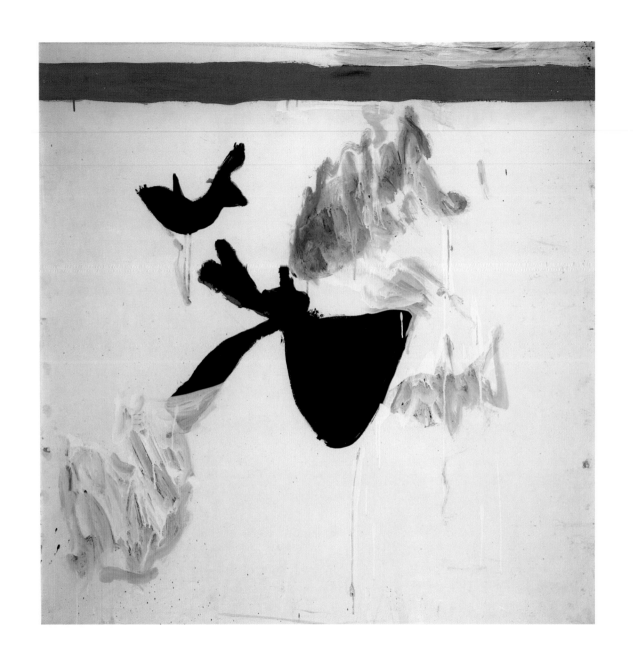

Fishes with Red Stripes, 1954
oil on paper, 42½ × 41⅛"

While that puts a large lot in, in another way it also leaves an awful lot out. My paintings are not an "abstract version of nature," nor is most Abstract Expressionist painting. My work has a strong sense of light, but it is not atmospheric light; it is generated instead by planar color and value. And in real life, I would rather spend time looking at nature that has been modified by man— at parks or town squares with walls, say—than at raw nature or wilderness.

The Open *series was generated in part by these feelings. In Mexico, in the old days, they built the four walls of a house solid, without windows or doors, and later cut the windows and doors beautifully proportioned, out of the solid adobe wall. There is something in me that responds to that, to the stark beauty of dividing a flat solid plane.*

The different images in my paintings are the result of these and various other preoccupations. If I work with these more or less a priori conceptions, plus gestures, then my own imagery is just what comes out. I name it all afterwards. Naming is a primitive, inadequate but deeply rooted way of identifying the ineffably complex nature of reality.

What about the sense of duality that one often feels in your individual works—as in the *Opens*, where the geometry of the lines is set against the amorphousness of the color field?

The duality is present in many ways. Contrasting straights with curves. Strong color contrasts, such as black and white or orange and blue. A certain kind of rhythm, as In Black and White No. 2, *which began quite spontaneously, but then was revised and refined (almost as in a Renaissance picture, in*

that though the shapes are organic, nevertheless they are subtle variations on what could very easily be turned into straight geometry).

In a similar way, Little Spanish Prison *(ill. p. 17), perhaps my very first mature work, done in the first year I was painting, is made up of stripes: each stripe is subtly modeled so it is not just a straight stripe, as in a flag, but has the feeling of the rhythm of the wrist in it. In the way that I love the beauty of human skin, I would like my paintings to have a surface that is not just lovely or seductive, but that glows, the way certain human beings radiate life under that beautiful skin. "Lighting up the room," as we say.*

Despite the diversity of the images, there is a strong feeling of unity of thought and feeling that runs through all of your work. A while back, you said that you judged whether your work was good or not by whether or not you recognized yourself in it.

I mean that in the sense of the phrase "shock of recognition," and with no a priori idea of how to bring it off. It is not like walking up to a mirror where you look and see yourself. As you fiddle around with the malleable, plastic stuff of paint, you begin to shape a sense of your own inner semblance—what Baudelaire refers to as "mon frère, mon semblable." Baudelaire's poetry is a kind of miracle—that a subject matter so radical, in trying to represent one's inner archetypes rather than social conventions, can be expressed with such clarity, in classical, faultless rhyme. As Picasso said somewhere, drawing is a form of rhyming. If you use gestures, you instinctively make forms rhyme, either against a void or against a wall. That, in a way, is what I have

15

been doing all my life. Sometimes though I work off and on for years on a picture, it never becomes "mon semblable" and ultimately I have to abandon it.

When I look at a great number of my pictures, as I have recently while this show was being chosen, I can see ones where I really let go, in an almost physical sense—where I got down on my hands and knees, where I got my face and my hair and my clothes covered with paint, where I got involved like a desperate animal in a cave, or whatever. There are others that were painted with my street clothes on, so to speak. I can tell by looking which ones I wrestled with, like Jacob and the Angel, and which ones I painted almost with the detachment of Velasquez.

What about the collages? They seem to be in quite a different category. Do the collages provide you with a different kind of experience, as well as with a different kind of subject?

They do. Delacroix said that nature is a dictionary—by which he meant all of the world, from nudes or landscapes or violent animals to still-life. There is a whole vocabulary in nature; all you have to do is look and you will find it. I would say that, in that sense, I do not look at nature very much. The part of my vocabulary that is not from inner pressure, but that is drawn from the external world, is from the social world. To pick up a cigarette wrapper or wine label or an old letter or the end of a carton is my way of dealing with those things that do not originate in me, in my I. Max Ernst once told me that his father, who was a Sunday painter, liked to paint the courtyard of his house. The courtyard had a tree in the middle, and the father always had

difficulty with the damned tree; everything else he did in the picture satisfied him, but not the tree. Finally one day he went out and cut the tree down, so that it would not interfere with his composition. I think collage works so. Instead of having to fuss with drawing things and reworking and changing them, you pick up objects that are in the room and simply put them in the picture—or take them out—wherever you like. Collage is both placing and ellipsis.

Most of the papers I use in my collages are random. Even the sheet music. In fact, I don't read music. I look at printed music as calligraphy, as beautiful details. I do not smoke Gauloises cigarettes, but that particular blue of the label happens to attract me, so I possess it. Moreover, the collages are a kind of private diary—a privately coded diary, not made with an actual autobiographical intention, but one that functions in an associative way for me, like Proust's madeleine. For a painter as abstract as myself, the collages offer a way of incorporating bits of the everyday world into pictures. Some of my collages make past years and places in all their concreteness arise in my mind in a manner that the paintings do not: the paintings are more timeless.

Some of your paintings such as *Face of the Night (For Octavio Paz)* (ill. p. 117), seem to have the same kind of spatial discontinuity that your collages do.

That painting was done over a period of six years. It went through three radical transformations. It began as a Monster, and the monster is still there, but buried. The monster began as painted against Mexican popular colors, of which only fragments remain. The third operation was the spreading

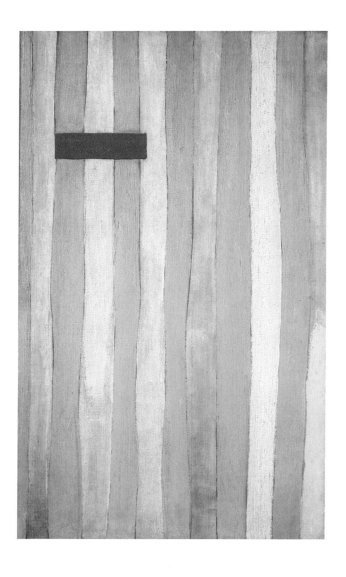

The Little Spanish Prison, 1941
oil on canvas, 27⅛ x 17"

of the black, as in the Iberia *paintings. These separate operations are an indirect process of collaging. Time is collaged.*

When you are not satisfied with a picture, when you do not feel the "shock of recognition" we were talking about earlier, you know that there is something that is not working, but it is not so easy to figure out what. If you have a squarish black shape, for example, it is an element in several structural systems at once: it is the darkest tone there is; it is the absence of color; it is the strongest opposition to light; it is a relatively geometric form; it can seem spatially either adhering to the picture plane or the opposite— to be deep, dark, behind. It has a certain literal physical extension: there can be too much or too little extension. Being geometric, it is also opposed to the idea of gesture, of automatic drawing. It is an element that is working in perhaps ten different systems of relations. Maybe you do realize the painting problem is somehow that black square; but sometimes it can take months until you realize which of the relational systems it is not functioning in. What confuses even more is that it may be functioning beautifully in all the systems but one, so your reaction may be to look at that relation as a problem last, not first.

What about residual images in your work? By that I mean forms and shapes that suggest things in the real world, such as the bulls in *Iberia* or *Spanish Painting with the Face of a Dog* (ills. pp. 18, 72)?

I almost never start with an image. I start with a painting idea, an impulse, usually derived from my own world. Though sometimes images may emerge from some chord in my unconscious, the way a dream might. Even in those paintings where

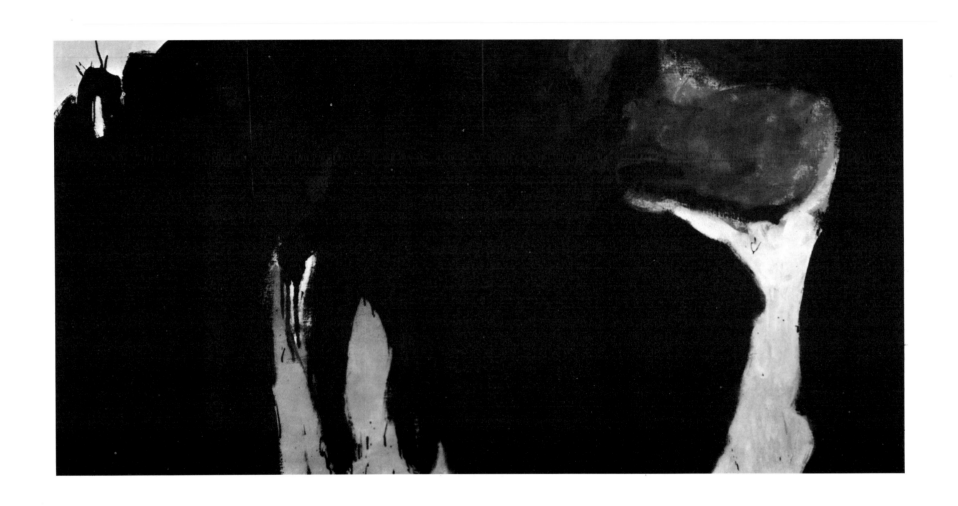

Spanish Painting with the Face of a Dog
(earlier state), 1958
oil on primed bed linen, 37⅛ x 75¼"

an image unconsciously develops, a certain kind of experience is usually necessary in order to perceive it. In Iberia *or* Spanish Painting, *for example, you would have to know that a Spanish bull ring is made of sand of an ocher color, and that Spanish bulls are very small, quick, and coal black. Both of those coal black, ocher pictures have a bull in them, but you cannot really* see *the bull. They are an equivalence of the ferocity of the whole encounter. This is perhaps what Mallarmé refers to in his famous phrase about describing not the object itself, but the effect it produces.*

4.

The reference to Mallarmé is not gratuitous. The example of Mallarmé, and of the French Symbolists in general, has had an enormous effect on Motherwell's thought and art. In the early 1940s, when he was starting out, it seems to have acted as a kind of pole star, and to have given Motherwell a firm internal sense of intention which allowed him to absorb and synthesize the various and powerful outside influences to which he was being exposed. Even before he had discovered what he wanted his art to look like, he seems to have had a firm idea of what he wanted it to do. He wanted to create an art that would deal with the universal rather than the specific, yet be charged with feeling; that would be true to its medium, be quintessentially what it was physically, yet also evoke powerful reverberations beyond its mere physical appearance. The goal of Motherwell's art, like that of Symbolist poetry, has been one of compression and condensation, of making apparently simple relationships of form and color be charged with as much feeling, and as much meaning, as possible.

Possibly because his previous training had been in philosophy and he had not been exposed to the extensive art school background of most of his contemporaries, Motherwell was in a good position to confront the ideas of Modernism *per se*, without agonizing a great deal over whether to keep or abandon the figure. "I have continuously been aware that in painting, I am always dealing with, and never not, a relational structure. Which in turn makes permission 'to be abstract' no problem at all . . . so that I never had the then common anxiety as to whether abstract painting had a given 'meaning.'"[5] As a result, in the early 1940s, he was open to, and able to synthesize, the syntactic and aesthetic possibilities of three strong but disparate styles: those of Surrealism, Mondrian, and Picasso.

From Surrealism, Motherwell developed his technique of automatism, his early vocabulary of organic forms, and his susceptibility to an aesthetic of strong personal feeling, dynamism, and flux; from Mondrian he developed a sympathy for the vocabulary of rectilinear geometry and limited color, and an aesthetic of objective or "plastic" feeling; and from Picasso, especially the tough, Goyaesque Picasso of the late 1930s, he developed his own pictographic imagery and the violent subject matter of the early 1940s. As Motherwell developed each of these modes, forging from them a personal and distinctive style, he also made significant refusals. He refused the Surrealists' deep descriptive space and anecdotal subject matter; he refused Mondrian's extreme limitations of format and color; and he refused—

5. Bryan Robertson
"Interview with Robert Motherwell, Addenda," 1964.
Motherwell Papers, Greenwich, Connecticut.

except in his later collages—the Cubist space and narrative subject matter of Picasso.

What Motherwell took and built upon from these three styles is fascinating for, while they offered him a broad range of formal possibilities, they also allowed him to develop and use to his advantage powerful contradictory impulses within himself. Motherwell, both as artist and man, is a very contradictory person. He is extremely intelligent, well read, and articulate, and he holds all three of these qualities in high esteem. At the same time, he recognizes that the true content of his art is feeling, not thought, and when he paints and draws he tries to work as intuitively as possible, giving free rein to his impulsiveness and sensuality, and to the curiously graceful clumsiness that is characteristic of his person as well as his art. This polarity between thought and feeling, culture and individuality, historical awareness and faith in the vivid necessity of the moment, seems to underlie an enormous amount of his imagery. We have already seen how it makes itself felt in his use of color. It also seems to be a determining factor in his vocabulary of forms. Right from his earliest works, there has been a strong opposition between organic and geometric forms—at first under the influence of Surrealism and Mondrian, later reconciled into particularly Motherwellian imagery. This opposition was already felt in his earliest mature drawings, done in 1941, where the organic holds sway. But most of the oil paintings Motherwell did in 1941—such as *The Little Spanish Prison* and *Spanish Picture with Window* (ill. p. 53)—are based on an austere right-angle geometry. It was not until the mid-1940s that Motherwell began fully to master the balance between organic and geometric forms in the same picture, in what was to be-

come the distinctive dialogue between ovoid and rectilinear forms that eventually led to the format of the small 1948 drawing that became the first *Spanish Elegy*.

Until around 1945, the imagery of Motherwell's pictures was usually figurative and linear. Even as he began to develop his characteristic oval-and-rectangle formal vocabulary, in such paintings as *Pancho Villa Dead and Alive* 1943 (ill. p. 21), and in the numerous watercolors and brush and pen drawings he did at that time, his subject matter and graphic manner were still clearly related to Picasso. Over the next few years, as he shook off Picasso's influence and his imagery became more abstract, he began to think more in terms of area than of line, and to work almost exclusively in oil paint and collage. Motherwell did not draw less, but his drawing was absorbed by the technically more complicated procedures of painting and collage. Much of his energy in the early 1950s went into the large *Spanish Elegy* paintings that grew out of the small drawing he had done in 1948 to illustrate a poem by Harold Rosenberg. In this *Elegy* drawing, Motherwell developed the dialogue of rounded and rectilinear forms as a graphic equivalent to the chromatic polarity of black and white. This dual vocabulary of extremes eventually provided the basis for the nonspecific but highly charged iconography of the *Elegies*. It provided a consistency of syntax and level of intensity that could be carried from canvas to canvas, while allowing for great diversity of expression in each individual canvas. The little 1948 drawing, originally done to "decorate" a poem, turned out to be Motherwell's most seminal single image, and to contain within its relatively simple forms the basis on which Motherwell would be able to construct a new pictorial poetics.

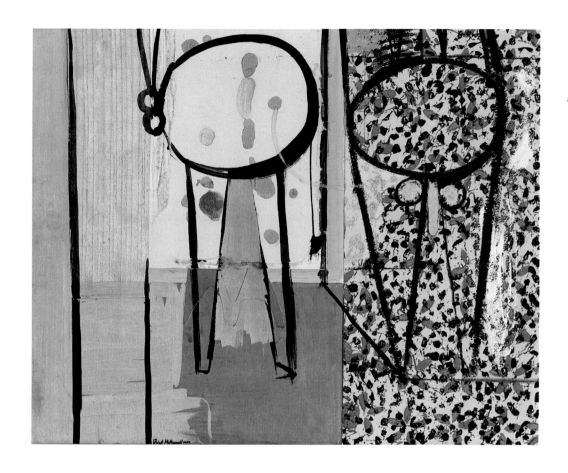

Motherwell's first mature drawings, as we noted, were done under Surrealist-inspired automatism, and he continued to rely on automatism to provoke his imagination and to act as what he has called "a plastic weapon with which to invent new forms."[6] Automatism was thus both a way of probing the subconscious and a way of confronting the medium itself.

By the 1950s, however, Motherwell had distanced himself from Surrealism. His post-*Elegy* automatic drawings had lost nearly all vestiges of Surrealist imagery, and he began to move toward an idiom of spontaneous brush work and bold simple form that appears to have been strongly influenced by Chinese and Japanese brush painting. This synthesis of psychic automatism and Oriental brush painting provided Motherwell with a way to combine several long-time pictorial concerns, and to merge his mystique of individual consciousness with a mystique of universal consciousness—to bring together his interests in Western and Eastern metaphysics, in psychoanalysis and Zen.

Once again, Motherwell was able to effect a synthesis of divergent modes. The long historical and theoretical tradition that lay behind Oriental brush painting, and its cultural exoticness, gave a new dimension to his practice of the historically recent and specifically Western mysticism of psychic automatism. It also seems to have opened him to the possibilities of drawing and painting as forms of writing. For if, in the West, the act of picture-making had been primarily descriptive, in China and Japan, painting had for several

Pancho Villa Dead and Alive, 1943
gouache and oil with collage
on cardboard, 28 × 35⅞"
Collection The Museum of Modern Art, New York
Purchase
Not in exhibition

6. Robert Motherwell
"The Modern Painter's World"
Dyn (Mexico City), I, 6 (November, 1944), p. 13.

centuries been a form of writing, and writing a form of picture-making.

When Motherwell began to write words—notably "*Je t'aime,*" into a series of images that were themselves like a form of writing, word and pictorial utterance were brought together, each reinforcing and enlarging the other's field of meaning (see ills. pp. 69, 70).

● ● ●

The *Elegies*, then, provided Motherwell with the basis upon which he could build a new pictorial vocabulary for himself. They did not define a series of limits but opened up a number of possibilities. As a result, from the mid-1950s onwards, Motherwell has been able to combine a number of divergent formal possibilities into a number of strong pictorial syntaxes, which not only draw upon different parts of the artistic traditions that he inherited, but also upon different parts of his own being.

5.

Making an Elegy *is like building a temple, an altar, a ritual place. The* Elegies *are never "a throw of the dice." They are almost the only pictures I do in the way one traditionally thinks of a Western artist working on a large scale, whether Leonardo or Rubens or Seurat, of starting with sketches, or using all one's resources to make a complete image, not improvised.*

Unlike the rest of my work, the Elegies *are, for the most part, public statements. The* Elegies *reflect the internationalist in me, interested in the historical forces of the twentieth century, with strong feelings about the conflicting forces in it. The*

collages, by contrast, are intimate and private; the Opens *tend to be more strictly involved with artistic problems—problems in the viscosity of paint, of color fields, of the skin of the world, highly abstracted. The instant I put in the U-shaped geometry in the* Opens, *it gives them a masculinity to complement the sheer sensuousness of the feminine. It gives completion, the union of opposites.*

The Elegies *use a basic pictorial language, in which I seem to have hit on an "archetypal" image. Even people who are actively hostile to abstract art are, on occasion, moved by them, but do not know "why." I think perhaps it is because the* Elegies *use an essential component of pictorial language that is as basic as the polyphonic rhythms of medieval or African or Oriental music. To put it another way, if you give a child something very complex to paint, such as a bouquet of flowers or a natural landscape, if he is very good, eventually he will get back—like Cézanne—to the essential forms of what he sees. If you start out with basic forms, it is more sensible and efficacious. That is perhaps the reason I was myself, my I, the first year I painted, and did not have to go through the drudgery of seeking out the essential. I was possibly lucky in that I came to painting through technical philosophy, so the question of whether one could "be abstract" and meaningful was never a problem for me. I started with straight, basic, symbolic structures. My problem now is opposite; as I get older, I try to make my paintings more contrapuntal, richer. But not always.*

You mention the language of signs and essential forms. How does this relate to the pictographic language of Oriental art?

The modern artist, unlike his artistic ancestors, is in a sense forced to invent his own pictorial language before he can even think about elaborating that language. He has the problem of both invention and elaboration. This is one thing that separates a modern artist from Oriental artists, who to a large degree inherited a preexisting language that they then each elaborated in a subtly different way. But there is an affinity between certain Oriental—especially Japanese Zen—painting and some of my own work. Aside from the obvious reduction of color, the predominance of black and white, and the importance of gesture, essentially it is the concept that we talked about earlier, of the metaphysical void. This is perhaps strongest in the Opens, built on a conception analogous to the Oriental conception of the absolute void: that you start with empty space, and that the subject is that which animates the great space, the void. The amazing discovery is that it takes relatively little to animate the absolute void. For example, if you are sitting by a flagstone pathway staring at the path as an ant comes along dragging a piece of something, and you begin to focus on it and watch it struggling along up and down a blade of grass in a crack, or moving this way and that, but always keeping more or less in the direction it is headed in, you realize that one little ant is animating everything around you: the surrounding lawn, the birds in the sky, the nearby pond, and all the rest. That single little ant (if you regard all those other spaces as the void, as the background to the ant's activities) is animating the world. More, the Orientals lead you to discover that the void is beautiful in itself.

Another thing I absorbed from Oriental art is the crucial role of viscosity in painting. Oriental painting is done with ink, often with rare inks, a hundred or two hundred years old. The inks come in hard bars, and you mix, by disintegrating them in water to various degrees of darkness and lightness, so that the consistency of the ink when it is right is crucial, like the difference between a store-bought violin and a Stradivarius.

Third, and probably most importantly in actual practice, is calligraphy in the sense of the hand taking off by itself, so to speak. You learn from Japanese calligraphy to let the hand take over: then you begin to watch the hand as though it is not yours, but as though it is someone else's hand, and begin to look at it critically. I find myself making it jump more, or making it become more rhythmic, or making it drive off the edge at a certain moment; that is a whole different way of drawing compared to looking at something and marking its shapes down. More like training yourself to play the violin. It becomes a kind of critical self-analysis, of how your body is functioning in relation to a plane surface. That is where viscosity becomes so crucial. If the medium is thick and you want to move quickly, it will not move quickly enough—it will be too inert. If the medium is too thin, it will drip, or run. But if it is exactly right, my hand just flies and I do not even have to think; my hand just does it, as though I am not there. The instant the viscosity is wrong, it is like a death battle with a snake—touch and go as to whether it is going to poison me or I am finally going to be able to get it by the neck and tear its head off. When the viscosity is right, it is close to (as the Orientals are always trying to express) mindlessness, or to pure essences, with nothing between your beingness and the external world. As though your beingness were being transmitted without intervention; so that you think of the hand as not being yours. It is more

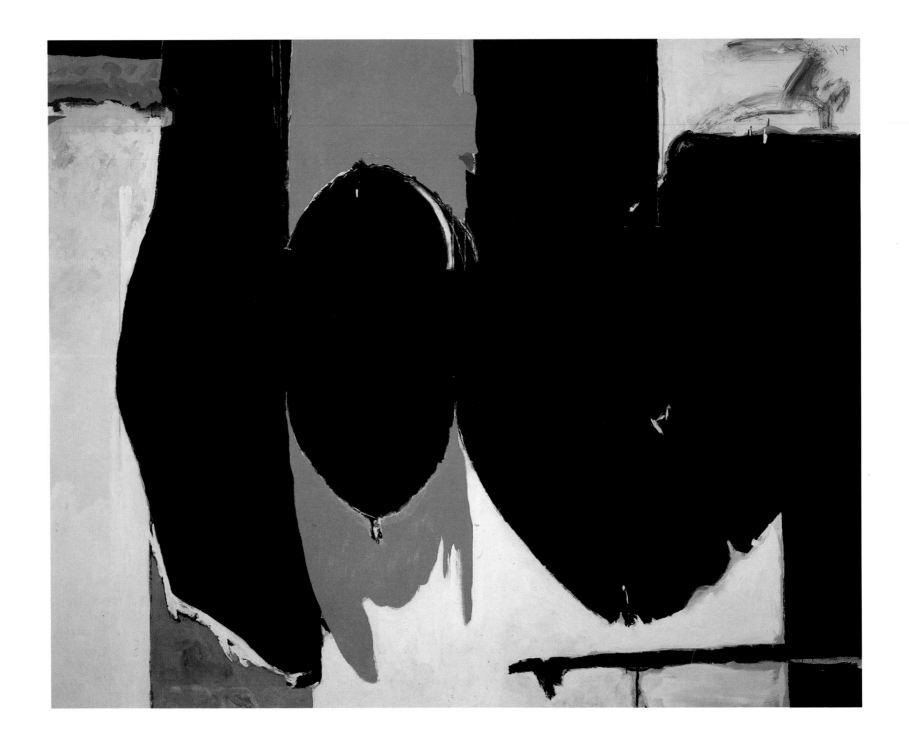

what you unconsciously know than what you think. In fact, I would say that most good painters don't know what they think until they paint it.

In Western art, the central concerns have been different, essentially iconographic, and of course have exerted a tremendous influence on me, especially in the Elegies. *Western artists, instead of thinking of an absolute void, think in terms of so-called "positive" and "negative" space. The art of drawing in the European tradition—or the art of composition—is that the negative and positive spaces be equally well shaped. There Piero della Francesca is in a class by himself. Nobody has even come close to him. Not even Cézanne. He is inexhaustible. His organization is so implacably there, and yet not over-emphasized. His color, his spatial sense, his enigmatic figures—he has so many stunning conceptions organized together that its effect is ultimate mystery, as unbelievably complex and moving as Mozart's last Requiem Mass.*

What about the relation between your writing and your painting?

I was always concerned with the culture of Modernism as much as with my personal fate—to the degree that that is possible. When I was still in my twenties, I realized that the enduring art and writing and music that had been produced in our time was that which almost always could be grouped together under the umbrella of Modernism. Another clear thing was that although Modernism was difficult for most people to accept or comprehend, it was our own historical creation. It was begun in large part as a critical act, as a rebellion against the corny academic art so beloved by the bourgeoisie; and not only by the bourgeoisie, as it turns out, but

also by the working class, comprising anecdotes, sentimentality, religion, and so forth. An art of what in the nineteenth century would have been called "moral uplift." What all this anecdotal art had in common was a lack of vitality and an essential falseness. It did not reflect reality as we know it; but rather an outmoded, and somewhat sentimentalized model of reality. The Modernist critical act, accomplished by the most serious artists and writers of our own century, involved not only getting rid of the worn-out baggage of officially acceptable art, but also, conversely and more positively, a new investigation into what constitutes art as art; and therefore of what constitutes reality as we know it.
One of the tasks that modern art set itself was to find a language that would be closer to the structure of the human mind—a language that could adequately express the complex physical and metaphysical realities that modern science and philosophy had made us aware of; that could more adequately reflect the nature of our understanding of how things really are. Cézanne, for example, discovered not an art that was "solid like the art of the museums," but something quite the opposite. In a way, he unknowingly discovered that the solidity of the museum itself—literally—was a false concept and that things are not solid. In so doing, he came closer to the nature of things, according to modern physics.

When I started out, all but a few were against abstract painting. The art world, as it was then, hated it. But the university world was very interested in what we were doing. Since I knew how to talk about it (I had originally been trained in philosophy) I was given, by default, the office of spokesman for the Abstract Expressionists, especially in the university world.

Elegy to the Spanish Republic No. 132, 1975–82 acrylic on canvas, 96 x 120"

25

A lot of my writings were originally speeches—there was an audience, and a direct feedback—either the people in the audience visibly agreed or didn't agree—something you don't get with painting. If you have a show, a dozen or so people may be moved to tell you how they felt about it, but on the whole, exhibiting paintings is a very indirect way of "exposing" yourself. Music and drama are played in front of an audience, an intelligent book is widely reviewed by literate people, and people talk about it. But with painting, there is relatively little direct feedback. I meet people who look at me with a certain amount of awe, but they rarely say anything about my painting. With writing there is a lot more feedback, a much more literate audience.

I was going to write my Ph.D. thesis on Delacroix' Journals. Delacroix was constantly preoccupied with theoretical questions, with the nature of art, the moderns versus the ancients, and so forth. He was very sustaining to me when I started out. I was interested in ideas—in talking about them and in writing about them. Poets, for example, have traditionally been involved in writing criticism. In the same way that, say, T. S. Eliot wrote criticism as well as poetry, there is no reason, if one regards one's paintings as "poems," that a university-educated painter cannot write criticism as well, and become involved with theoretical issues. I never met an outstanding artist not interested in ideas, as well as in sensuality.

6.

An artist loves what he can afford to love. Or rather, he gives his love freedom only where he can afford to: always feeling the need to afford more, yet constantly knowing that a careful—if inexact—accounting must be kept. One must neither be too attached to the concrete, to the poignant but fleeting situations that make up a man's life and root him in the commonplace, nor be too much enamored of the purely abstract aspirations that serve philosophy better than art. Somewhere a balance must be struck between the tension of life as it is lived and of life as it is conceived. In the history of painting the most awesome resolution of this tension is perhaps that found in the art of Piero della Francesca—in the almost inconceivably fine balance that Piero achieves between the incidental and the essential, the commonplace and the cosmic. No form or shape is too small to escape the relentless order and patterning of the whole, yet the whole itself is rife with eccentricity and surprise, and constantly allows free play to even the smallest form or shape.

Robert Motherwell's own high regard for Piero appears to be related to his perception of just how well balanced are thought and feeling in Piero's art, and how utterly pictorial his expressive means. Those are the qualities that have also been at the core of Motherwell's ambition, right from the beginning of his own venture as an artist. The tension between life as it is lived and life as it is transformed into art has for a long time been evident in Motherwell's work. It is this tension that underlies his concern with subject matter, and has to a large degree determined the range of color and imagery he has set for himself in the various mediums in which he works. And it is probably this tension that has impelled him to keep his almost obsessive concern with autobiographical detail—the scraps of paper, souvenirs, invitations, certificates, labels, envelopes, packages, tickets, and customs stamps that he saves—confined to

a single autobiographical medium: collage. His collages, in a sense, are almost the opposite of his paintings. They reconstitute an actual lived life, whereas the paintings invent a parallel one. *I am who? I am what? I am where? I am when?* The answers to these specific questions are sometimes given in the collages, frequently in relation to other individuals who by chance or design have come into Motherwell's life. But the paintings are images in a solitary world. Even the *te* in *Je t'aime* remains unnamed and elided, engulfed by the *I* and the *love*. As if to say: Because of this image, I am. I paint, I draw, therefore I feel.

How aware of this might Motherwell be? More, probably, than one might suppose. Throughout his career, Motherwell seems to have been aware that the demands of his medium—his love for it, and his way of working it—would necessitate certain preclusions; that certain aspects of his life and of his awareness of life could not be included in his art if what he *would* include was to have the intensity and the resonance that he wanted it to have. An artist is known as much by what he will *not* permit as by what he includes in his painting, Motherwell once remarked.[7] And as long ago as 1951, he wrote: "One of the most striking aspects of abstract art's appearance is her nakedness, an art stripped bare. How many rejections on the part of her artists! Whole worlds—the world of objects, the world of power and propaganda, the world of anecdotes, the world of fetishes and ancestor worship. . . . Nothing as drastic an innovation as abstract art could have come into existence, save as the consequence of a most profound, relentless unquenchable need."[8] And, one might add, what a relentless courage it takes to love so passionately and to keep one's love so austere.

Yet what is also striking is how much Motherwell has managed to include in so abstract an art. The explicit autobiography of his collages and writings apart, how much of the complexity of the man comes across in Motherwell's work: the puritan and the sensualist, the social being and the recluse, the thinker and the force of nature. And how much culture is evident in those works. How many references—both overt and recondite—are woven into his paintings and drawings; references to myth and poetry, to politics and history, to philosophy and to other art.

It sometimes seems that part of the reason that the movement to abstraction has found such fertile ground here in America is related to the fact that the intellectual and sensual life of the nation have for so long been found in some way lacking. Abstract art, in its move around history straight to myth, has provided the possibility of a way to leave behind the incidental and the temporal, and to deal directly with the universal and the timeless. To deal with life on art's terms.

For more than forty years, Robert Motherwell has not only been a key figure in this movement but has produced some of its finest images.

7. Frank O'Hara
Robert Motherwell
(New York: The Museum of Modern Art, 1965), p. 15.
8. Robert Motherwell
"What Abstract Art Means to Me"
The Museum of Modern Art Bulletin
(New York) vol. XVIII, no. 3, Spring, 1951, p. 12.

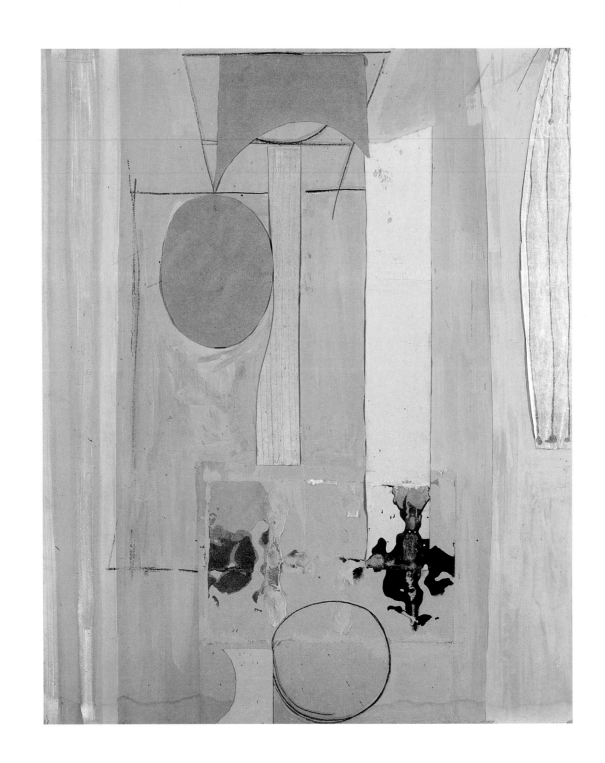

Mallarmé's Swan, 1944–47
collage, 43 ½ x 35 ½″

On Motherwell

Dore Ashton

A few generalities:

A romantic temperament that seeks to exclude all but the most tremulous of emotions, dark or bright. He craves the edge. His greatest fear: that it could be said, "you have a voice, you know all the styles, but you will never bring it off because you have no *duende*." This last was written by Federico Garcia Lorca when he emerged from his perplexing year in New York into the palmy light of Havana. There volatile emotions reigned. There he offered his meditations on the spirit of *duende*, confident that he could be understood. His passion made a deep impression on Motherwell whose temperament has drawn him again and again to the psychological and physical warmth of meridional places. Lorca said that in all of Andalusia people constantly speak about *duende* and "find in it everything that springs out of energetic instinct." He records a comment of a flamenco singer, "Whatever has black sounds has *duende*," and adds, "There is no greater truth." Lorca defines *duende* as a power and not a construct, a struggle and not a concept: "That is to say, it is not a question of aptitude, but of a true and viable style—of blood, in other words; of what is oldest in culture: of creation made act." No great artist works in a fever, Lorca had said. "One returns from the inspired state as one returns from a foreign country. The poem is the legend of the journey. Inspiration furnishes the image, but not the investiture."

Duende is defined as the "ineffable, enchanting quality present in some people and certain works of art and literature."

Motherwell is an expressionist in its most simple connotation, but one who knows the corrective of geometry and measure. There is in him the *grito* (cry) of pain and of pleasure, but also a bit of the slow smile and calm delectation conveyed by the more classical cultures. He strains to expel the blackest of sounds, but also the trill. In this he is true to his tradition. Motherwell is plainly a traditionalist in an explicit way: he knows the value of continuity. But the modern tradition, to which he has remained faithful, is one of radical change and constant conflict, of paradoxes. The central problem for all modernists remains: how to insure meaning, which requires a certain amount of stability, and how to change meanings, which requires a certain amount of innovation and disequilibrium. In short, surprise, as Baudelaire insisted. How does an artist break out of the confinement of tradition without losing touch with the communal language? It is always a matter of tact; of knowing, as Cocteau said, how far to go too far. Motherwell, by declaring himself a modernist, and spelling out his sources, stayed in touch with what he felt to be a powerful cultural force—one that extended from the mid-nineteenth century through to the present. He felt a part of something valuable that had to be conserved. But that something, in its very essence, housed a germ of uncertainty and alienation. "Everyone knows that there is a difference between modern art and the art of the past. The reason may be that since the romantic period, the artist is solitary, isolated." The modern artist is remote from his audience and even from his fellows. His background, training, habits, milieu are so diverse as to make a commonality of artists all but impossible. "Only the modern artist is a 'homemade' artist." If Motherwell is a homemade artist, he is one who has built himself a culture with energy and discrimination; who went to the greatest creative minds to reshape his own; who thrilled to the pronouncements of the original modern rebels, Baudelaire and Rimbaud; to the moody introspective commentaries of Delacroix and the post-Impressionists; to the apocalyptic thoughts of Nietzsche and Kierkegaard, and the moral lessons of Matisse and Picasso.

Early in the century the painter Kandinsky discerned two major trends in painterly modernism which he expressed in the simple formula: Matisse=color; Picasso=form. He might have said Matisse=plenitude; Picasso=profusion. Or Matisse, wholeness; Picasso, disruption. These two poles are there for the modern artist, whoever he is, if he is an inventive possessor of traditions. They are the poles between which the romantic artist strings up his tightrope to perform his own ritual—a ritual which must differ radically from tradition and at the same time carry enough familiarity to make meaning. Motherwell acknowledged them. He has said more than once that painting is a language. If painting is a language, then it is shared by all, and it is eternally yoked to context. Motherwell's task, as he shaped it himself, has been to make his language intelligible, while yet burnishing it through his uniqueness. As a modern artist, or rather, a "modern" artist, Motherwell knows, as Paul Klee said, that he can only follow his own heartbeat. The entire modern tradition is posited on the principle of the singularity of each artistic personality, and its isolation, but it is also expected to reach the deepest level of communion with humanity at large, by tortuous and ill-defined feints. That is a tall order.

It is a tradition beset with contradictions, its practitioners casting glances in opposing

directions. In its very beginnings, around the turn of the nineteenth century, there were those who were sick of the classicizing hypocrisies, and looked to themselves and their own culture, for antidotes. To be "modern" was for them to be of and in their time and place and not somewhere in a counterfeit Greek paradise. In the pantheon of modernists, the romantic poets preached individuality, and one of their number, Friedrich Hölderlin, boldly prefigured Nietzsche (to whom the artists of Motherwell's generation owe so much) when he wrote in 1801:

Nothing is more difficult for us to learn than to use our native gifts freely. And, as I believe, it is precisely clarity of representation that is originally as natural to us as the fire from heaven is to the Greeks. . . . But what is inborn must be mastered just as thoroughly as what lies outside one . . . as I have said, the free use of one's own gifts is the hardest. . . .

It was paradoxical that the "moderns" sought to free their own native gifts through estranging themselves from their society. All through the nineteenth and twentieth centuries artists have flung themselves into both a private *terra incognita* and a real place far away from their native cultures. The spell of exoticism held them; enabled them to distance themselves from the habitual in their own culture and to seek that which was unique to them through estrangement.

Motherwell, steeped in the legends of modernism as no other American painter, shares the impulse. Behind him stands Delacroix, who sought and found a rich emotional resource in the high light of North Africa; Gauguin who un-Europeanized himself consciously, passionately, in the South Seas; Matisse who sought the "light of the mind" in the light over the lagoons of Tahiti.

This thirst for foreignness in order to find a self not mired in habit and native conventions is germane to modernism. Motherwell has insistently turned to other places, other cultures, other lights, for assistance in learning to use his native gifts freely. His childhood in California where "everything is clear as in early Italian painting," endowed him with a permanent affection for the resplendent dry light of southern lands. His first onrush of creative afflatus occurred during a youthful trip to Mexico. Subsequently he has haunted Spain, Italy, and again California and Mexico, in his imagination and in numerous real journeys. For the French romantics the inspiring southern places with their exotic coloration were the French colonies. For Motherwell, an American, Mexico was closer, and Spanish things more familiar in their strangeness.

The place he instinctively headed for was the communal product of many previous artists and poets—a place that could be deciphered only by a sensibility attuned to analogy. The value of association, and later, free association, is unquestioned. For Motherwell, metaphor is the heart of the matter. From Baudelaire on, the romantics have believed that the whole world is a kind of master rhyming scheme that needs to be scanned, deciphered and recast constantly. The demon of analogy, as Mallarmé insisted, was the muse of poets and painters. The quest to discover prime analogies is endemic to a painter's life, if it is to be a life of struggle to preserve the integrity of intuitive insights. The analogy, or metaphor, requires this dual activity: first the flash of insight, then the crafted response. Motherwell has remained faithful to this modernist vision from the beginning.

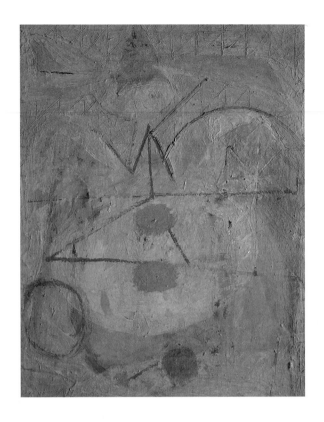

The Homely Protestant (Bust), c. 1947–48
oil on canvas, 30 x 24″

The Homely Protestant, 1948
oil on composition board, 96 x 48″

A few specifics:

It has been noticed repeatedly in the ample literature on Motherwell that his work shuttles back and forth between two moods: the darkly monstrous in which mythic undertones reside, and the brightly ecstatic, which confirms the vicissitudes of material daily life. This has led to considerable confusion. No matter how light-hearted some of Motherwell's incidental work has been, it has always veered, becoming an expressive tide that sometimes overflows its boundaries. There is very little in his work which, as he has said, has "the accumulated meaning of ten thousand brushstrokes," that can be seen as exemplary of a classicizing instinct—not even those seemingly geometric acts known as the *Open* series. Working, choosing, stroking the canvas, reworking, is a form of salvation, "the alternative to the black void" for Motherwell, as it was for most of his colleagues in the Abstract Expressionist circle. With such a psycho-physical need—to work, to stay in the work, never to emerge if possible—there can be little question of *cool* classicizing. Picasso's "form" became multiform, and Matisse's color became autonomous to the point of pure originality. The entire reality of existence for such a painter as Motherwell (and he was, it must be remembered, a close student of Delacroix' writings, in which the artist confessed that he experienced nothing so real as when he was in the act of painting or contemplating painting) resides in the unfathomable procedures of painting. "What a mysterious thing it is, exhausted and inexhaustible!" wrote Motherwell.

The way to get at the mystery was established early. It rested on a conviction inherited from the modern tradition that beneath the conscious experience there are rich wellsprings that the artist must learn to tap. Motherwell accepted the theories of Freud and Jung; of the Surrealists (that automatic drawing can call forth the hidden ore of the subconscious); of the romantic poets, and of such theorizing artists as Gauguin, Matisse and Klee. The emphasis on process, derived from so many decades of release from the classic deference to logic, and from the evolutionary, biologically scientific trends that confirmed the organic principle (forms have no interior or exterior, as Goethe said, because that which is within is also without) was to be Motherwell's principal guide into the maze. His way out was through the now-this-way, now-that-way groping toward the light he not only remembered but had created in himself as a mental construct. The basic attitude—that the art of painting is a mystery that a lifetime may not resolve—resides in every phase of Motherwell's life's work. He has said that he mostly feels "like a minotaur monster."

Too often we become entangled in the mystery in the wrong way, looking for what we call development. The cues to an artist's personality, his style, reside more in his *lack* of development; his repetitions; his reiterations of key motifs and key feelings. He comes to know himself by his own study of where he has been. If the whole enterprise is to run the maze successfully, the destination, as Matisse put it plainly, is always the same.

Motherwell's shapes: There is a repertory of shapes that can be traced from the early forties to the present. Shape (and not form) is one of a painter's most important means of identification. Some shapes are given (as Plato supposed) and

some shapes are invented. Some merely reside as a reflexive gesture; a *summa* of an artist's psyche that springs up again and again, spontaneously, in his work. Matisse told Apollinaire that he found himself, "or my artistic personality," by looking over his earliest works:

There I found something that was always the same and which at first glance I thought to be monotonous repetitions. It was the mark of my personality which appeared the same no matter what different states of mind I happened to have passed through.

If we look over Motherwell's earliest works— those of the 1940s—the mark of his personality appears in shapes that would recur throughout his life. For instance, in the much discussed early work, *The Little Spanish Prison* (ill. p. 17), once the sequence of bars, or stripes, is seen *as it is painted*, the rigor of what at first glance seems a geometrizing impulse in which the basic shapes are essentially rectangles subsides. This painting too is made up of "ten thousand strokes" and those strokes swell with the memory of organic forms. Metamorphosis was one of the Abstract Expressionists' lures. These stroked and shaped bars possess the trace of living things in their fullness, and will later be expanded and worked until they are indeed symbols of human organic formation, as in *At Five in the Afternoon* (ill. p. 35). The procession of stripes, if such vital shapes can be called that, becomes a procession of figures, or near-figures, or metaphors.

Even when his painting impulse was to free himself from inherited strictures, and from the tyranny of the near-past—that is, Cubism— Motherwell had his reflexive shapes. In the freely brushed expressionist mode, the paintings called

The Homely Protestant of 1947 (ill. p. 32) and 1948 (ill. p. 32) offer up the human figure in rounded shapes punctuated by lines that, like the leaves of a papyrus plant, radiate broadly. These radiations later become a *sign* of the human figure in a painting such as *Doorway with Figure* (ill. p. 64) and again in *Wall Painting No. 3* (ill. p. 66) of 1952. At the same time, Motherwell's affinity for the collage medium appears in the early 1940s to enhance the significance of shape. After all, that which is torn, even if painted over, has its integral shape.

Spirals, triangles, cones, bones, pinwheels, echoes of Altamira and other caves, do appear in these early works—shapes that Miró had introduced in several important exhibitions in New York during the early forties—but so do certain shapes that Motherwell alone drew forth. For instance, as early as 1943, in *Personage* (ill. p. 57), Motherwell quite unconsciously drew the swaying trapeze shape that would dominate the *Open* series years later. It is a young man's painting, with echoes of Picasso's studio paintings of 1928, the curvilinearism of Matisse, and the bone shapes of Miró, but the curiously drawn shape that suggests the swaying of a trapeze in the lower half of Motherwell's painting is straight from the depths of his own form-sense and will be stated again without his being aware.

On color: Just as shape can be reflexive, so can color. Motherwell devoured the words of the symbolist poets and painters, and it is safe to say that he drew in that which concerned him emotionally. Color for Motherwell is never abstract. It is saturated with possibility. It is metaphorical in its essence. He agrees with the modernist tradition that declares that there is no

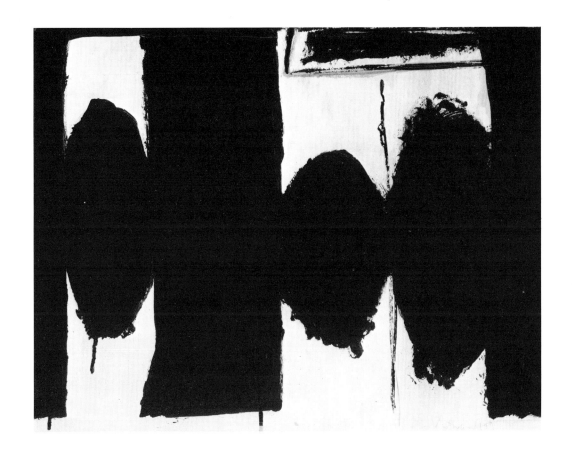

At Five in the Afternoon, 1949
casein on composition board, 15 x 20″

sense that cannot be translated through another; no experience that cannot be related through another. When Motherwell uses certain colors, they are always associated in his own mind with specific sense impressions. Yellow ocher: the walls of Mexican adobe houses washed over lightly by pigment and sun; the winter views of his childhood in northern California; Spain. Blue: the sea, first and above all; the sky; the mournful and the gay (Picasso and Matisse), vastness (Baudelaire). Red: memories of Mexico; *The Red Studio* by Matisse; blood and *duende*, folk art. And of course, chalk white and black, used by Motherwell as by Redon, for their chromatic purposes. No matter how we contemplate Motherwell's various activities—on paper, with paper, on canvas, with canvas, drawn, collaged, printed—the color always has the possibility of symbolizing, although not in the easily legible Renaissance way. Rather, it is filled with the rebellious, occult indirection that inspired the genius child Rimbaud to write:

I invented colors for the vowels! A black, E white, O blue, U green. I made rules for the form and movement of every consonant, and I boasted of inventing, with rhythms from within me, a kind of poetry that all the senses, sooner or later, would recognize. And I alone would be its translator.
—translation by Paul Schmidt

In fact, Motherwell's spiritual concourse with many poets is singularly slanted toward those for whom color—*named* color—is a kind of magical catalyst. No doubt he has had moments of heightened recognition while reading these poets, and has infused them in his work. The list is long, including Coleridge, Poe, Baudelaire, Rimbaud and Mallarmé of the nineteenth century. Perhaps even more significant is Motherwell's contact with

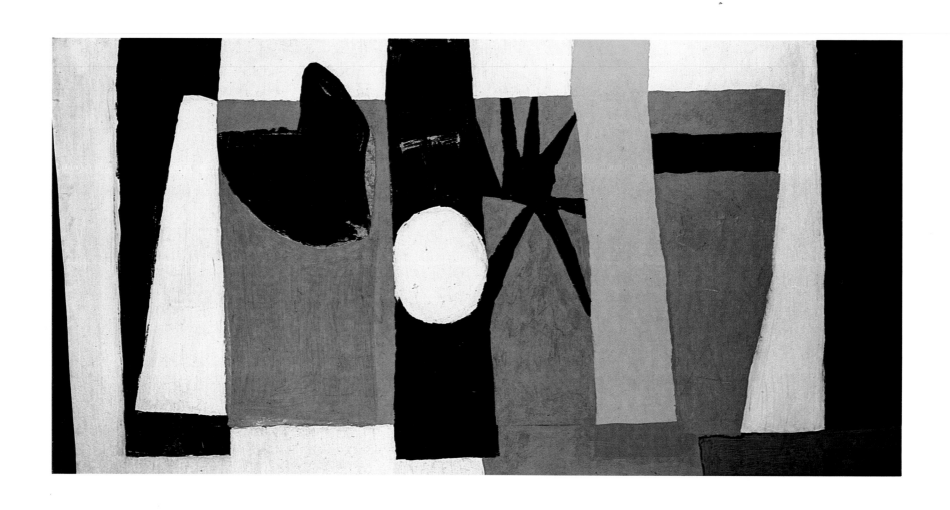

The Voyage, 1949
oil and tempera on paper,
mounted on composition board, 48 × 94″
The Museum of Modern Art, New York
Gift of Mrs. John D. Rockefeller III
Not in exhibition

poets of the twentieth century, most of whom are writing in the Spanish language. There was Lorca, as early as the 1940s, whom Motherwell recognized as a fellow painter (but in words); Lorca whose famous ballad begins by naming a color: "Green, how I love you, green," and who paints the bullring with "five bulls black as jet with ribbons of black and green." Much more intense is Motherwell's involvement with a contemporary of·Lorca, one of the generation of *Ultraístas* who renovated modern Spanish poetry. Rafael Albert Alberti speaks often of his youthful romance with painting, and in his poems spells out colors not only by metaphorical allusion, but literally. Although literal coloration appears most appropriately and frequently in *A la pintura*, which Motherwell lived as he illustrated it, Alberti's entire poetic oeuvre is spattered with swatches of color, named and named again. Finally, there is Octavio Paz, a Mexican. A superb feeling for color—specific color—infuses his work throughout:

In my window night
 invents another night
another space:
 carnival convulsed
in a square yard of blackness.
 Momentary
confederations of fire,
 nomadic geometries,
errant numbers.
 From yellow to green to red,
the spiral unwinds.

—from *San Ildefonso Nocturne*, translated by Eliot Weinberger

This abstract but allusive way of using color, the "modern" way, is Motherwell's way. He accepts the sometimes independent quality of color, its occasional character, as a thing among things that can move and define in its purity. He can even envisage color that can be "new" for, like the poet, he understands that it is in context and not neologism that the original perception can shine forth. Motherwell said about Rothko, his "mixtures resulted in a series of glowing color structures that have no exact parallel in modern art, that in the profoundest sense of Baudelaire's invocation to modern artists, are *new*."

Concerning movement: The movement in Motherwell's work is perpetual. There is no work in which the restless imp of invention does not intervene to disturb or enliven. He seeks animation wherever he moves. There is literal movement in the way he composes—even in those austere late *Open* works—and a movement throughout the oeuvre in varied cadences. His *rhythm*, like the poet's *voice*, is his signature. That is why the seminal vision of Motherwell's painting, *The Voyage* (ill. p. 36), can serve as an overall metaphor for his oeuvre. The voyage motif is a resource of his personal culture. It derives from Baudelaire's allegory of the artist's life, in which the poet states his willingness to risk oblivion in his quest for the new. It derives from Rimbaud's trumping work, *The Drunken Boat*, in which the artist and the vessel are one: a condition the modern artist craves. (Motherwell admired and wrote about his contemporary, Jackson Pollock—perhaps it was Pollock's avowed aim to live within the work, in its very center, that attracted him.) Voyagers on the modern seas of ambiguities are fretful. They seek their inspiration on the move, so to speak. Painters have a long tradition of gathering images. Even such original artists of the past, as Titian or Rembrandt, or of

the near past, as Monet and Manet, fed upon the host of painters before them and around them. Motherwell's voyage has taken him through the worlds of many modern masters and their images. He moves from quotation to gestation. His visual intelligence is voracious.

The Voyage can be taken as a resumé of concerns until 1949: The spiritual voyage of a young man through many emotional climates reaches a temporary harbor where calmness prevails and the story can be told in measured phrases. Like Pollock, Motherwell dreamed of walls; of the surpassing experience that took him away from the easel. On this flat surface he would indite the preoccupations that had accompanied him. The painting would be legible. It could be read from left to right, or right to left, but either way, it would show a series of events in time, for time is an increment in painting to which the Abstract Expressionists paid attention. It would have the lean clarity of the spatial system developed by Picasso, plane slightly overlapping plane. It would have worked surfaces, brushmarks to tell of the plethora of feelings that swiftly assail a painter as he works. It would have symbolic shapes: a heart swelling, splayed ideogram of the human figure, a bar of yellow from the sunny climes and the letter A, an inconvertible sign that will always lie on the surface.

Motherwell painted *The Voyage Ten Years After* in 1961, gathering up into an untrammelled exclamation the wealth of experience that a decade offers a vigorous man in his late thirties and early forties. By this stage he had traveled into the interior and had emerged victorious. The painting is commandingly horizontal. It is unavoidably perceived in a scanning procedure that is almost equal to undertaking a voyage. The viewer moves through openness into an abstract space (the light of the mind?) in which there are bursts of feeling: a blue automatic shape with its spontaneous character emphasized in the fine spray that vanishes in the clear infinity; an ocher shape, enigmatic in its associations, floating before the one stable element, the black bar. This painting is almost a companion piece to *The Golden Fleece* (ill. p. 39), which is a more subtle evocation of the sensuous delights and terrors of imaginary voyaging. That which is human is indicated in two modes: the amorphous, or "automatic" shape, as Motherwell would call it, riding before an aperture and, to the right, the almost defined bar of absence (a truncated stripe with its organic swell as in the earliest paintings). Free association is demanded, although the meaning of the painting is clearly the meaning of voyage. The triumphant pink at the right with its two blue emblems—flesh and sky—is also the meaning. There are many meanings, subsumed by the general notion of voyage.

Motherwell's attraction to shapes and techniques that seem to emerge spontaneously from the depths of his unconscious, overtakes him at regular intervals in his oeuvre. He was once a Benjamin among Surrealists. For them the minotaur, so marvellously resurrected by Picasso, was the dominant metaphor. This symbol of the two states of man—his vital animality and his clear human consciousness—can stand for the Motherwell who voyages. In the spirit of the voyage, then, Motherwell's reiterations of leitmotifs can be mapped. ("If all the ways I have been along were marked on a map and joined up with a line, it might represent a minotaur." —Picasso.)

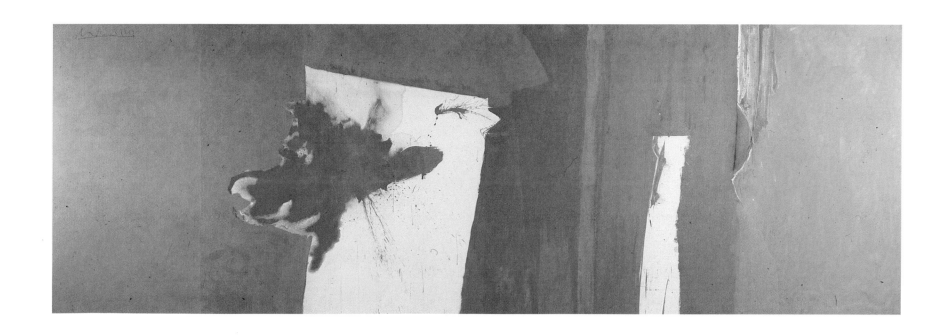

The Golden Fleece, 1961
oil on canvas, 69 x 204″

39

What can we make of his insistent return to the Spanish elegy? It must be seen as quarrying. The artist has been moved. He travels abroad and returns to his own source. An emotion was once born. It revisits. The artist must find its source, must struggle to describe it to himself. Motherwell functions here as the lyric artist par excellence; the lyric artist who addresses his *self* first and only later the others. The emotion itself can never be satisfactorily re-presented. Each time it appears in a different guise like some mythic god. Each time the artist strains to hear its light footfall, to catch it as it moves. Begin again. Motherwell has begun hundreds of times.

The Spanish elegy and related themes have been extensively studied by serious writers. The wealth and variety of their approaches attest to Motherwell's success. For Motherwell is a modern, and the modern does not describe discrete things, he alludes, allegorizes, makes metaphors that are, as Paul Valéry pointed out, multivalent. Motherwell's multivalence in the *Elegy* series appears in the phrasing, the surfaces, the final contours, the juxtapositions of black and white. With a light touch of blue or ocher or purple he can alter the whole and suggest yet another emotional nuance. Out of all the hundreds of essays in truth, or moments of truth, a few emerge that come close to the artist's intentions, or emotions. Within the corpus there are those works that emerge directly from the emotions inspired by Lorca's best ballad, *Llanto Por Ignacio Sanchez Mejías* with its refrain "at five in the afternoon," which became the title for the small seminal painting in casein of 1949 (ill. p. 35). I will not expatiate on Lorca here, but it should be remembered that this lament is deliberately cast in a rhythm endemic to Lorca's native city, Granada, with its notable gypsy population. When the religious processions form at Easter, and the companies walk through the ancient town, slowly bearing their tableau-floats, they are accompanied by music. It is the fateful rhythm of the *saeta* with its echoing, steady drumbeats; sober reminders of death and tragedy. The *coplas* recited when the procession occasionally halts, often seem an extension of the drumbeat that thumps, slowly, steadily, inexorably thumps beneath all the colorful pageantry. Motherwell has been inspired more by the rhythm than by anything else, for many of the *Elegies* seem to march faithfully across the searing white grounds— those absences that make the presences so much more weighty.

Aside from all the associations for which the painter gives permission in his deliberate ambiguities, there are three or four structural details that must be accorded a certain weight. In one kind of elegy, Motherwell strings up his forms as though they were beads sliding on a wire, or banners. In another, they are entrapped between strong vertical bars. In another, they break out into white spaces like dynamic figures, whole human figures, struggling. In still another they are soberly aligned on a surface, firmly anchored in white shapes and stabilized by black, flat verticals. These structural variations give weight or lightness. To be elegiac is not necessarily to be heavy. Music, that nineteenth-century ideal for painters, offers the nearest analogy, for it

A *saeta* is an Andalusian song generally performed in religious ceremonies and Holy Week processions.

A *copla* is a verse or strophe.

Monster (for Charles Ives), 1959
oil on canvas, 78 x 118"

is in the musicality, as Delacroix called it, that the structures of the *Elegy* series can alter the inherent meanings. In short, in the abstraction. If *duende* appears, and it does not always do so in Motherwell's insistent recapitulation of motifs, it appears rightfully as the "blackest of sounds." Not *duende* as such: In Motherwell's vocabulary there are other designations. He speaks of his "demonic" side, aptly using Nietzschean terminology. Quite often the demonic side speaks with a Spanish accent, an acquired dialect that has never failed to set off something quite incalculable in Motherwell's soul.

The demonic visits modern artists through many openings in the net of modern culture. Picasso called his *Demoiselles d'Avignon* his "exorcist" painting. As firmly structured as it was, the demonic burst through. With Motherwell, the demonic is associated mostly, it seems, with his experiences of Mexico and Spain, but it extends as well to other visions derived from Africa and Japan, or just from the terrible realm of his own complex psyche. It bears the mark of such painters of nightmares as Goya and Velasquez, and all the primitive, child-derived, or even insane products of the modern imagination. One of the worst circles in Dante's inferno is reserved for those whose presumption has condemned them to metamorphosis. Their shapes become monstrous— a hellish, deeply disturbing condition for the symmetrical human. That is how the demonic is represented in one vein of Motherwell's characterization. It occurs in the menacing, off-balance shapes of *Two Figures With Cerulean Blue Stripe* of 1959, and in *The Black Sun* (ill. p. 76) of the same year. In its very fullness this shape is frightful, as is the endless extension of *Monster (for Charles Ives)* (ill. p. 41).

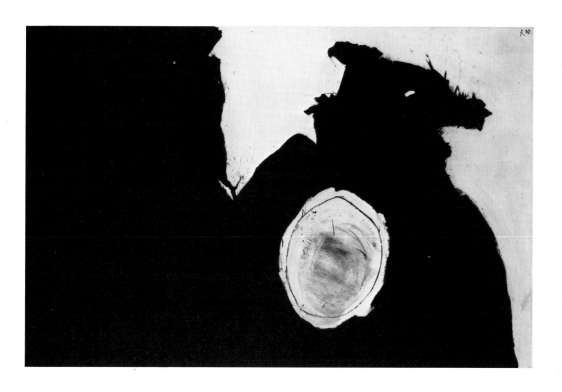

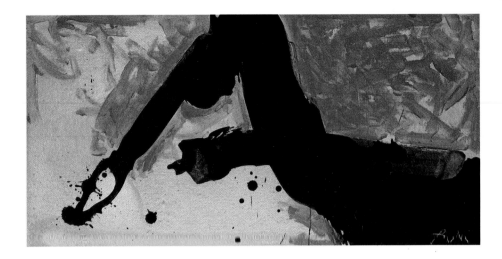

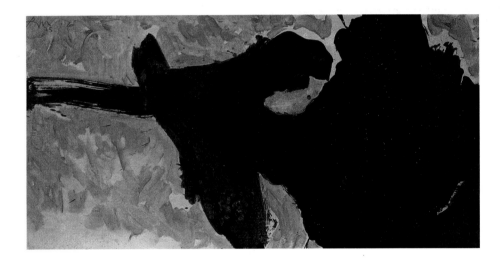

Primordial Study, 1975
acrylic on canvas board, 12 × 24"

Primordial Sketch No. 9, 1975
acrylic on canvas board, 12 x 24"

42

Sometimes the quality of the demonic, which Motherwell clearly believes springs spontaneously from the most inaccessible regions of his psyche, is not derived from shape and its distortion so much as from a sense of pervading malaise, a kind of dark vacuum in which breathing becomes difficult. The space of darkness, its sometimes frightening opacity and its dense, crawling animation, have been the motif of several groups of works ever since the 1950s. There are the works such as *Iberia #2* of 1958, in which a large surface of dense black is broken only at the lower edge of the painting by amorphous struggling ocher shapes. The mysterious presence of Goya's dog, whose upward gaze has never been fathomed, and who is either sinking into oblivion or rising from it, is hinted at here, while it is explicit in the *Spanish Painting with the Face of a Dog*, 195 (ills. pp. 18, 72). There are reminiscences of nothing other than fearfully vast blacknesses in a whole series of small oils of 1958, in which the black opens only to the most fragile of small lights painted as though torn from the blackness. Similarly, there are only the most obscure possibilities for associations other than the general feeling of uneasiness that the viewer has before the very large black arches straddling endless white space, as in the *Africa* paintings of the early 1960s. Motherwell himself seems to have been baffled by these powerful shapes until he returned to the motif, in works such as *In Black and White No. 2* in 1975 (ill. p. 8), and found its great suggestive slopes taking shape in his mind as the peaks of Kilimanjaro, as seen in the small study of 1975 (ill. p. 42). His "atavistic returns," as he puts it, take him into the millennial past, to the cave painters, as we see in *Primordial Sketch No. 9* of the same year (ill. p. 42).

It is not always the dark cave, however, that bestirs Motherwell's drive to record and define his feelings. There are other wall paintings that have mattered. "Sometimes," he has written, "I feel like a Cretan painter pure and simple who happens to be alive now." Those Cretan painters, like the Etruscans, rendered their feeling in pure, bright colors, exactly as they perceived their lives, and displayed an exuberance rarely matched in the modern era. Such exuberance, as Nietzsche reminded us, cannot be expressed solely in Apollonian terms. It gains its vital power from the contest with the chthonic forces. All through Motherwell's course there are reminders of his sensuous acknowledgment of the immediate sensation. His exuberance is particularly marked in the collages. These make up a kind of journal—from the word *jour* (day) with all its connotations of light. In the 1940s, they are abundantly figured, full of energetic thrusts and bright colors.

The bright yellows, pinks and blues of *Mallarmé's Swan*, 1944–47 (ill. p. 28), speak of Motherwell's pleasure in color, in shaping the viscous paints, and in associating with the poet, whose most perfect poems always had a note of anxiety and even terror, as is the case of the swan. Later, Motherwell's collages often contain an affixed notation of the day's events, the "certainty" as Braque called it, around which his feelings swirl or rush, as in the *N.R.F. Collage No. 2* (ill. p. 44), with its broadly brushed commentary on the fragment life had deposited that day. Motherwell's use of the certainty—those bits of identifiable real things that set off a train of associations—continues throughout his oeuvre. During the 1970s, for instance, there are allusions to his trip to Germany with his German-born wife, such as the *Ungluleckliche Liebe* of 1974 (ill. p. 45).

Here the characteristic vertical with its entasis suggesting the human form, is qualified by a fragment of a German *lied*, whose words Motherwell does not understand. It is the suggestiveness of the strange that attracts him here, as it does in many other contexts. The shape appears again, thrusting up in white drama in *Leda* (ill. p. 109), but here its harshness must have been suggested by the uncomfortable myth that lent the collage its name. Very often Motherwell composes with fragments of cut, painted papers, much as he would work in an automatist way on canvas. The effects arrive and he then freely associates their meanings. In the collages, even the most soberly abstract, the effects always seem immediate, attesting to a temperament easily aroused by color, motion and sensuous surfaces.

This side of Motherwell's personality has been expressed at various times in other modes. The *Je t'aime* series of the late 1950s (see ills. pp. 69, 70) is filled with allusions to surges of delight. The surfaces are caressed repeatedly with a paint-laden brush, the colors are warm to hot and even the handwriting, spelling out a triumph of emotion, is full of *je m'en fichist* verve. In the early 1960s Motherwell offered several groups of works that were initiated in an expressionist, spontaneous response to certain experiences. There were *Caprices* and there were *Beside the Sea* groups that played upon the interaction of water and wind during the summer months when Motherwell watched the sea before his Provincetown studio. Great leaping shapes and free spatters of spume appear in these works, often defined by a few simple colors spanning the lower canvas to suggest sky and sea. Less specific but equally vivacious is the enormous body of ink drawings on rice paper produced in 1965. These small

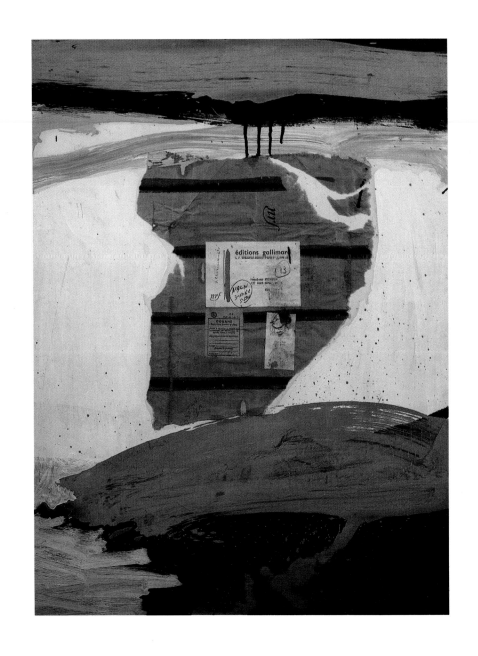

N.R.F. Collage No. 2, 1960
collage of oil and paper, 28⅛ x 21½″

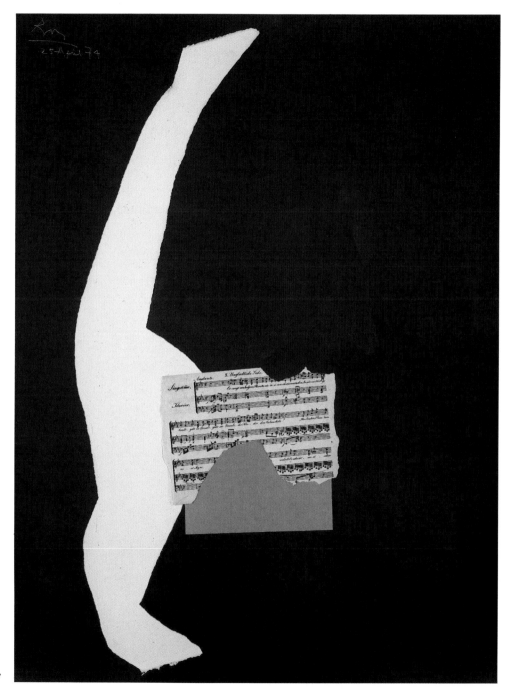

Unglueckliche Liebe, 1974
acrylic and paper on board, 48 x 36″

45

drawings which, as Motherwell has written, are in a technique of "unadulterated automatism" were perhaps his most candid affirmation of his belief in the resources of the hidden psyche: "I took a thousand identical sheets of Japanese rice paper, an English watercolor brush, and common American inks, and worked perhaps forty at a session, without conscious preconceptions, and with no revision—that was the rule of the game. . . ." These fluent outpourings were often the source of more worked paintings in which Motherwell could study the spontaneous shapes and modify them deliberately. In a later group of ink drawings, this time on parchment, which Motherwell titled the *Rimbaud* series, there are full and sometimes menacing shapes, as there are also in the *Samurai* drawings (see ill. p. 114)— shapes that make their way back into the larger paintings and express the swift metamorphosis of the artist's emotions—from light-hearted affirmation to foreboding.

It is apparent that the lyric impulse often moves artists in the direction of a sign language. The artist needs to tell himself who he is and where he has been. Motherwell has often discerned symbols or signs in his spontaneous exercises and developed them in an ideographic direction. His "handwriting" often verges on the literal. He is a lover of alphabets and the printed word. He admires calligraphy as an art. It is only natural that at times he has struggled to refine his own interior alphabet so that he could read himself unmistakably. In the early 1970s his need to condense and yet to write in his own alphabet expressed itself in a group of drawings in charcoal and acrylic washes on beige grounds that are consummate expressions of his will. The simple shapes of a mysterious alphabet are given an

expressive weight by means of delicate shadowing and ambiguous linear recessions. The central form with its letter-like presence hovers in a warm and evocative space, an eloquent testimony to Motherwell's instinctive need to create a poetic place, one in which no other voice can rend its wholeness.

The charcoal line, with its rich emphasis and its propensity to hint at another dimension, became a natural ally when Motherwell embarked on his extended *Open* series. The series was initiated, according to Motherwell's ingenuous explanation, by a moment in the studio when he noticed a congress of shapes where a small rectangular painting leaned against a larger one. But this simple explanation does not go far toward explaining the range of expression found within the works. For that one must return to the formative thoughts of the young Motherwell who, already in 1951, spoke rhapsodically of the value of modern painting which is in essence abstract. The modern, he said, basically felt unwedded to the universe. "I think one's art is just one's effort to wed oneself to the universe, to unify oneself through union." The best means for Motherwell lay in a kind of poetic condensation that he called abstraction. He likened himself to Mallarmé in his study late at night, working with "the secret knowledge that each word was a link in the chain that he was forging to bring himself to the universe." And like Mallarmé, he expressed his conviction that the heart of modern expression lies in its extremely condensed mystery. Motherwell wrote that "one of the most striking aspects of abstract art's appearance is her nakedness, an art stripped bare." This nakedness he identified as a new kind of mystique, "for make no mistake, abstract art is a form of mysticism."

Mysticism generally involves an intense effort to reach a moment of exaggerated clarity, a revelation. Motherwell's desire, already apparent when he spoke with such aplomb about abstract art, was to participate in the same sacred enterprise that led Mallarmé to compose his *Un coup de dés* with blankness as a metaphor. Blankness is to be filled with reverberations from the active word, mysteriously activated by careful reductions, whittled contours, quintessential characters. Paradox was implicit. Was not this carefully composed and shaped poem likened to a throw of the dice? But it was likened, also, to the galaxies, which eternally hold to their nonsymmetrical patterns, fixities and ambiguities —never changing, always changing. The young Motherwell vibrated like a tuning fork to the tune of the patrician Mallarmé and longed to know the terrible and exalting experience of the abyss that had so mesmerized the nineteenth-century poets. To know it requires endless beginnings. The good mystic starts again each time. In the *Open* series, Motherwell's beginnings are always the same: the ground which is seemingly unbounded, and the spare figure written upon it, qualifying and reducing the space to manageable human dimensions. The charcoal lines with their almost organic vibration are the reduced means Motherwell has selected to indicate the presence of specific feelings. Here too there are, as there were in the *Lyric Suite*, rules of the game. The shape must always somehow suggest its origin in the association with window or door. But windows and doors are redolent of poetic associations. They also always invoke mirrors. Matisse had already explored the metaphysics of doors and windows as reflections, as gateways to a universe with no inside or outside, where inside always takes in outside: "The wall around the window does not create two worlds," he said. This infusion of space with rhymed entities—not things but feelings that are yoked; feelings of space and of enclosure— was Motherwell's lure in the *Open* paintings, works that occasionally achieved associations beyond the quality of openness and then were given titles, such as *The Garden Window* (ill. p. 48) and *The Spanish House* (ill. p. 90) of 1969. Trapezoids and rectangles conferred the associations which in turn summoned a host of others. Sometimes color was laid down for its symbolic associations. But sometimes, as in the group, *In Plato's Cave* (see ills. pp. 49, 98), a moodiness overtakes the artist and is expressed through sooty blacks and grays laid on with feeling, glimmering around the open rectangle that has transformed itself into the most elementary of man-made signs. Not even here, in the dim light of the cave, is man's mark extinguished and Motherwell has captured the shadowy realm, at least for the time when he is in, or contemplating, the painting. His weddedness to the universe is only possible within the painting; within the act of painting and its recapitulation in the viewing. In the *Open* series, Motherwell has the same objective as in his symbolic use of the voyage motif.

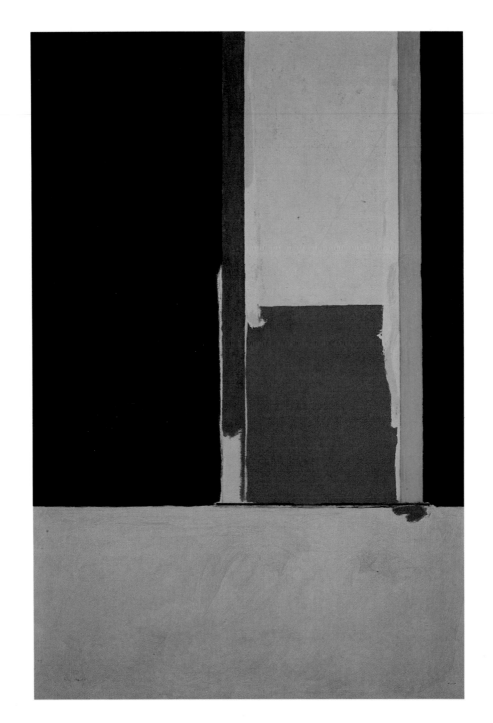

The Garden Window
(formerly *Open No. 110*), 1969
acrylic on sized canvas, 61 x 41″

opposite
In Plato's Cave No. 1, 1972
polymer paint on
oil-sized canvas, 72 x 96″

48

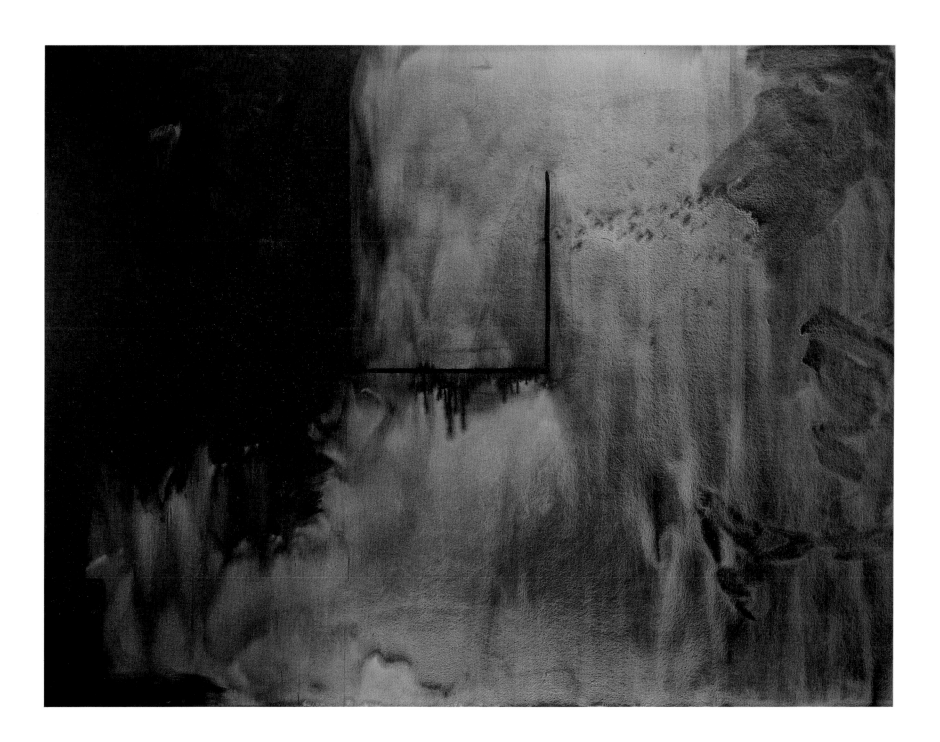

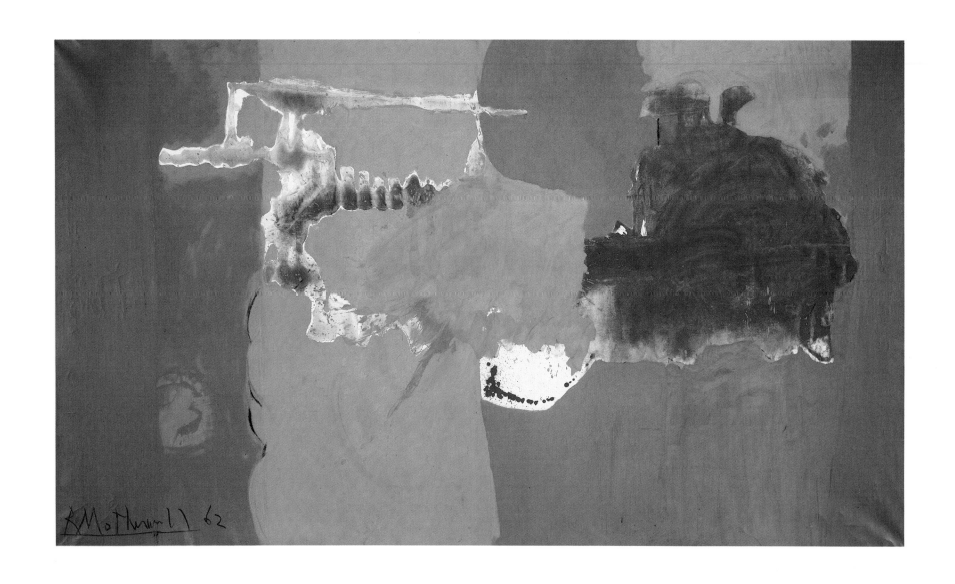

Chi Ama, Crede, 1962
oil on canvas, 82 x 141"

A few more generalities:

The men and women of Motherwell's generation shared an experience that we have come to call Abstract Expressionism. Motherwell has written about his years as a youthful participant in a tide of feeling that swept on, past the past, into an uncharted realm. The big canvases this generation produced awed the world. The large statement, in every sense, was liberating. Most of these artists believed, as does Motherwell, that painting could be a language. And, in time, it came to be that many of these huge canvas exclamations could be read as such by a constantly growing public. What meaning could be extracted was in terms of feeling —feelings of plenitude or distractedness or spatial euphoria. Motherwell has remained faithful to the premises that produced this movement, as he has stated in many essays, notes and letters.

But, as articulate as he is, Motherwell has remained a painter. His "language" has no fixed alphabet and he cannot rely on repeatable sequences of formal strategies such as paragraphs and ellipses. The language of a painter is untranslatable. If it is translated, it becomes factitious. Therefore, to read Motherwell's language requires an investment of time and attention. It is incumbent upon the viewer to move in and out of moods with Motherwell and to lay bare the process by which he expresses them. The *process* for Motherwell and his confreres among the Abstract Expressionists is the most commanding aspect of the work. The equivalent of adjectives must be found in small flourishes of the brush or bold juxtapositions of chromatic sequence or in the insistent flirtation with the written work called calligraphy. The language of the Abstract Expressionist artist

springs from the desire to speak *generally* of *specific* experiences, a paradoxical procedure— not, "I love this apple" but, "I love apples."

In the course of a painter's life the decisions are always to exclude. The very act of painting is an act of exclusion. A painter cannot take in all the particulars of a teeming world. Yet Motherwell has come to the world as a child to a groaning table, rushing from this delicacy to the next, eager to savor everything and always anxious lest something be overlooked. He has a robust appetite. In the zig-zag course he has run, there are grand and compelling works, such as *Chi Ama, Crede* (ill. p. 50), and small *aperçus* such as the *Lyric Suite* observations. These different weights are not important to him. In his stream of consciousness there is little hierarchy. What he craves, what his spirit wants is that which "springs out of energetic instinct" that can tell "of creation made art." For this, a whole lifetime is not enough. The painter circles his quarry—the initial moment of attentiveness and its attendant excitement—and circles again, always poised for the capture. The very surfaces of Motherwell's works tell of this constant alertness, and the desire to entrap the fleeting. The nature of Motherwell's work is, then, a kind of endless telling; a flow of language that is shaped and fondled and recast constantly in order to tell again what was once experienced, a flow that can be likened technically to that of James Joyce.

Plates

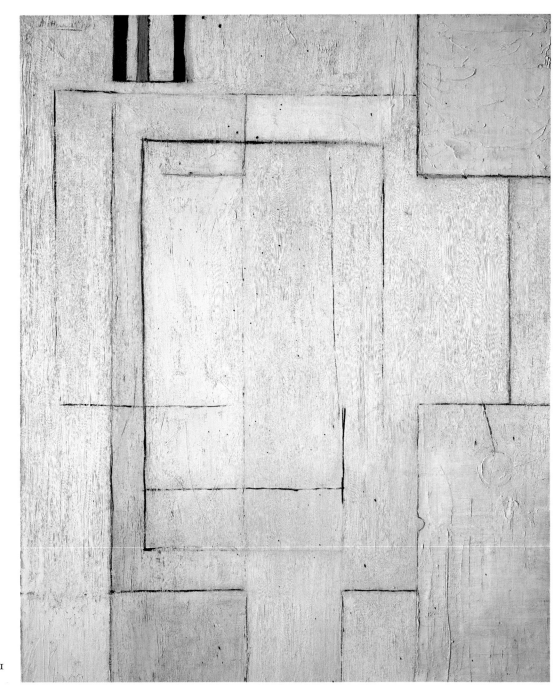

Spanish Picture with Window, 1941
oil on canvas, 42 × 34″

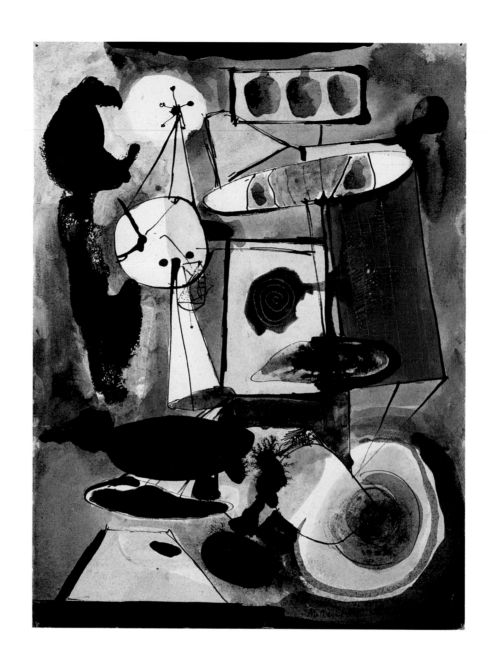

The Door, 1943
colored inks on paper, mounted on board, 13 ¼ x 10″

54

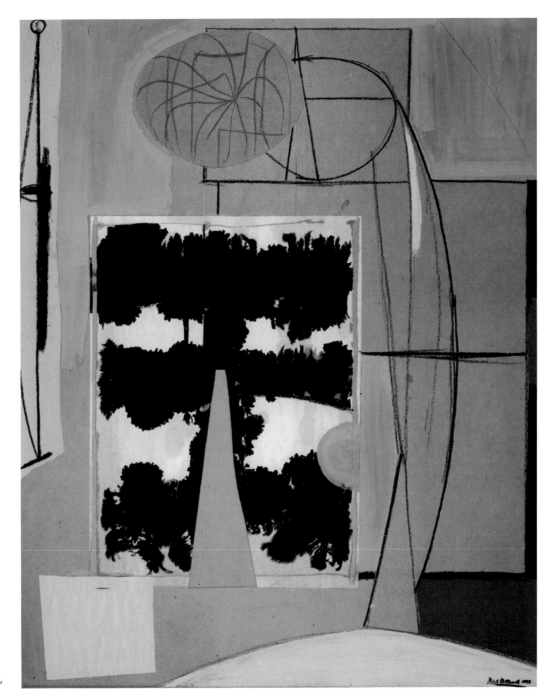

Figure with Blots, 1943
oil and collage on paper, 45½× 38″

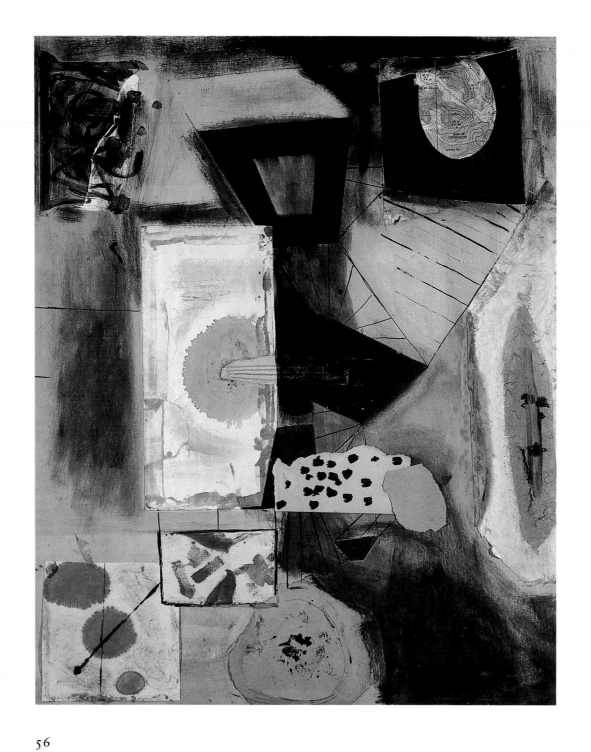

Joy of Living, 1943
collage, 43 ½ x 33 ¼"

56

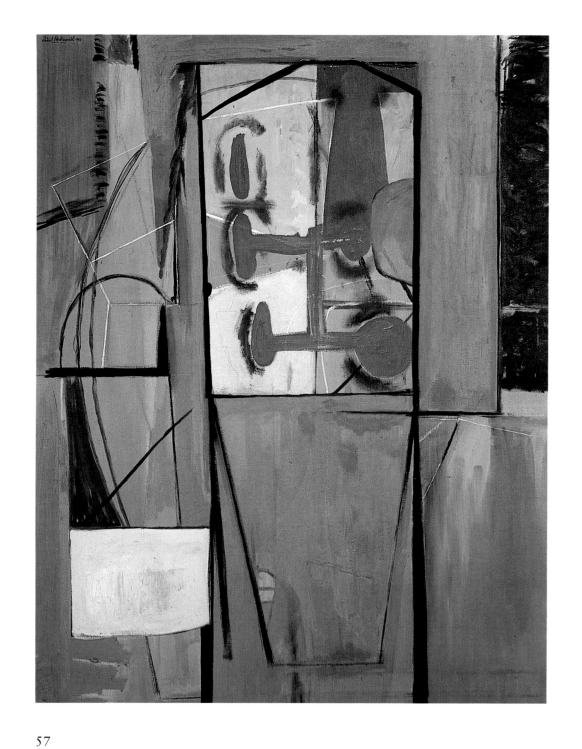

Personage, 1943
oil on canvas, 48 x 38"

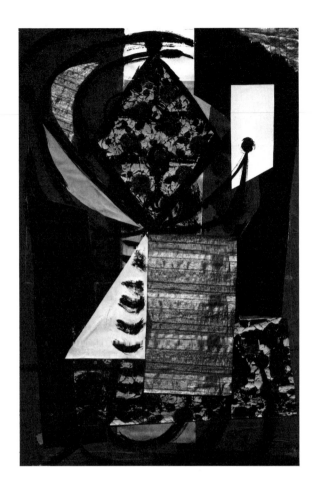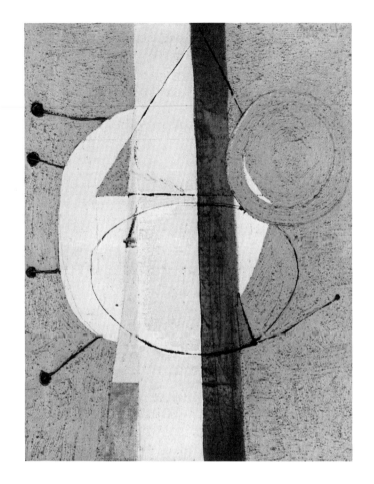

Collage No. 2, 1945
oil and collage on board, 21⅞ x 14⅞"

Figuration, 1945
oil on canvas, 18¼ x 14¼"

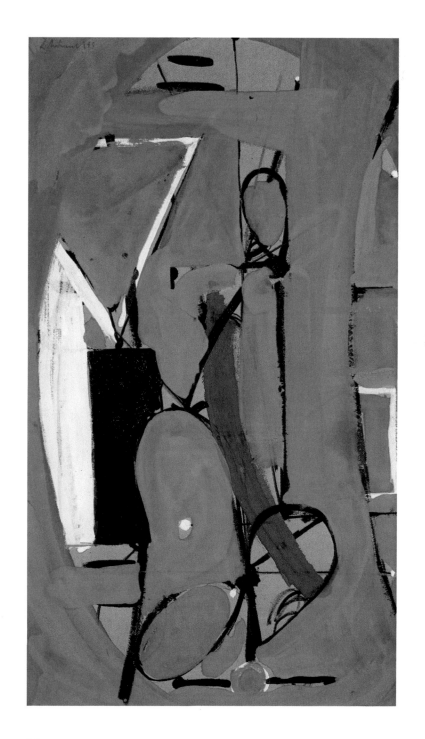

Personage, 1945
gouache on paper, 20½ x 12″

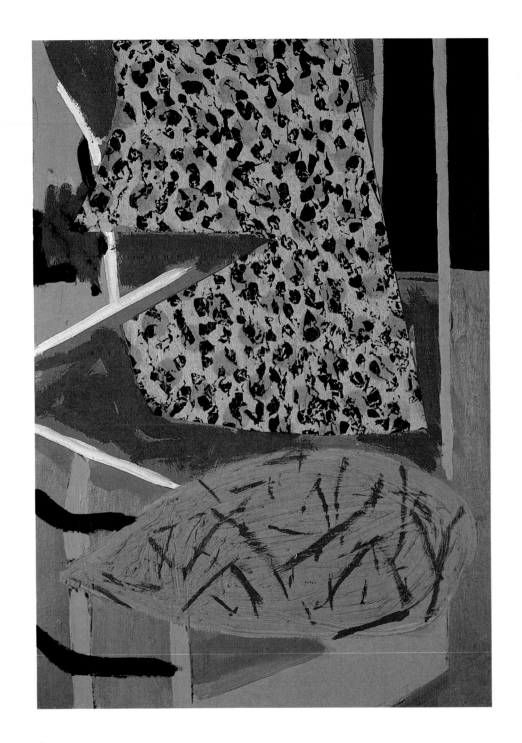

Collage, 1947
oil and collage on academy
board, 26¼ x 18¾"

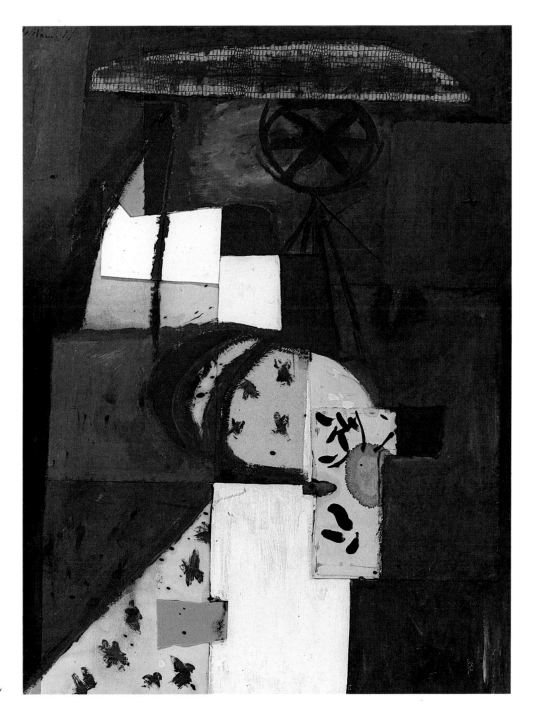

In Grey with Parasol, 1947
oil and collage on board, 48 × 36″

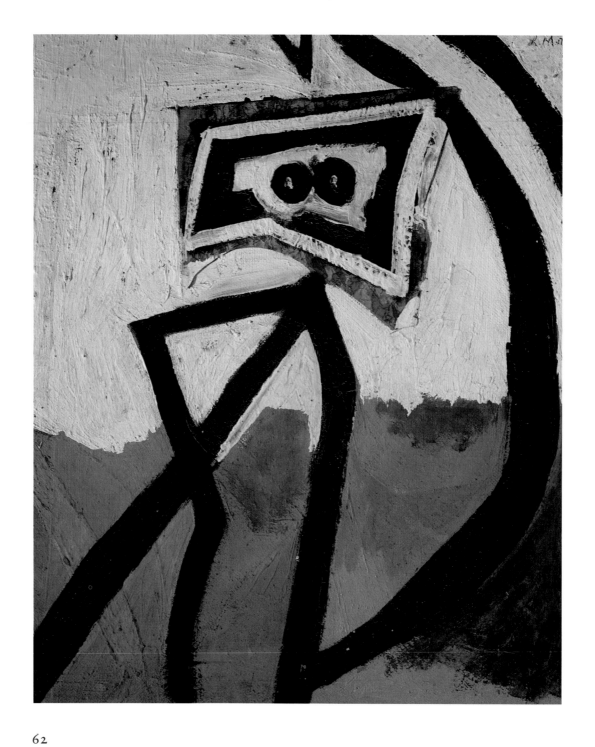

Figure in Black, 1947
oil on canvas, 24 x 19"

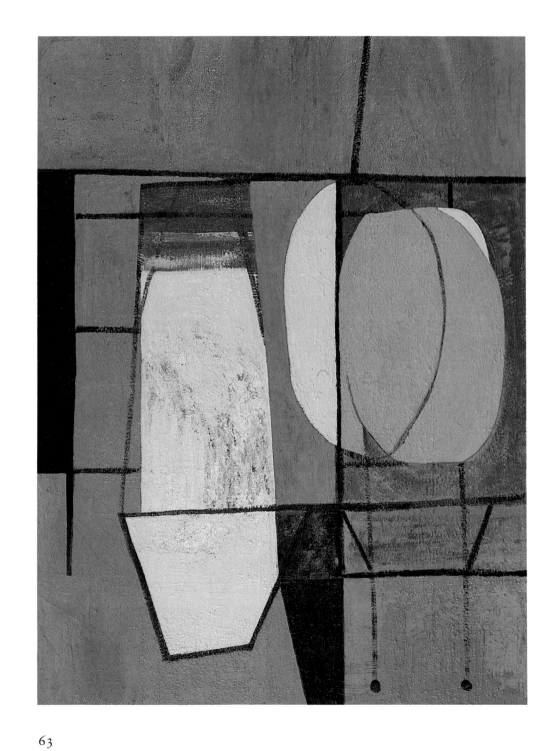

Western Air, 1946–47
oil on canvas, 72 x 54″

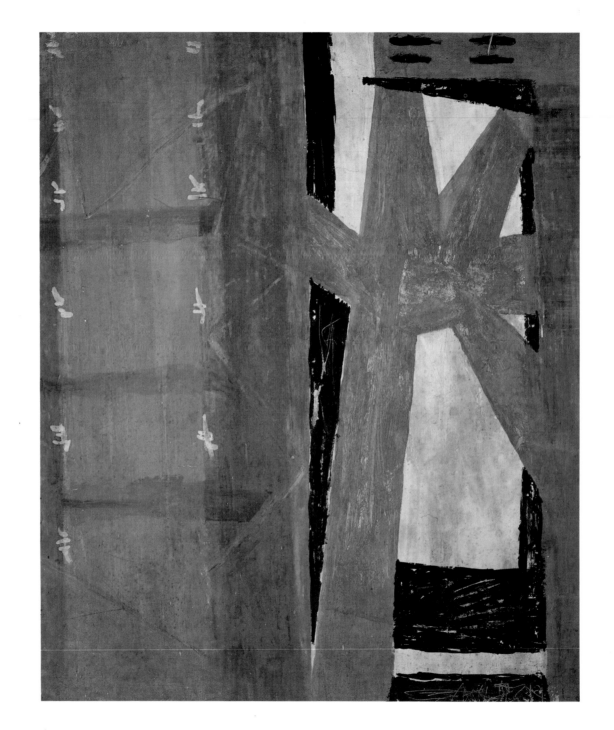

Doorway with Figure, c. 1951
oil on paper, 48 × 39¾"

64

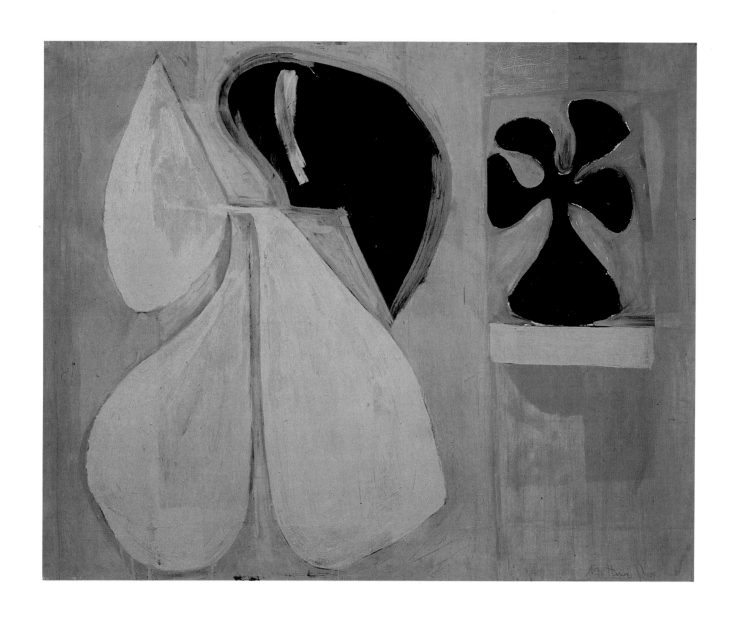

Interior with Pink Nude, 1951
oil on masonite, 44 × 55″

65

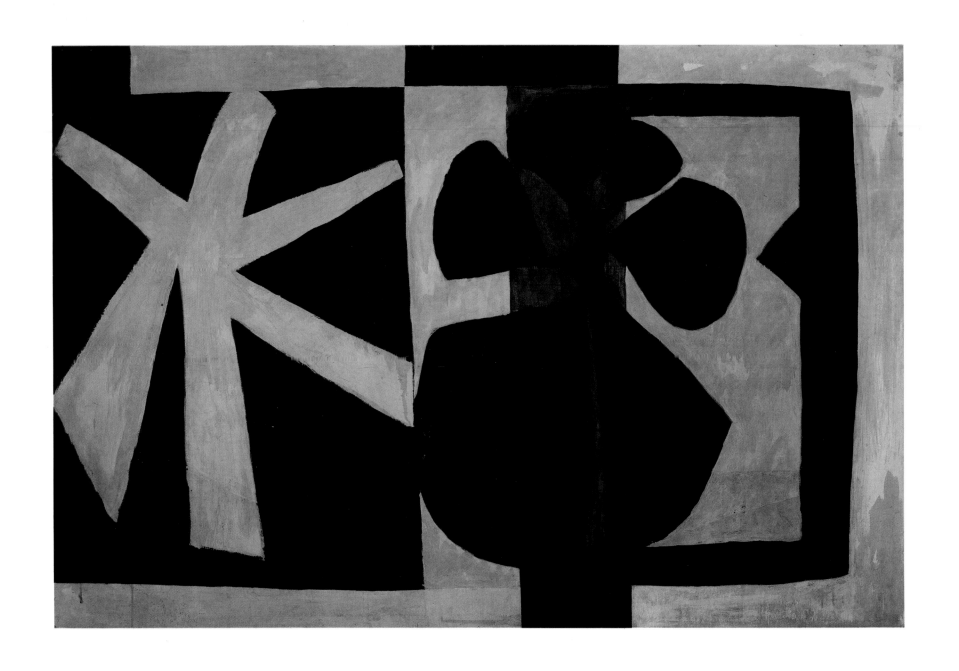

Wall Painting No. 3, 1952
oil on masonite, 47½ x 71½"

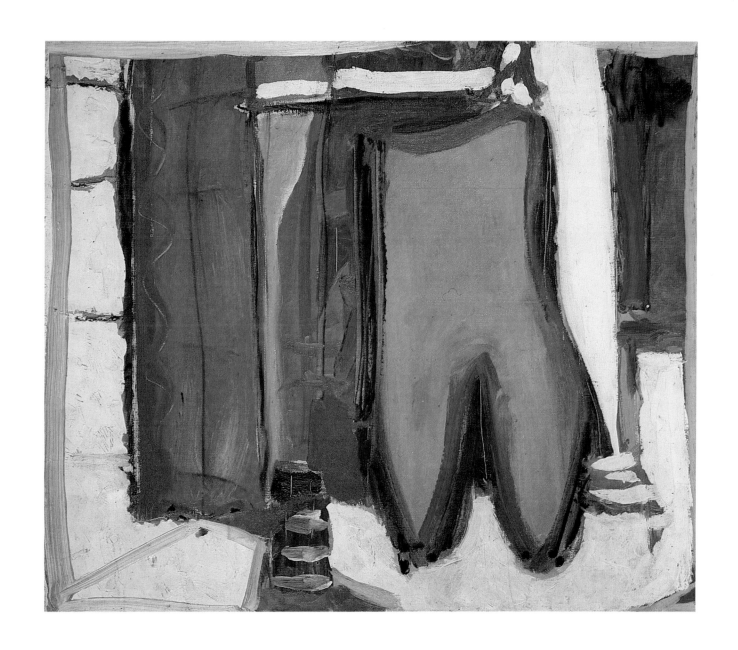

Orange Figure with Interior, 1953
oil on canvas, 20 × 24″

67

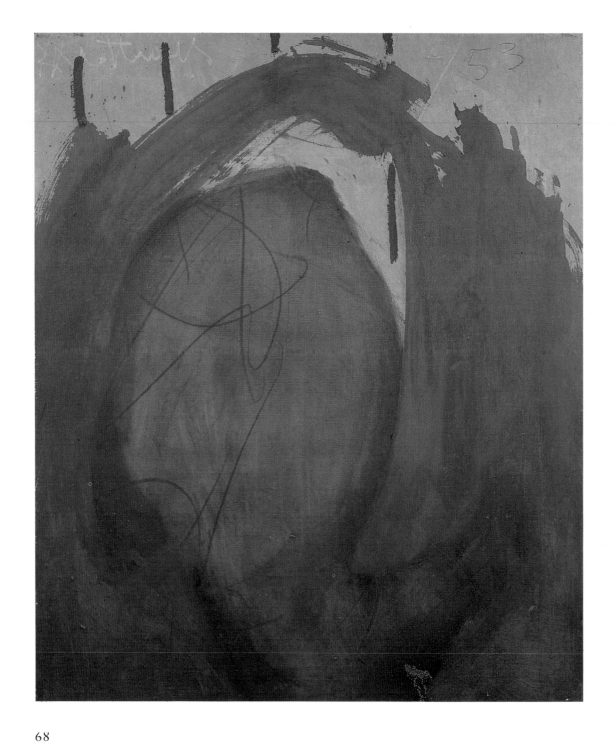

Abstract Head, 1953
oil on canvas, 24 x 20″

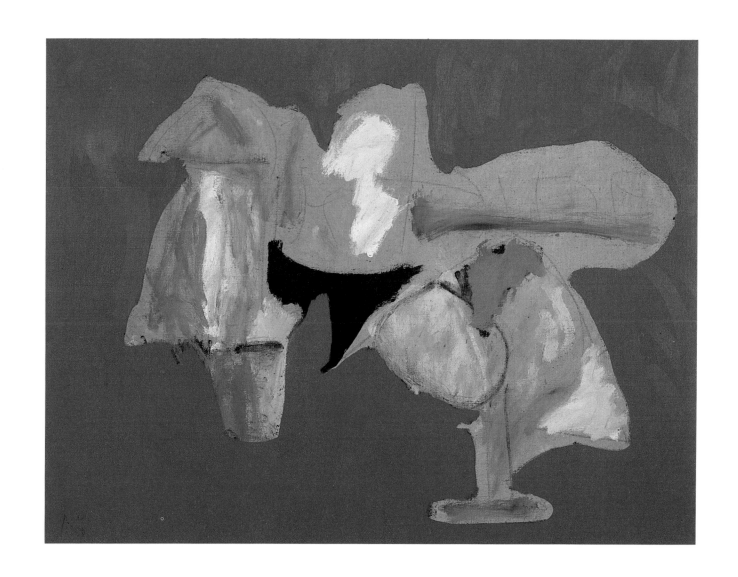

Je t'aime No. VII, 1956
oil on canvas, 36 x 48"

69

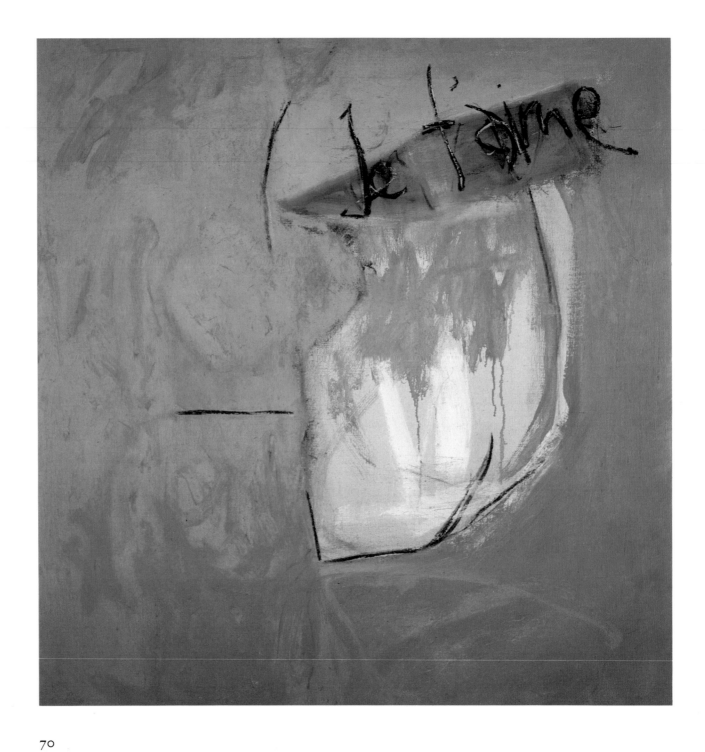

Je t'aime No. VIII, 1957
oil on canvas, 40 x 42"

70

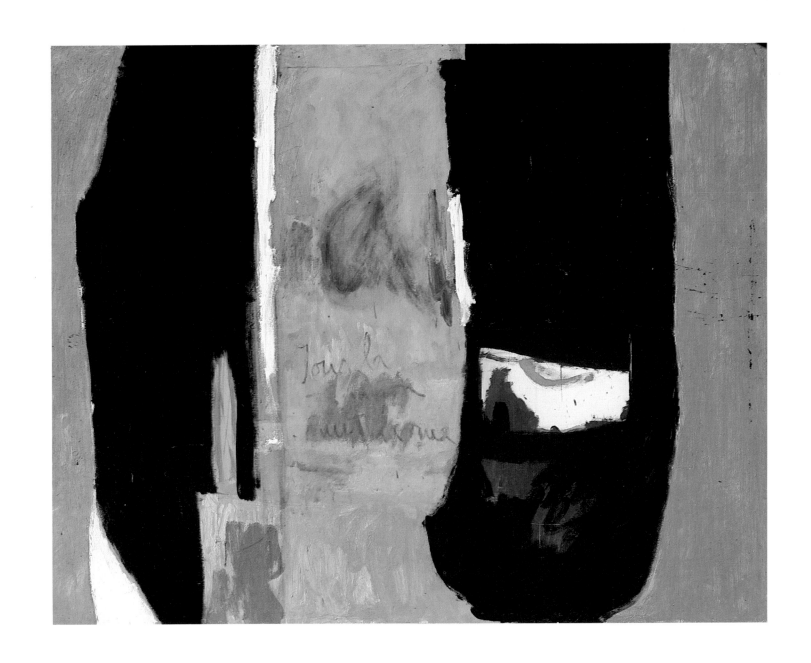

Jour la maison, nuit la rue, 1957
oil on canvas, 69¾ x 89⅝"

71

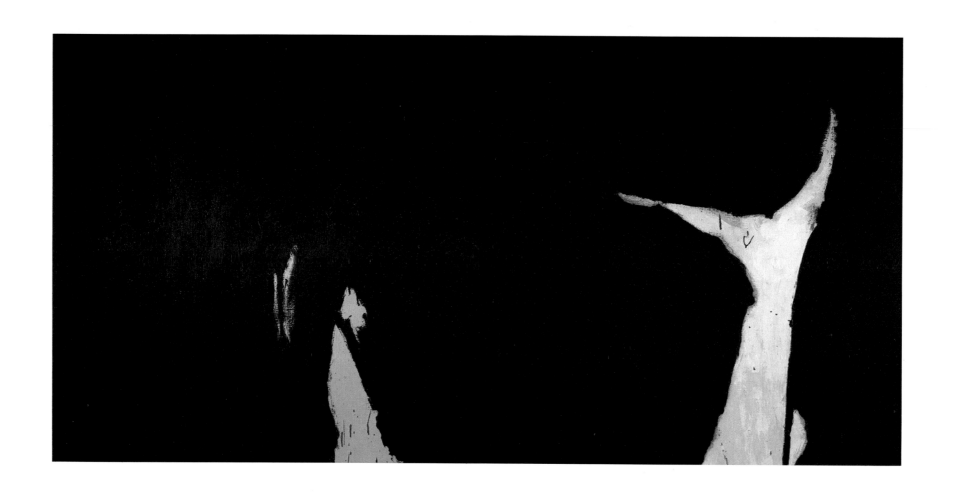

Spanish Painting with the Face of a Dog
(final state), 1958
oil on primed bed linen, 37⅛ x 75¼″

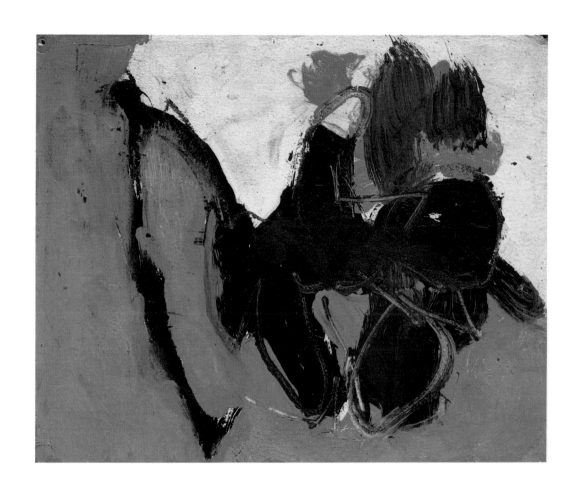

Two Figures No. 11, 1958
oil on panel, 8½ x 10½"

73

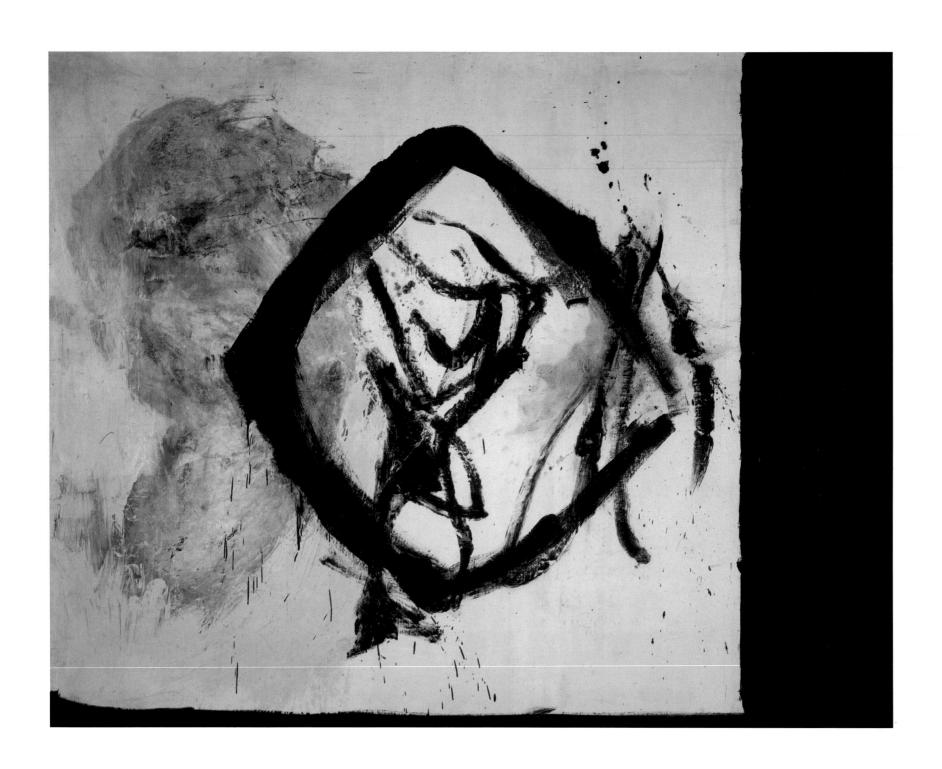

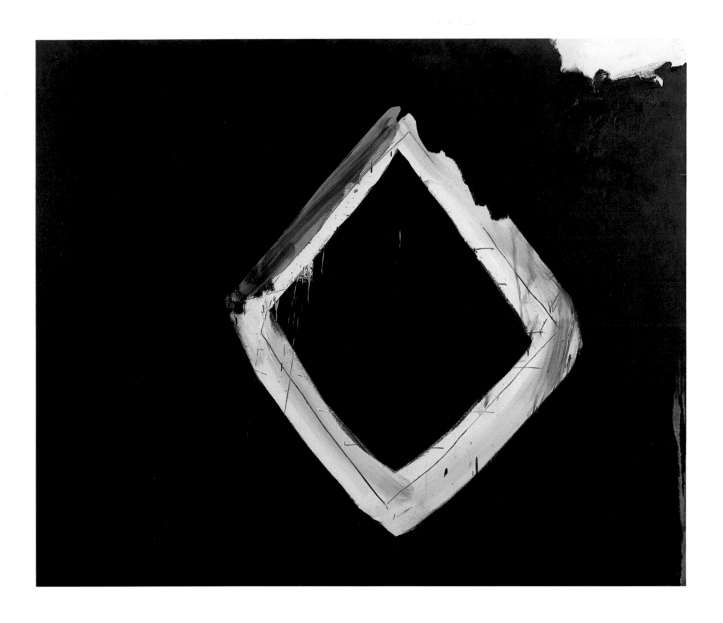

opposite
A View No. 1, 1958
oil on canvas, 81⅛ x 104"

A View No. 10, 1958
oil on canvas, 69 x 85"

75

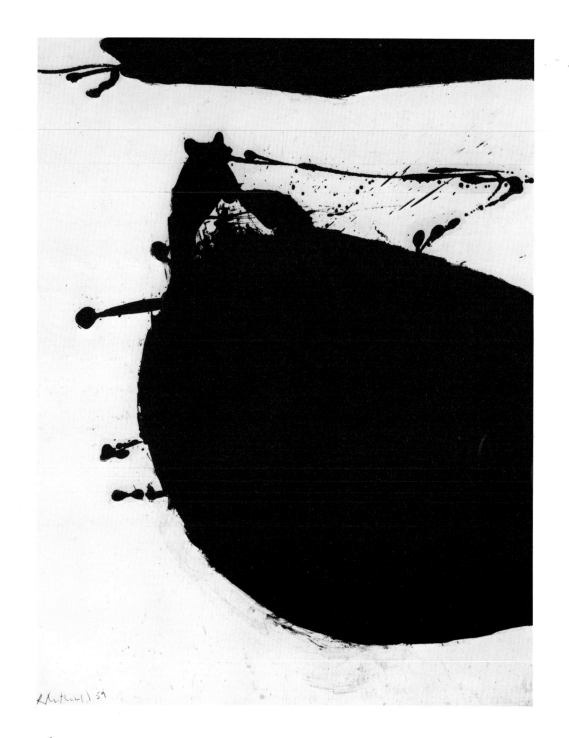

The Black Sun, 1959
oil on laminated paper,
28⅞ x 22⅞"

76

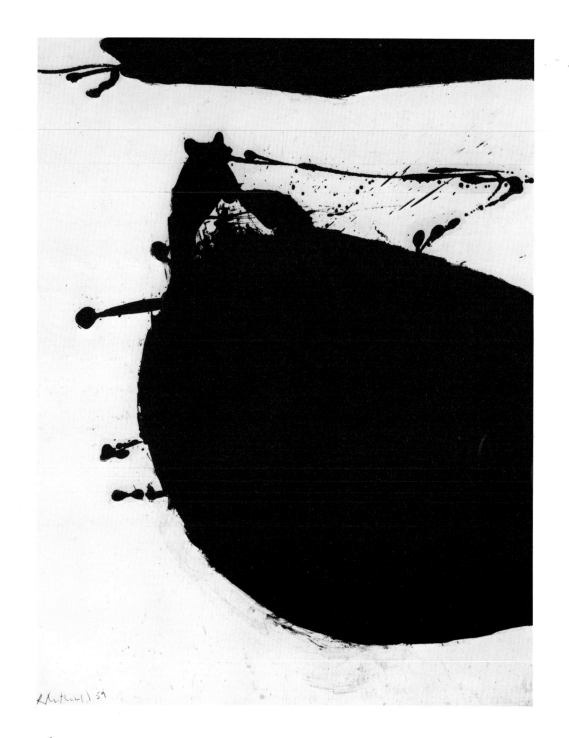

The Black Sun, 1959
oil on laminated paper,
28⅞ x 22⅞"

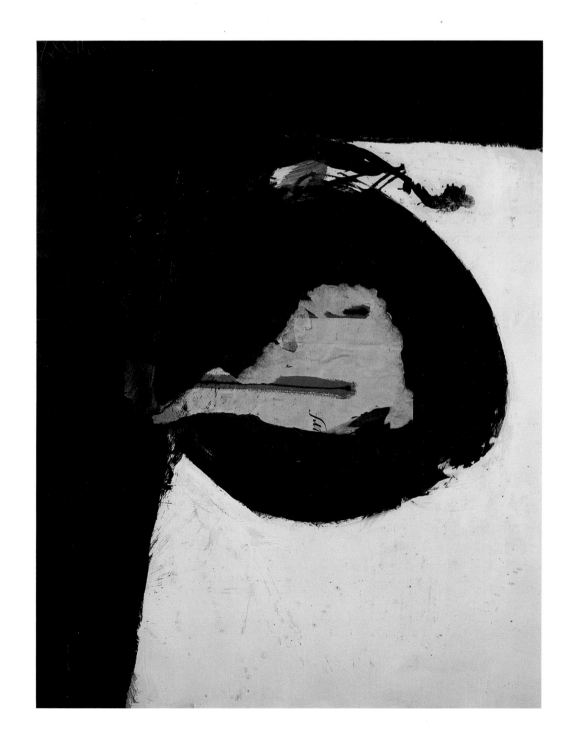

N.R.F. Collage No. 1, 1959
collage of oil and
paper, 28⅜ x 22⅜″

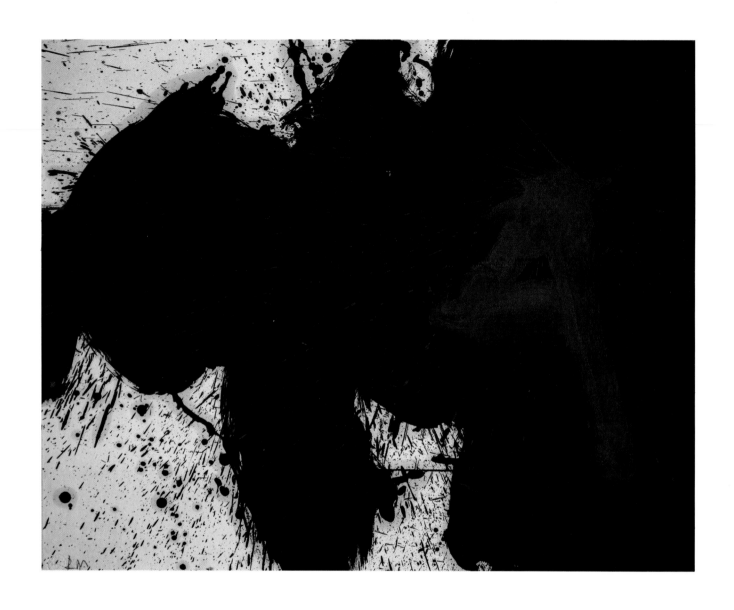

The Figure 4 on an Elegy, 1960
oil on-paper, 22⅞ x 28¾"

78

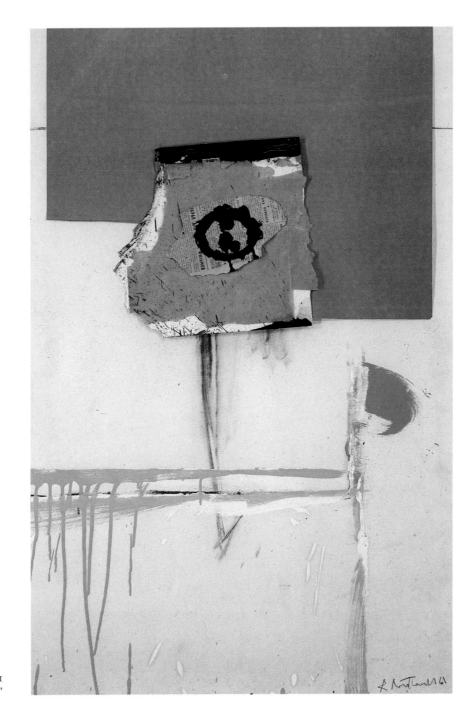

In White and Yellow Ochre, 1961
collage and oil on paper, 41 x 27″

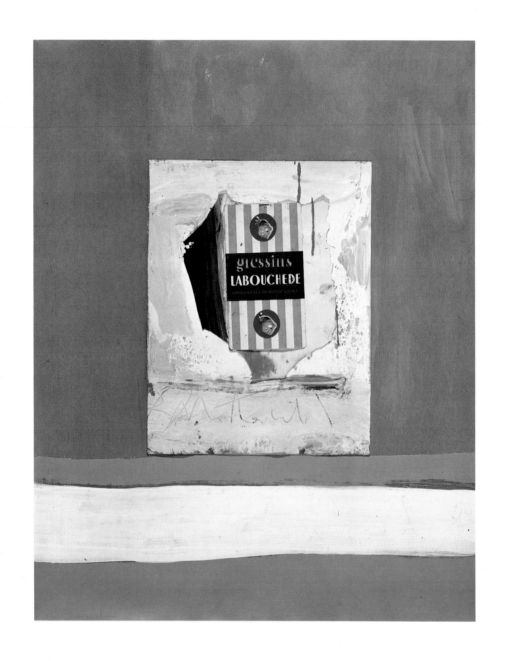

The French Line, 1960
oil and collage on laminated rag paper, 30 x 23″

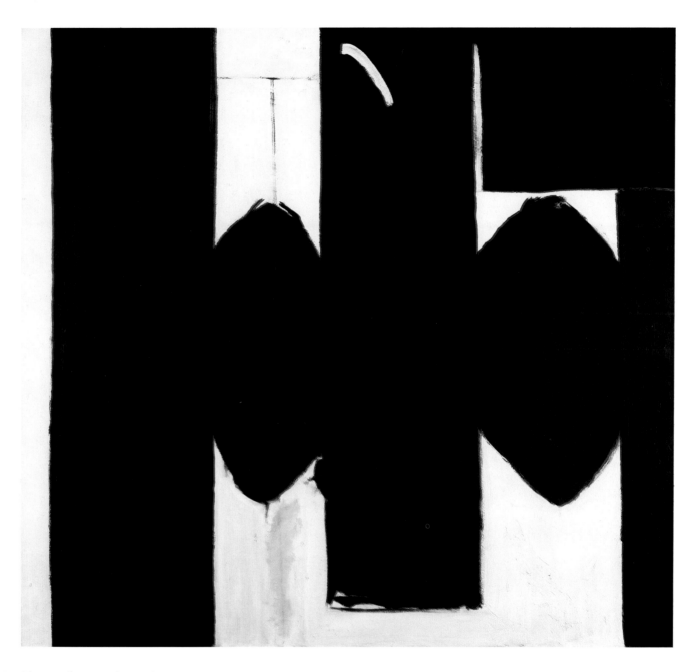

Elegy to the Spanish Republic No. LV, 1955–60
oil on canvas, 70 x 76″

81

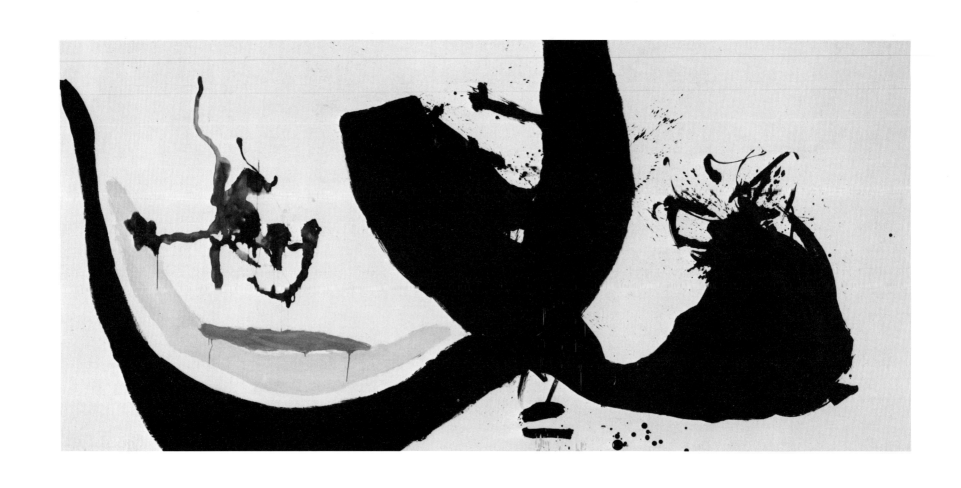

Black on White, 1961
oil on canvas, 78¾ x 163¼"

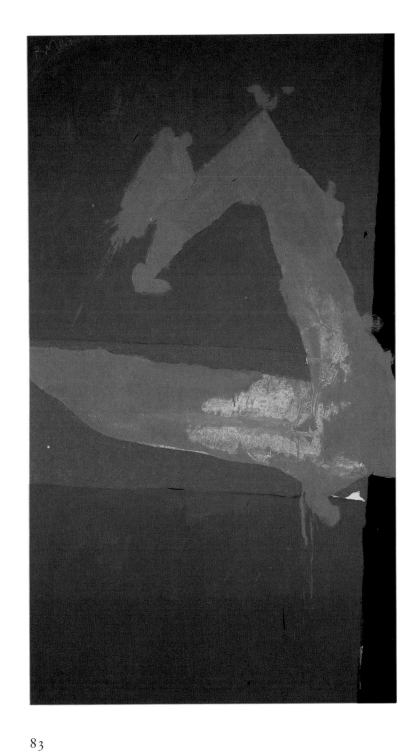

Summertime in Italy, 1967
acrylic on canvas, 82 x 48"

83

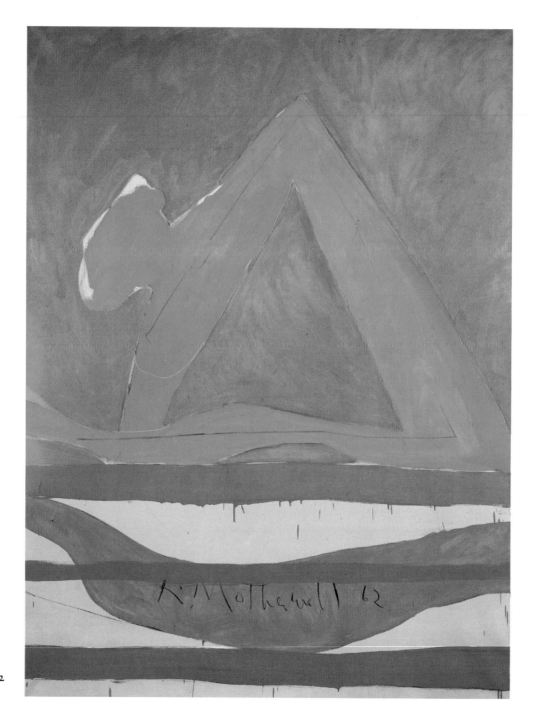

Summertime in Italy, No. 28, 1962
oil on canvas, 96½ x 72½"

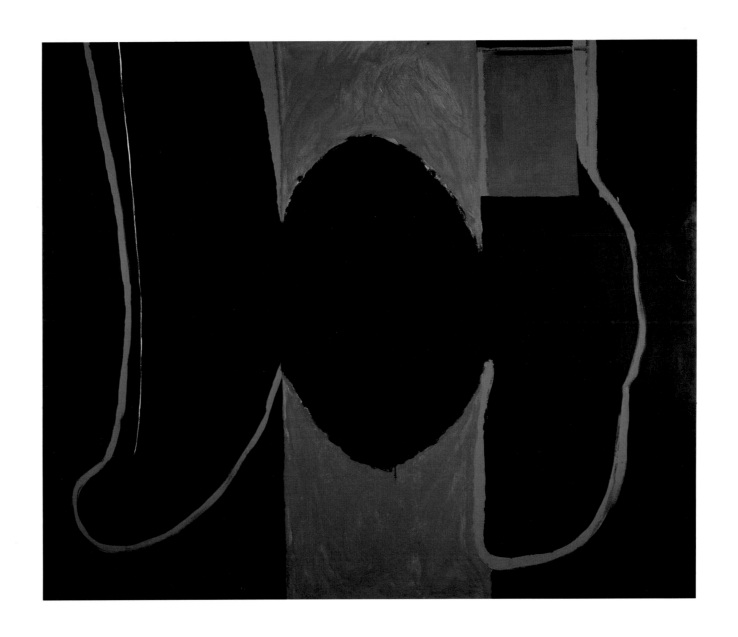

Irish Elegy, 1965
acrylic on sized canvas, 69 3/8 x 83 3/4"

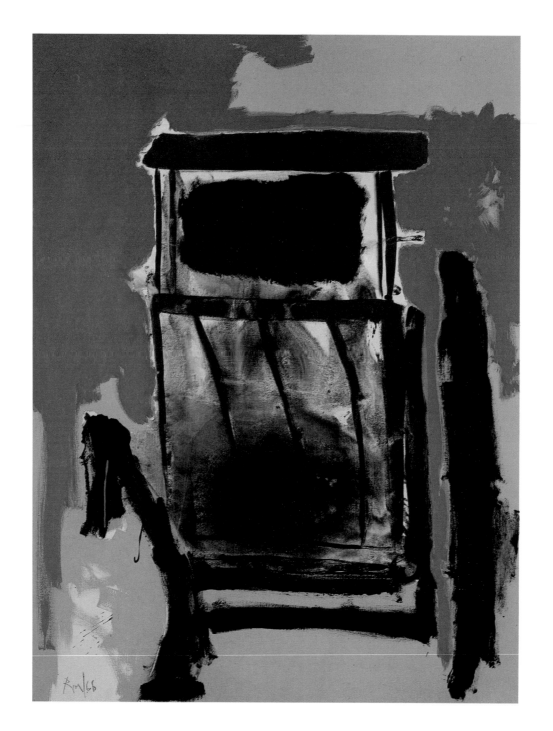

Guillotine, 1966
oil on canvas, 66 x 50″

86

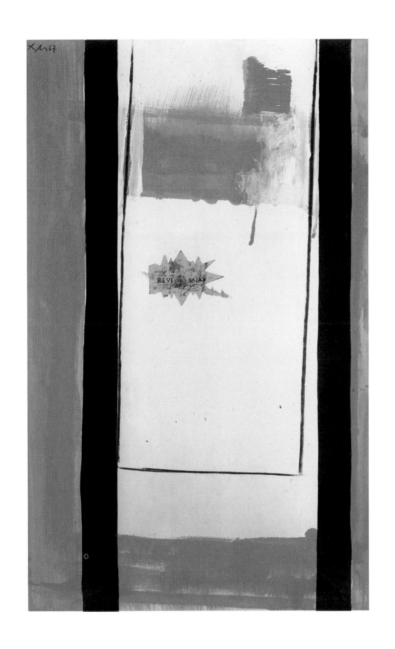

Blotting Paper Collage, 1967
collage, acrylic and charcoal on blotting paper, 37 x 23″

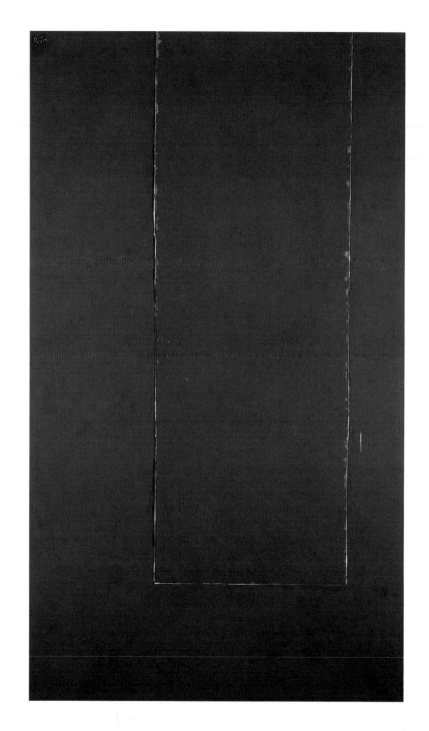

Open No. 60 (in Mottled
Brown and Green), 1968
acrylic on canvas, 118 x 69″

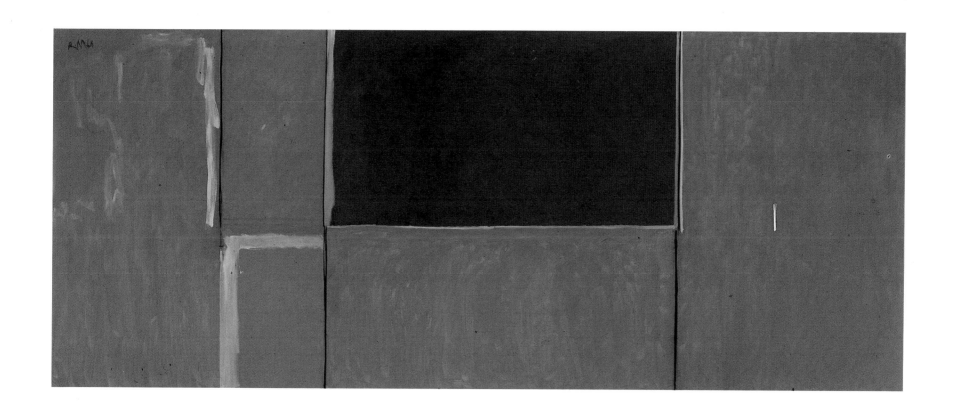

Open No. 11 (in Raw Sienna with Gray), 1968
polymer paint and charcoal on canvas, 87 × 211⅜″

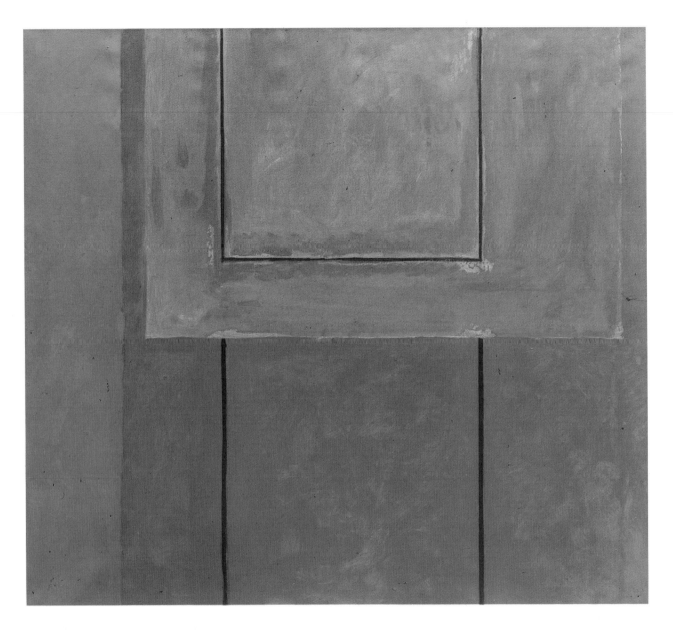

Open No. 104 (The Brown Easel), 1969
acrylic on canvas, 54 x 60"

opposite *Open No. 97 (The Spanish House)*, 1969
acrylic on sized canvas, 92½ x 114½"

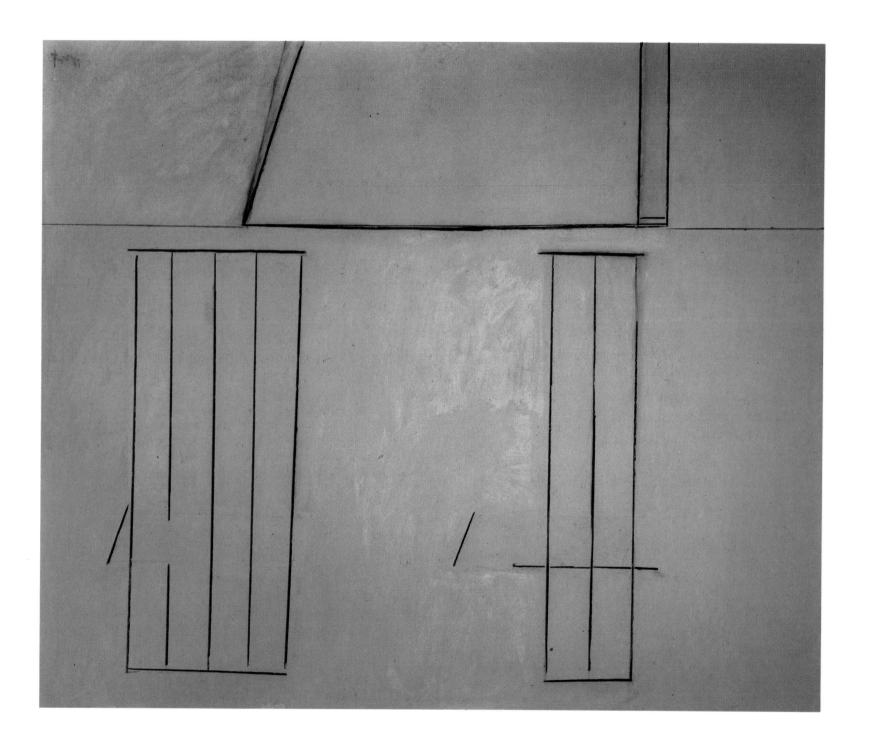

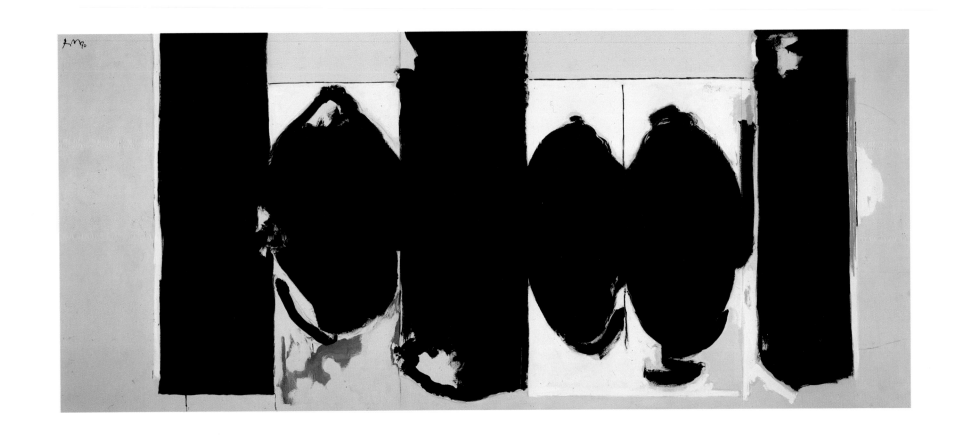

Elegy to the Spanish Republic, 1970
oil on canvas, 82½ x 188½"

92

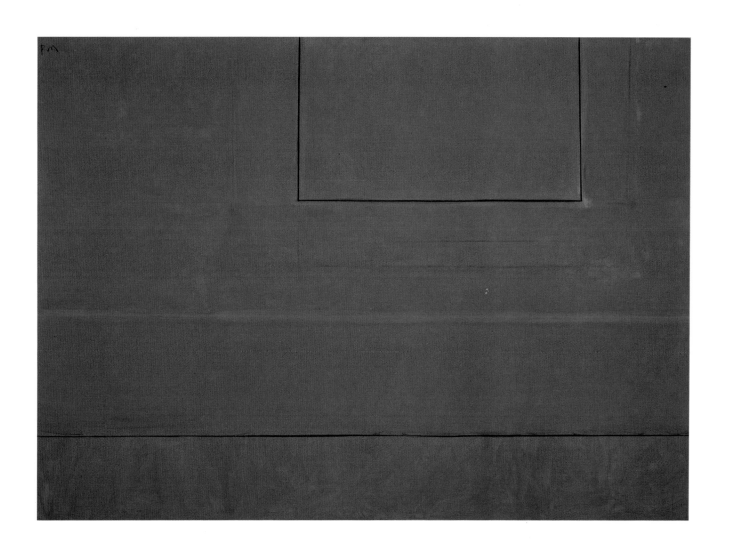

Open No. 107 (in Brown and Black Line), 1970
acrylic on canvas, 88 x 122″

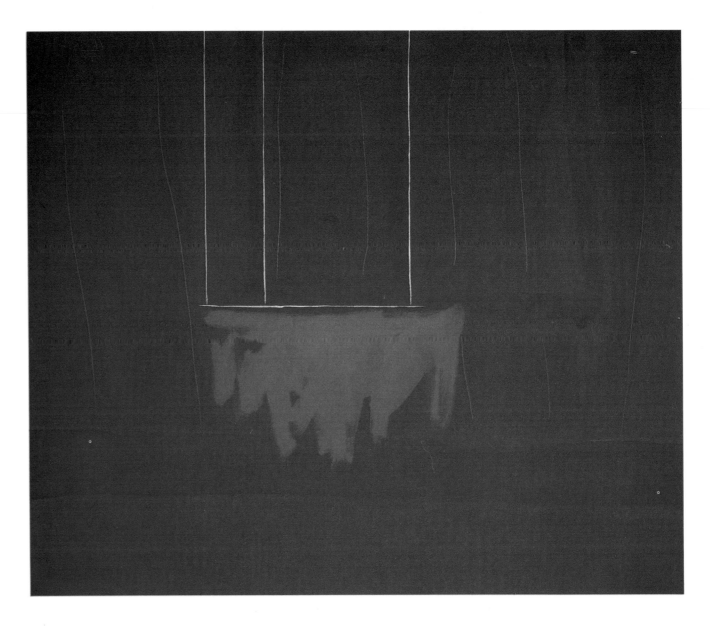

Red Open No. 1, 1970
acrylic on canvas, 59½ x 71¾"

opposite *A la pintura No. 12,* 1971
acrylic on sized canvas, 108 x 120"

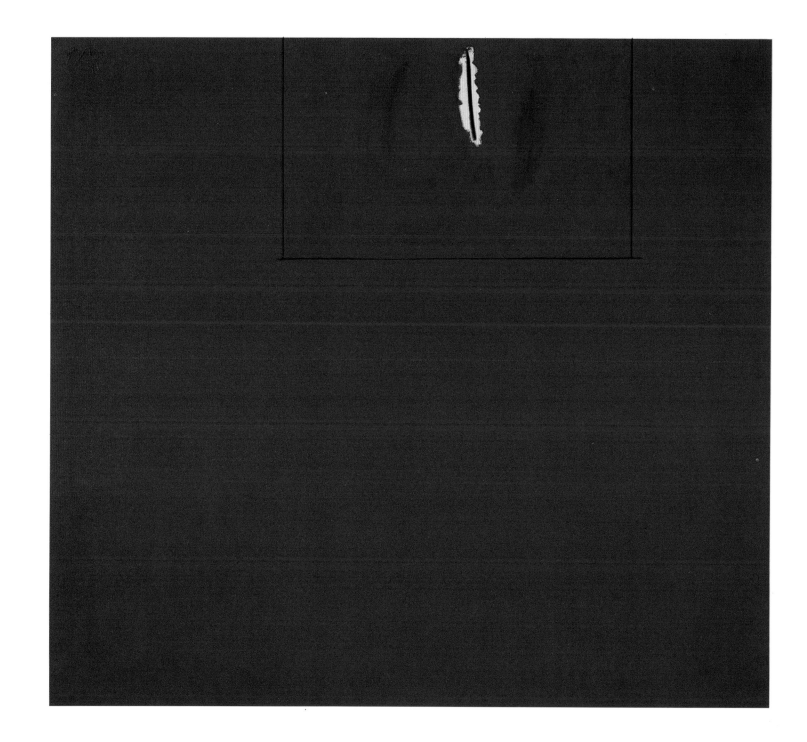

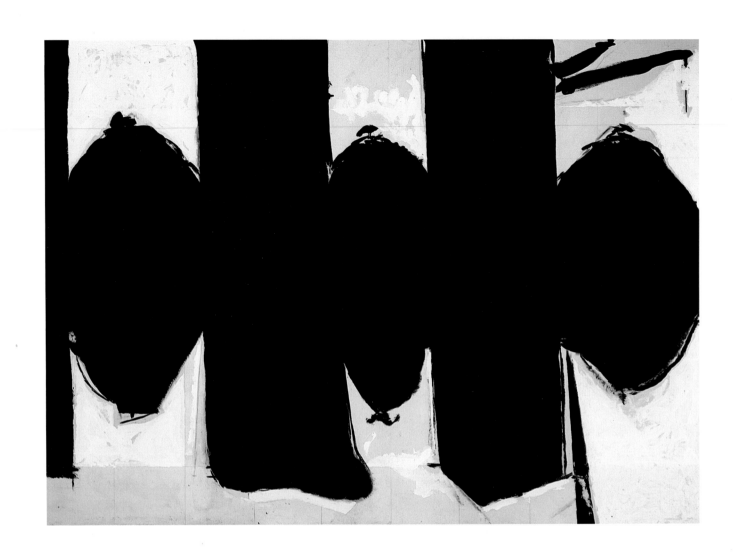

Elegy to the Spanish Republic, 1971
acrylic on canvas, 82 x 114"

96

Riverrun, 1972
acrylic on canvas, 60 x 150″

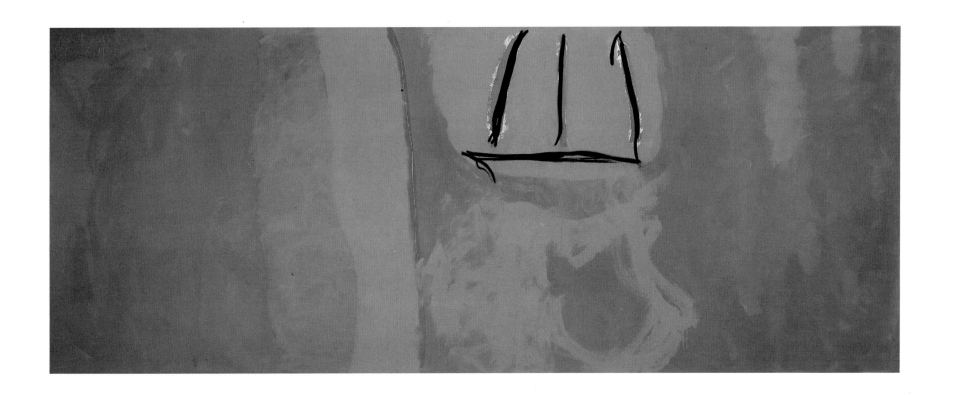

opposite
*The Blue Painting Lesson
Nos. 1–5*, 1973
acrylic on canvas

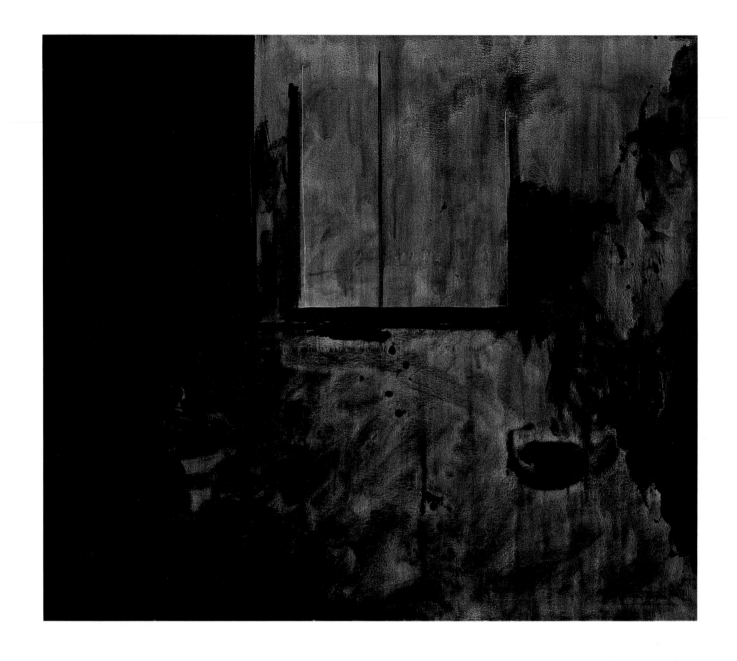

In Plato's Cave No. 4, 1973
acrylic on sized canvas, 72 x 84"

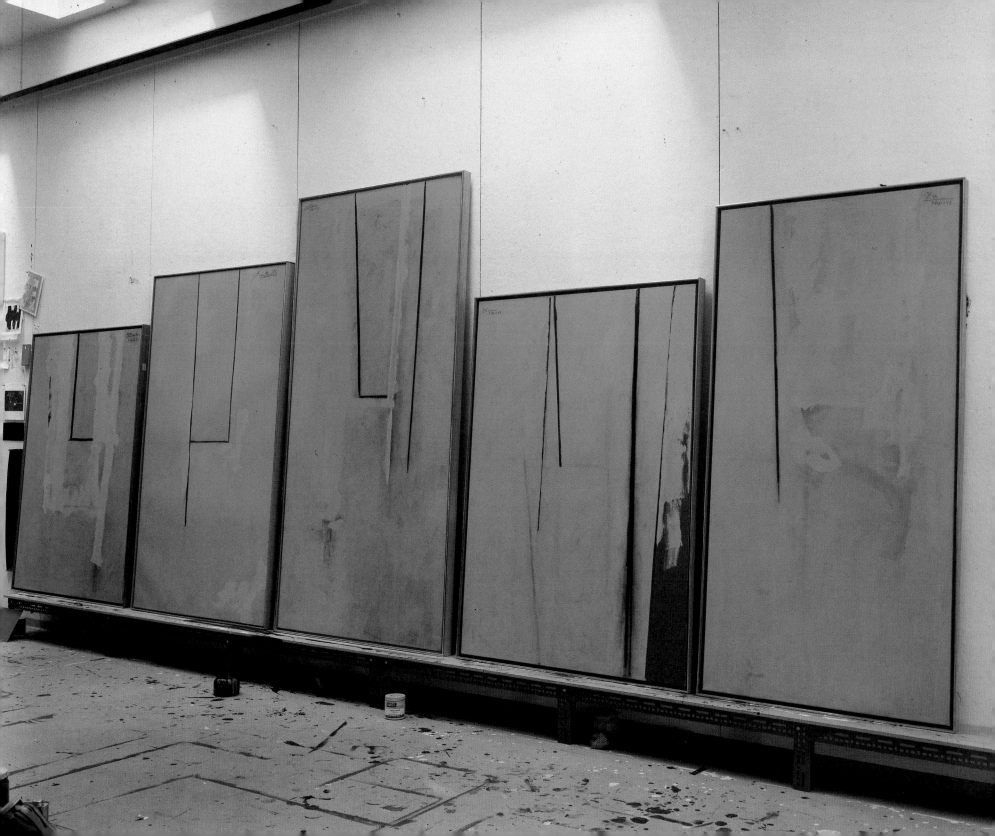

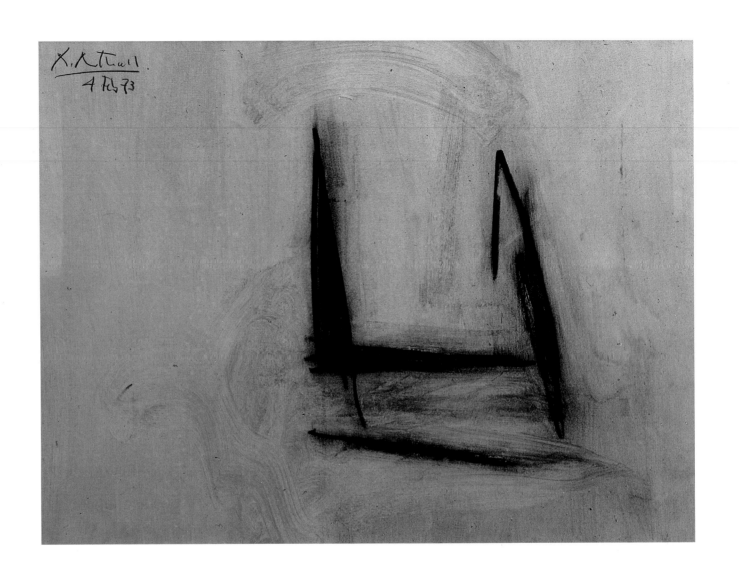

In Beige with Charcoal, 1973
acrylic and charcoal on board, 35 × 47″

opposite *A la pintura No. 7*, September 1974
acrylic on sized canvas, 80 x 85″

100

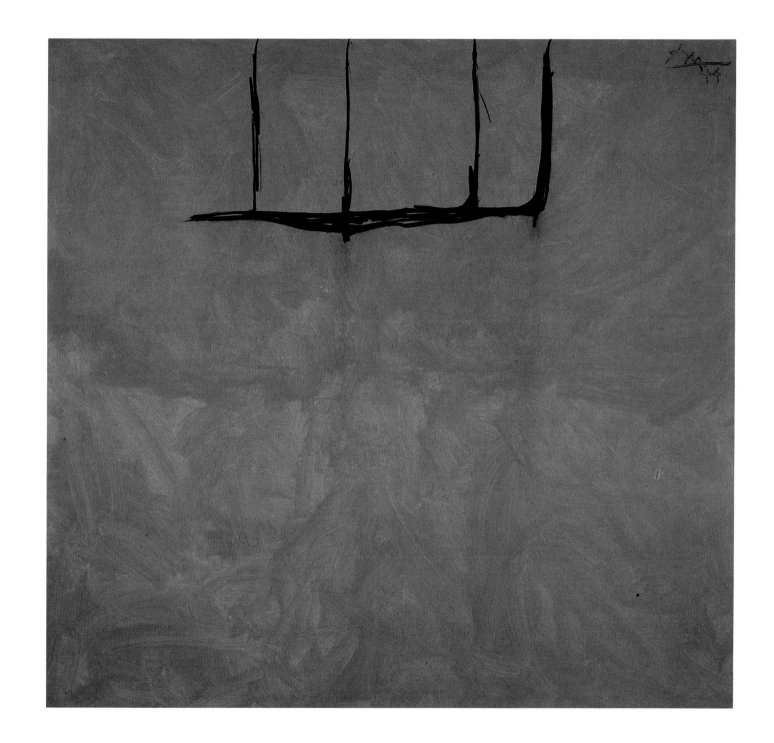

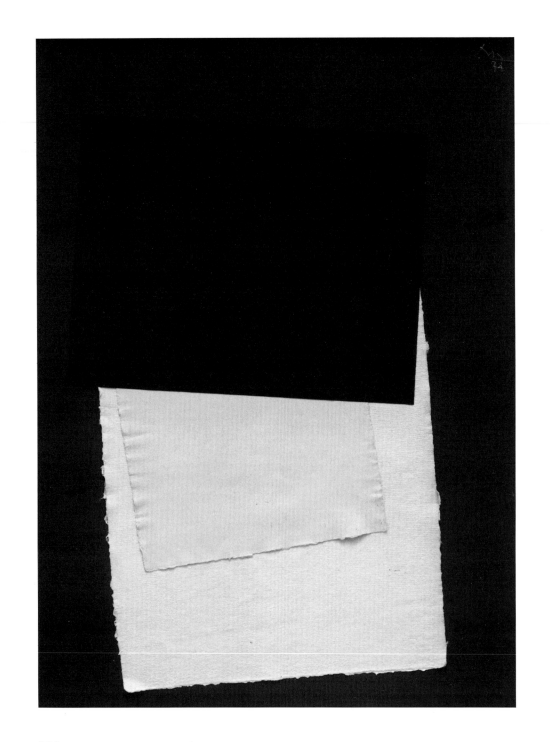

Black Refracts Heat, 1974
collage on laminated
rag paper, 48 x 36″

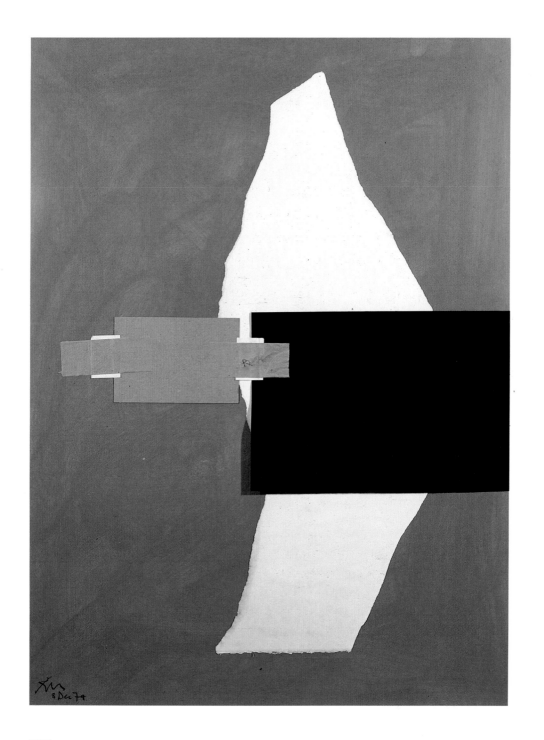

Metaphor and Movement, 1974
paper and acrylic
on Upsom board, 48 x 36″

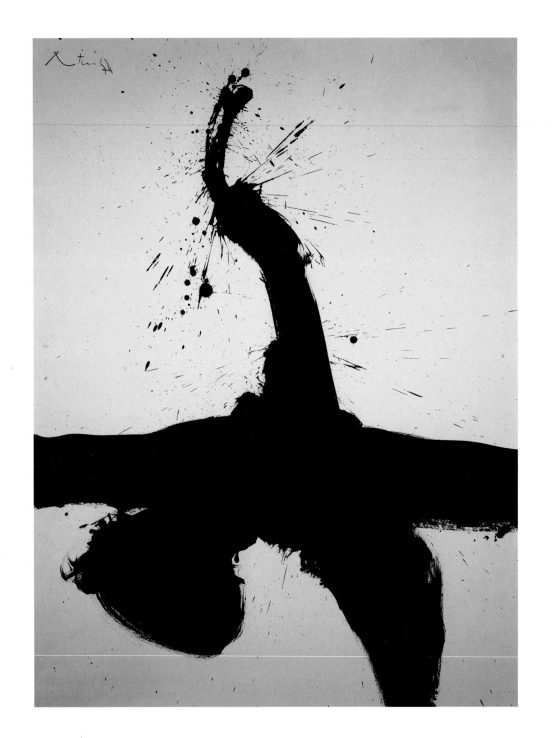

Samurai III, 1974
acrylic on rag board, 48 x 36″

104

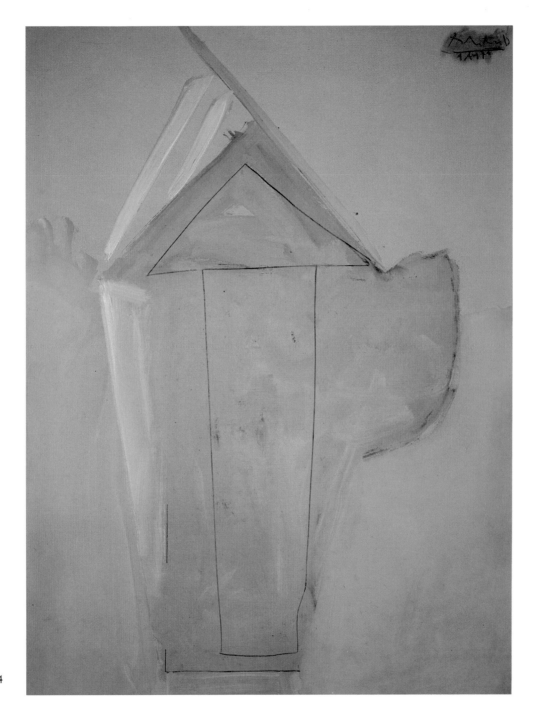

The Persian No. 1, August 4, 1974
acrylic on board, 48 x 36″

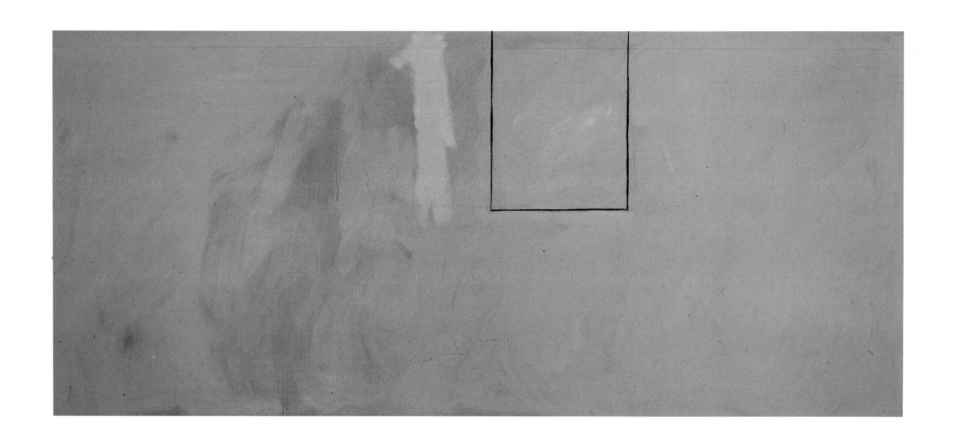

Summer Open with Mediterranean Blue, 1974
acrylic on canvas, 48 × 108″

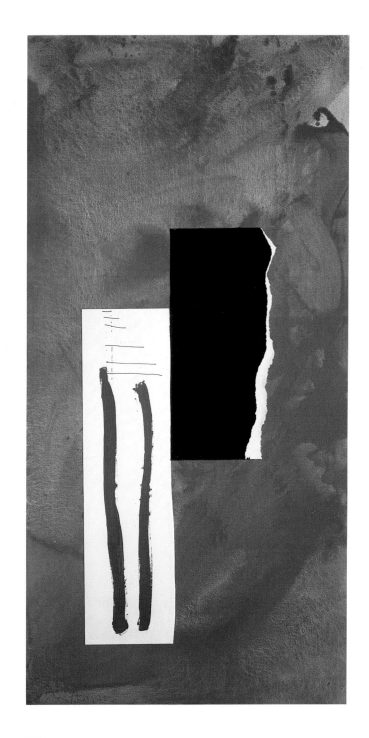

Altamira No. 1, 1975
acrylic and paper
on sized canvas, 72 x 36″

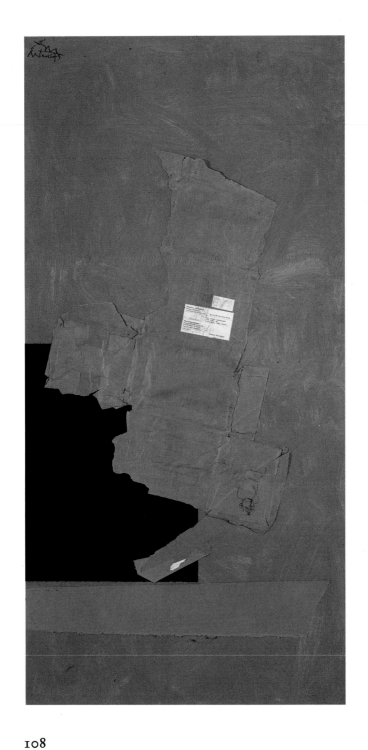

In Memoriam:
The Wittenborn Collage, 1975
paper and acrylic on
canvas board, 72 x 36″

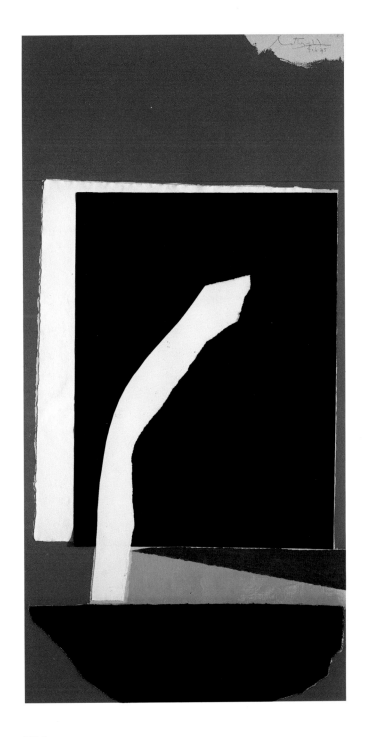

Leda, August, 1975
paper and acrylic on board,
72 x 36"

109

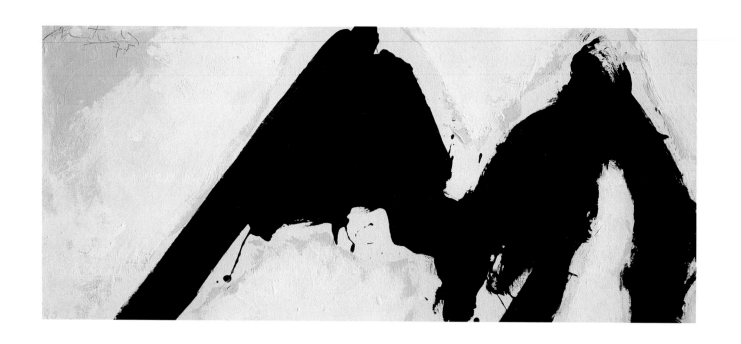

Study for In Black and White No. 2, 1975
acrylic on canvas panel, 13 ½ x 30″

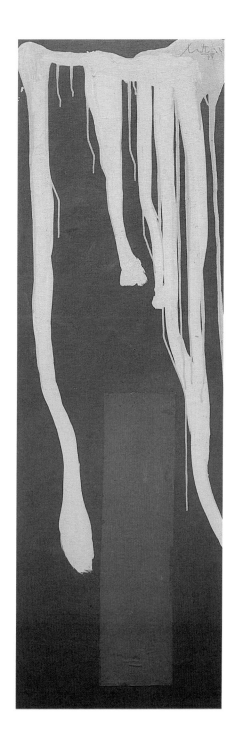

River Liffey, 1975
acrylic and paper on canvas board, 72 x 24″

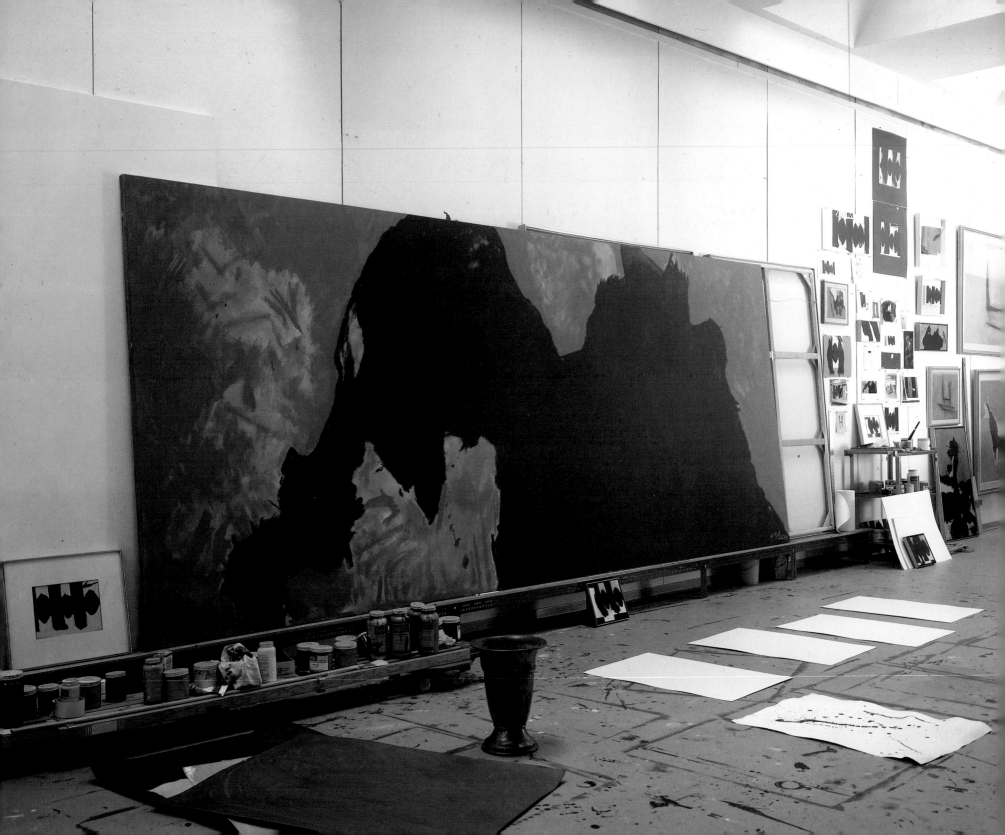

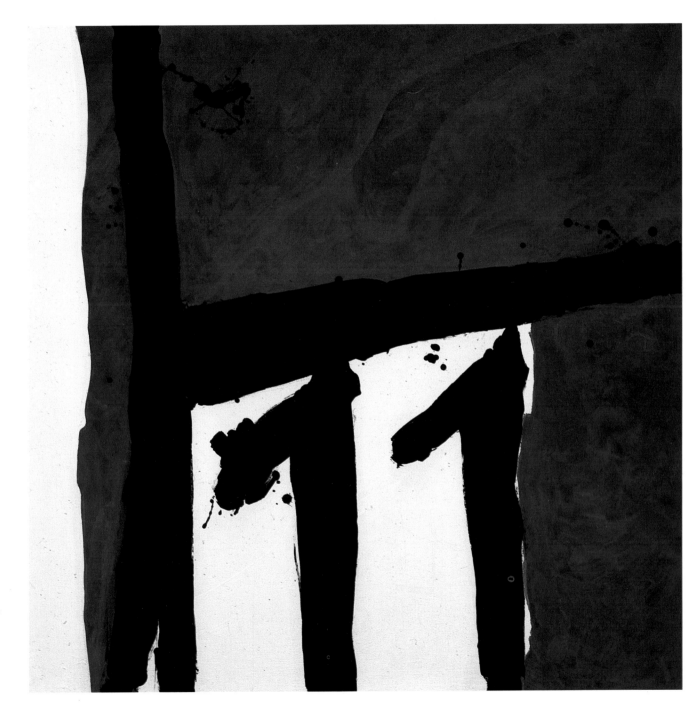

opposite
Threatening Presence, 1976
acrylic on sized canvas, 72 x 180″

Mexican Night, 1979
acrylic on canvas, 48 × 48″

113

The War Machine, 1979
oil on rag board, 30 x 40"

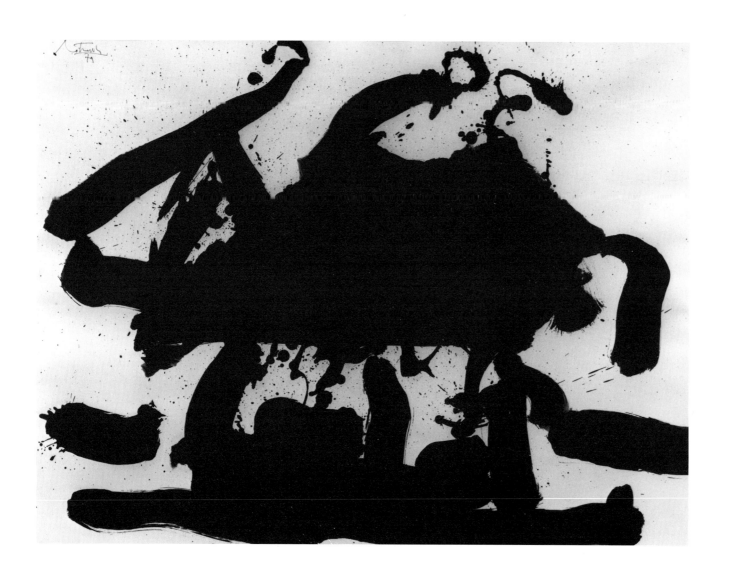

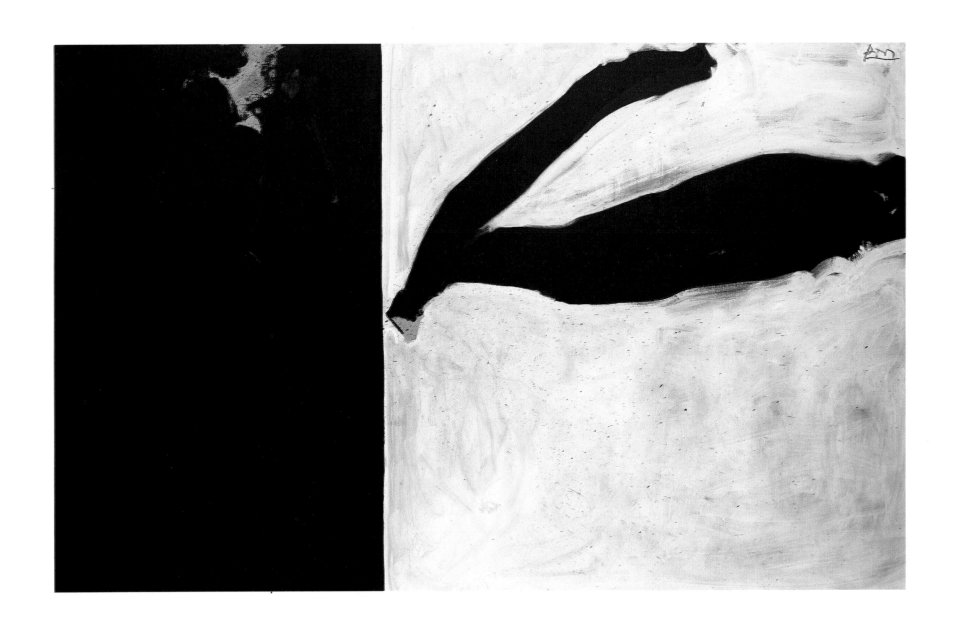

The Blank End Off, 1981
acrylic on canvas, 60 x 96″

115

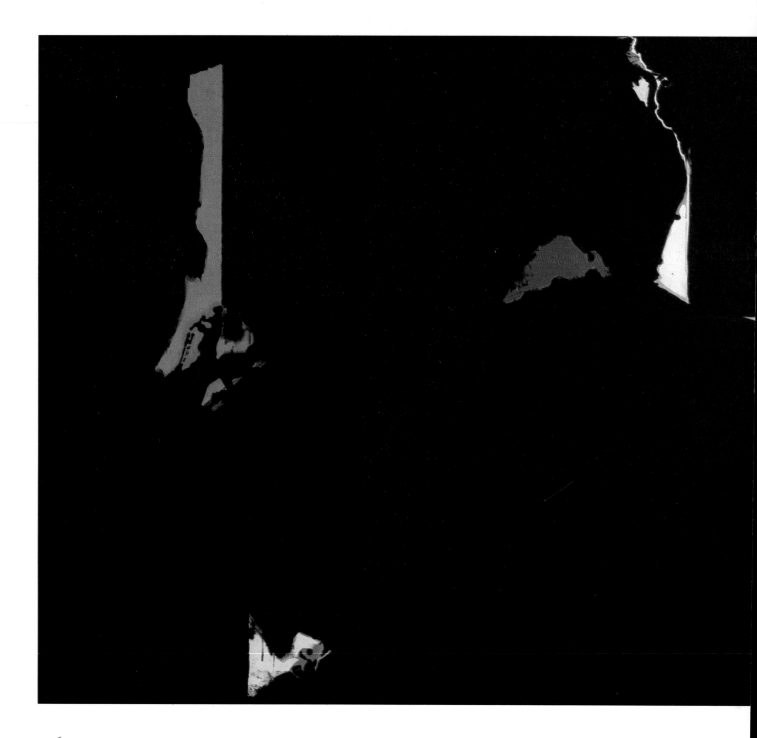

Face of the Night
(for Octavio Paz), 1981
acrylic and oil on sized canvas,
72 x 180"

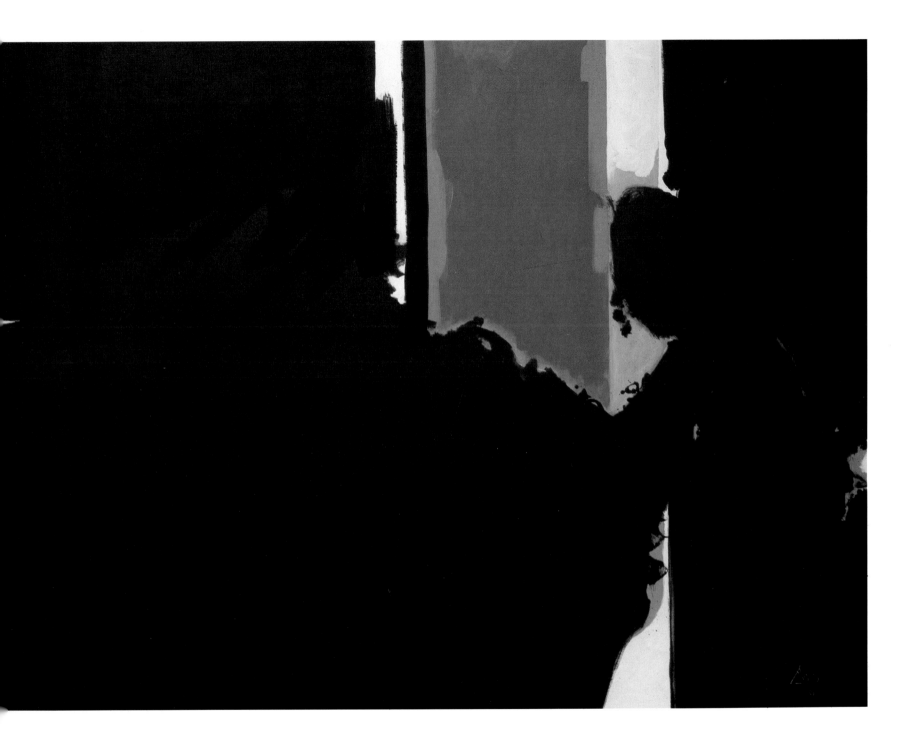

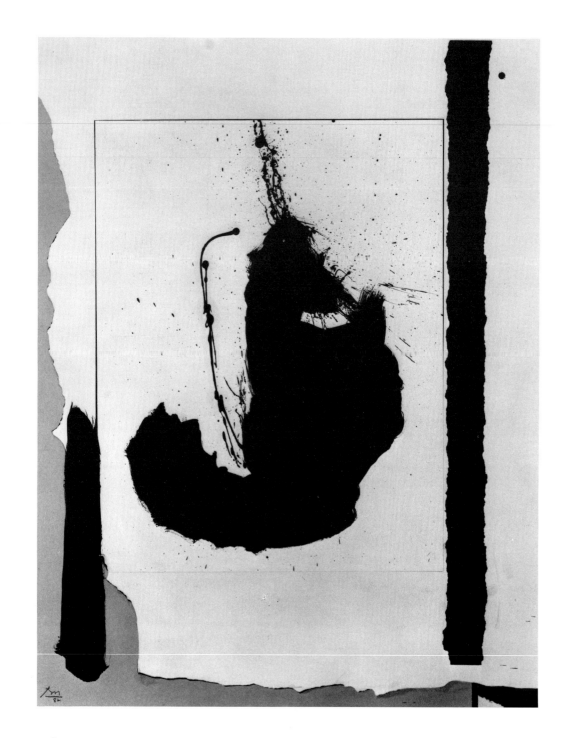

Spanish King, 1981–82
collage and acrylic
on rag board, 45 x 35″

118

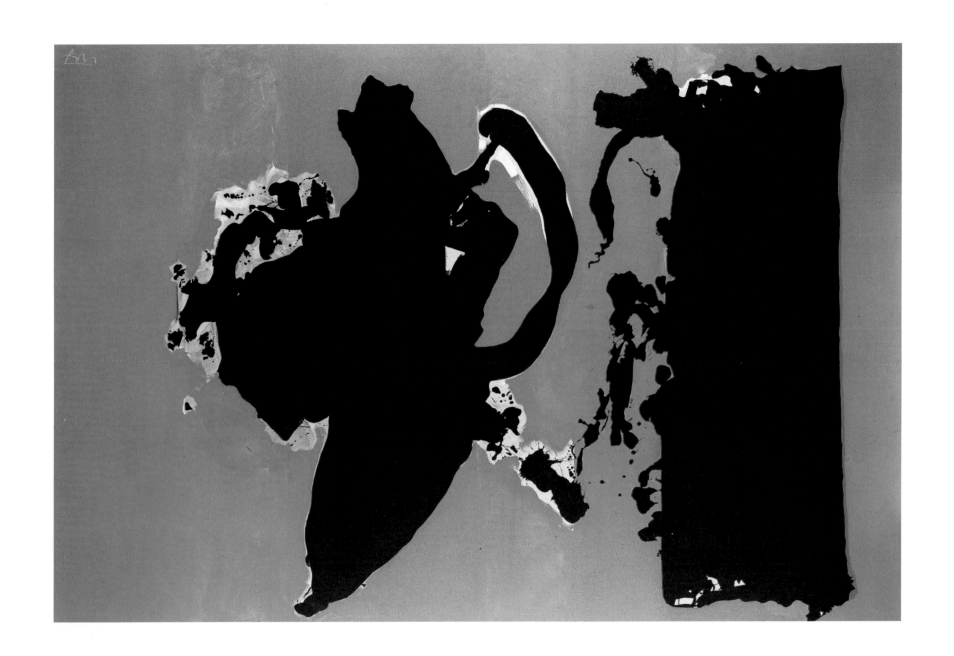

Dance, 1981
acrylic on canvas, 84 x 126″

119

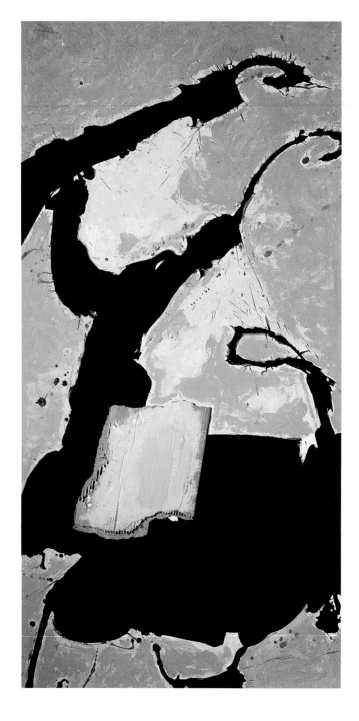

The Irish Troubles, 1981
acrylic and paper on canvas board,
72 x 36″

opposite
White Sanctuary, 1981
acrylic on canvas, 88 x 120″

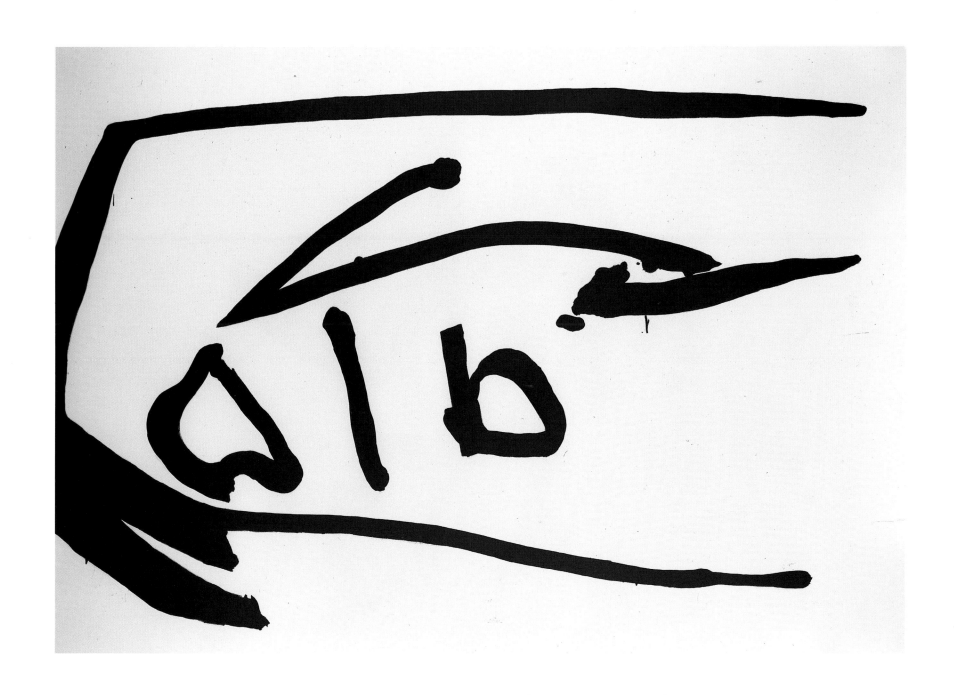

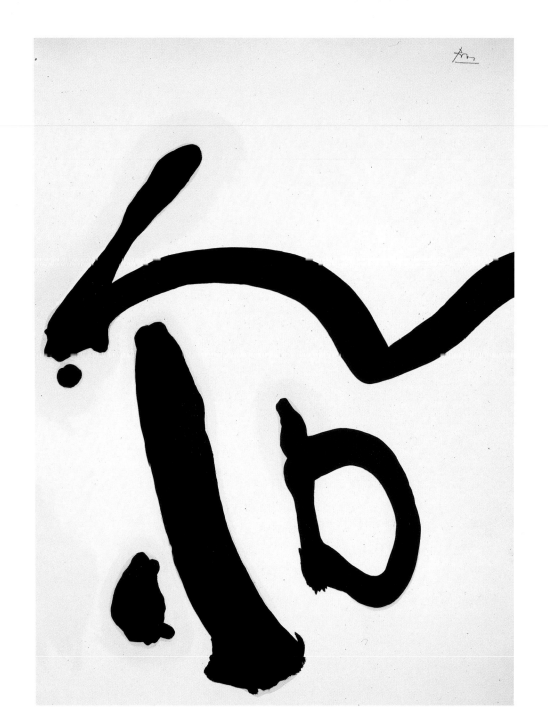

opposite
The Hollow Men, 1983
acrylic and charcoal on canvas,
88 × 176″

Wall Fragment, 1982
acrylic on canvas, 90 x 66″

122

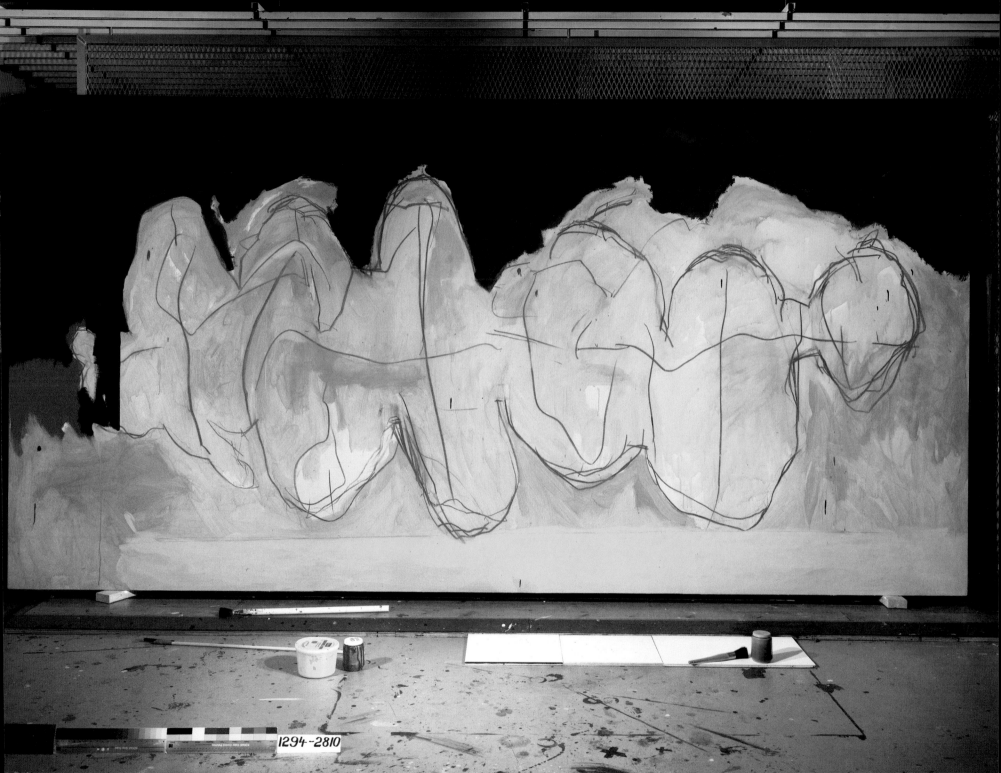

1294-2810

Robert Motherwell, 1950

Catalogue of the Exhibition

1. *The Little Spanish Prison*, 1941
 oil on canvas, 27⅛ x 17″
 Collection the artist, promised gift of the artist to
 The Museum of Modern Art, New York

2. *Spanish Picture with Window*, 1941
 oil on canvas, 42 x 34″
 Private collection, U.S.A.

3. *The Door*, 1943
 colored inks on paper, mounted on board, 13¼ x 10″
 Collection of Thos. Marc Futter

4. *Figure with Blots*, 1943
 oil and collage on paper, 45½ x 38″
 Mr. and Mrs. David Mirvish, Toronto, Canada

5. *Joy of Living*, 1943
 collage, 43½ x 33¼″
 The Baltimore Museum of Art
 Bequest of Sadie A. May (BMA 1951.344)
 (Will travel only to Buffalo.)

6. *Personage*, 1943
 oil on canvas, 48 x 38″
 Norton Gallery & School of Art,
 West Palm Beach, Florida

7. *Collage No. 2*, 1945
 oil and collage on board, 21⅞ x 14⅞″
 Collection the artist

8. *Figuration*, 1945
 oil on canvas, 18¼ x 14¼″
 Mr. and Mrs. Gifford Phillips

9. *Personage*, 1945
 gouache on paper, 20½ x 12″
 Anne Mirvish, Toronto, Canada

10. *Collage*, 1947
 oil and collage on academy board, 26¼ x 18¾″
 Smith College Museum of Art, Northampton,
 Massachusetts
 Purchased 1950

11. *Figure in Black*, 1947
 oil on canvas, 24 x 19″
 Private collection, New York

12. *In Grey with Parasol*, 1947
 oil and collage on board, 48 x 36″
 Art Gallery of Ontario, Toronto, Canada
 Gift from the Women's Committee Fund, 1962

13. *Mallarmé's Swan*, 1944–47
 collage, 43½ x 35½″
 Contemporary Collection of The
 Cleveland Museum of Art

14. *Western Air*, 1946–47
 oil on canvas, 72 x 54″
 The Museum of Modern Art, New York
 Purchase (by exchange), 1950
 (Will travel only to Buffalo and New York.)

15. *The Homely Protestant (Bust)*, c. 1947–48
 oil on canvas, 30 x 24″
 Collection the artist

16. *The Homely Protestant*, 1948
 oil on composition board, 96 x 48″
 Collection the artist, on loan to The
 Cleveland Museum of Art

17. *At Five in the Afternoon*, 1949
 casein on composition board, 15 x 20″
 Private collection
 (Will travel only to Buffalo.)

18. *Doorway with Figure*, c. 1951
 oil on paper, 48 x 39¾″
 Private collection, U.S.A.

19. *Interior with Pink Nude*, 1951
 oil on masonite, 44 x 55″
 Collection the artist

20. *Wall Painting No. 3*, 1952
oil on masonite, 47½ x 71½"
Private collection, New York

21. *Abstract Head*, 1953
oil on canvas, 24 x 20"
Private collection, New York

22. *Orange Figure with Interior*, 1953
oil on canvas, 20 x 24"
Collection the artist

23. *Elegy to the Spanish Republic No. 34*, 1953–54
oil on canvas, 80 x 100"
Collection Albright-Knox Art Gallery, Buffalo, New York
Gift of Seymour H. Knox, 1957

24. *Fishes with Red Stripes*, 1954
oil on paper, 42½ x 41⅛"
Private collection;
courtesy Salander-O'Reilly Galleries, New York

25. *Je t'aime No. VII*, 1956
oil on canvas, 36 x 48"
Collection the artist

26. *Je t'aime No. VIII*, 1957
oil on canvas, 40 x 42"
Collection the artist

27. *Jour la maison, nuit la rue*, 1957
oil on canvas, 69¾ x 89⅝"
William C. Janss

28. *Spanish Painting with the Face of a Dog*, 1958
oil on primed bed linen, 37⅛ x 75¼"
Mr. and Mrs. Gifford Phillips

29. *Two Figures No. 11*, 1958
oil on panel, 8½ x 10½"
Private collection, New York

30. *A View No. 1*, 1958
oil on canvas, 81⅛ x 104"
The IBM Corporation

31. *A View No. 10*, 1958
oil on canvas, 69 x 85"
Collection Norman and Frances Lear

32. *The Black Sun*, 1959
oil on laminated paper, 28⅞ x 22⅞"
Private collection, U.S.A.

33. *Monster (for Charles Ives)*, 1959
oil on canvas, 78 x 118"
National Museum of American Art,
Smithsonian Institution
Gift of S. C. Johnson & Son, Inc.

34. *N.R.F. Collage No. 1*, 1959
collage of oil and paper, 28⅜ x 22⅜"
Lent by the Whitney Museum of American Art,
New York
Gift of the Friends of the Whitney Museum
of American Art, 1961 61.24

35. *Elegy to the Spanish Republic No. LV*, 1955 60
oil on canvas, 70 x 76"
Contemporary Collection of The Cleveland Museum of Art

36. *The Figure 4 on an Elegy*, 1960
oil on paper, 22⅞ x 28¾"
Collection H. H. Arnason, New York
(Will travel only to Buffalo and New York.)

37. *The French Line*, 1960
oil and collage on laminated rag paper, 30 x 23"
Mr. and Mrs. Bagley Wright

38. *N.R.F. Collage No. 2*, 1960
collage of oil and paper, 28⅛ x 21½"
Lent by the Whitney Museum of American Art,
New York
Gift of the Friends of the Whitney Museum
of American Art, 1961 61.34

39. *Black on White*, 1961
oil on canvas, 78¾ x 163¼"
Collection The Museum of Fine Arts, Houston
Museum Purchase

40. *The Golden Fleece*, 1961
oil on canvas, 69 x 204"
The Chrysler Museum, Norfolk, Virginia
On loan from the collection of Walter P. Chrysler, Jr.

41. *In White and Yellow Ochre*, 1961
collage and oil on paper, 41 x 27"
The Phillips Collection, Washington, D.C.

42. *Chi Ama, Crede*, 1962
oil on canvas, 82 x 141"
Collection the artist

43. *Summertime in Italy, No. 28*, 1962
oil on canvas, 96½ x 72½"
Collection the artist

44. *Irish Elegy*, 1965
acrylic on sized canvas, 69⅜ x 83¾"
Collection Richard E. and Jane M. Lang,
Medina, Washington

45. *Guillotine*, 1966
oil on canvas, 66 x 50"
Courtesy M. Knoedler & Co., New York

46. *Blotting Paper Collage*, 1967
collage, acrylic and charcoal on blotting paper, 37 x 23"
Courtesy M. Knoedler & Co., New York

47. *Summertime in Italy*, 1967
acrylic on canvas, 82 x 48"
Courtesy M. Knoedler & Co., New York

48. *Open No. 11 (in Raw Sienna with Gray)*, 1968
polymer paint and charcoal on canvas, 87 x 211⅜"
Collection of the San Francisco Museum of Modern Art
Anonymous gift in honor of Margaret H. Rosener

49. *Open No. 60 (in Mottled Brown and Green)*, 1968
acrylic on canvas, 118 x 69"
Mr. and Mrs. David Mirvish, Toronto, Canada

50. *The Garden Window* (formerly *Open No. 110*), 1969
acrylic on sized canvas, 61 x 41"
Private collection, Connecticut

51. *Open No. 97 (The Spanish House)*, 1969
acrylic on sized canvas, 92½ x 114½"
Collection the artist

52. *Open No. 104 (The Brown Easel)*, 1969
acrylic on canvas, 54 x 60"
Private collection, U.S.A.

53. *Elegy to the Spanish Republic*, 1970
oil on canvas, 82½ x 188½"
Mr. and Mrs. David Mirvish, Toronto, Canada
(Will not travel to Washington, D.C. or New York.)

54. *Open No. 107 (in Brown and Black Line)*, 1970
acrylic on canvas, 88 x 122"
Mr. and Mrs. David Mirvish, Toronto, Canada

55. *Red Open No. 1*, 1970
acrylic on canvas, 59½ x 71¾"
Private collection, Boston

56. *A la pintura No. 12*, 1971
acrylic on sized canvas, 108 x 120"
Collection the artist

57. *Elegy to the Spanish Republic*, 1971
acrylic on canvas, 82 x 114"
Private collection
(Will travel only to Washington, D.C. and New York.)

58. *In Plato's Cave No. 1*, 1972
polymer paint on oil-sized canvas, 72 x 96"
Collection the artist

59. *Riverrun*, 1972
acrylic on canvas, 60 x 150"
Courtesy M. Knoedler & Co., New York

60. *The Blue Painting Lesson No. 1*, 1973
acrylic on canvas, 61 x 44"
Courtesy M. Knoedler & Co., New York

61. *The Blue Painting Lesson No. 2*, 1973
acrylic on canvas, 72 x 42"
Courtesy M. Knoedler & Co., New York

Robert Motherwell
in Greenwich studio, 1983

62. *The Blue Painting Lesson No. 3*, 1973
acrylic on canvas, 84 x 42"
Courtesy M. Knoedler & Co., New York

63. *The Blue Painting Lesson No. 4*, 1973
acrylic on canvas, 61 x 52"
Courtesy M. Knoedler & Co., New York

64. *The Blue Painting Lesson No. 5*, 1973
acrylic on canvas, 72 x 36"
Courtesy M. Knoedler & Co., New York

65. *In Beige with Charcoal*, 1973
acrylic and charcoal on board, 35 x 47"
Collection the artist

66. *In Plato's Cave No. 4*, 1973
acrylic on sized canvas, 72 x 84"
Mr. and Mrs. Bagley Wright

67. *A la pintura No. 7*, September 1974
acrylic on sized canvas, 80 x 85"
Janie C. Lee Gallery

68. *Black Refracts Heat*, 1974
collage on laminated rag paper, 48 x 36"
Collection the artist

69. *Metaphor and Movement*, 1974
paper and acrylic on Upsom board, 48 x 36"
Collection Albright-Knox Art Gallery, Buffalo, New York
George B. and Jenny R. Mathews Fund, 1977

70. *The Persian No. 1*, August 4, 1974
acrylic on board, 48 x 36"
Collection the artist

71. *Samurai III*, 1974
acrylic on rag board, 48 x 36"
Courtesy M. Knoedler & Co., New York

72. *Summer Open with Mediterranean Blue*, 1974
acrylic on canvas, 48 x 108"
Collection the artist

73. *Ungluckliche Liebe*, 1974
acrylic and paper on board, 48 x 36″
Private collection, New York

74. *Altamira No. 1*, 1975
acrylic and paper on sized canvas, 72 x 36″
Donn Golden

75. *In Black and White No. 2*, 1975
acrylic on canvas, 72 x 160″
Collection the artist

76. *In Memoriam: The Wittenborn Collage*, 1975
paper and acrylic on canvas board, 72 x 36″
Collection the artist

77. *Leda*, August, 1975
paper and acrylic on board, 72 x 36″
Courtesy M. Knoedler & Co., New York
(withdrawn)

78. *Primordial Sketch No. 9*, 1975
acrylic on canvas board, 12 x 24″
Collection the artist

79. *Primordial Study*, 1975
acrylic on canvas board, 12 x 24″
Collection the artist

80. *River Liffey*, 1975
acrylic and paper on canvas board, 72 x 24″
Collection the artist

81. *Study for In Black and White No. 2*, 1975
acrylic on canvas panel, 13½ x 30″
Private collection, New York

82. *Threatening Presence*, 1976
acrylic on sized canvas, 72 x 180″
Courtesy M. Knoedler & Co., New York

83. *Mexican Night*, 1979
acrylic on canvas, 48 x 48″
From the collection of Douglas S. Cramer,
Los Angeles, California

84. *The War Machine*, 1979
oil on rag board, 30 x 40″
Courtesy M. Knoedler & Co., New York

85. *The Blank End Off*, 1981
acrylic on canvas, 60 x 96″
From the collection of Martin Z. Margulies,
Coconut Grove, Florida

86. *Dance*, 1981
acrylic on canvas, 84 x 126″
Private collection, New York

87. *Face of the Night (for Octavio Paz)*, 1981
acrylic and oil on sized canvas, 72 x 180″
Collection the artist

88. *The Irish Troubles*, 1981
acrylic and paper on canvas board, 72 x 36″
Collection the artist

89. *White Sanctuary*, 1981
acrylic on canvas, 88 x 120″
Courtesy M. Knoedler & Co., New York

90. *Spanish King*, 1981–82
collage and acrylic on rag board, 45 x 35″
Collection the artist

91. *Wall Fragment*, 1982
acrylic on canvas, 90 x 66″
Private collection, New York

92. *Elegy to the Spanish Republic No. 132*, 1975–82
acrylic on canvas, 96 x 120″
Private collection, U.S.A.

93. *The Hollow Men*, February–April 1983
acrylic and charcoal on canvas, 88 x 176″
Collection the artist

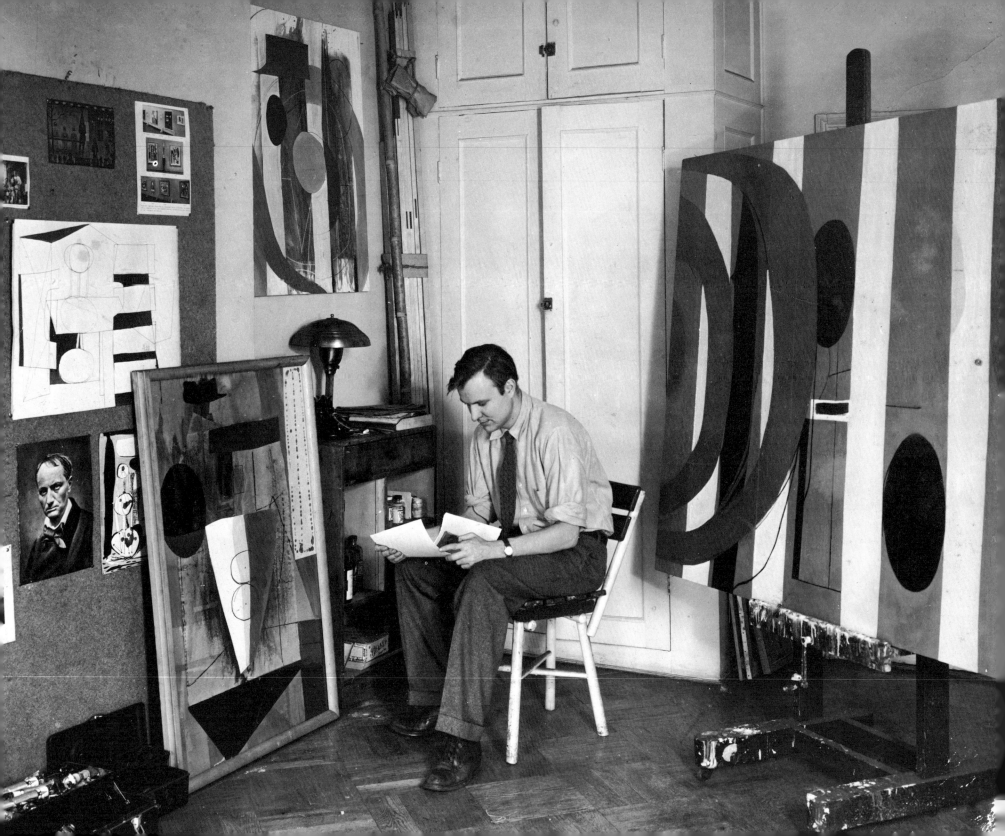

Chronology

This chronology is an updated version of the abbreviated "Brief Chronology" in H. Harvard Arnason, *Robert Motherwell*. New York: Harry N. Abrams, Revised Edition, 1982, p. 233.

For the most detailed chronology on the artist, see "Biographical Outline and Major Exhibitions" by Heidi Colsman-Fryberger in H. Harvard Arnason, *Robert Motherwell*. New York: Harry N. Abrams, 1977, pp. 229–240.

1915	Born January 24 in Aberdeen, Washington.
1918	Family moves to California.
1919–26	Family lives in Salt Lake City, Utah.
1926	Family moves permanently to California.
1929–32	Attends Moran Preparatory School, Atascadero, California.
1932	Studies painting briefly at the California School of Fine Arts, San Francisco.
1932–37	Attends Stanford University, Palo Alto, California. Receives A.B. degree in philosophy, 1937.
1935	Summer. Visits Europe for the first time. Travels to France, Italy, Switzerland, Germany, Holland, Belgium, England and Scotland, including the town of Motherwell, near Glasgow.
1937–38	Studies philosophy at the Graduate School of Arts and Sciences, Harvard University, Cambridge, Massachusetts.
1938–39	Works in France, primarily in Paris.
1939	Returns to the United States to teach art at the University of Oregon, Eugene.
	Moves to New York City where he studies at Columbia University with Professor Meyer Shapiro, who introduces him to European artists in exile.
1941	Goes to Mexico with Matta. Does "automatic" drawings and paints first major pictures including *The Little Spanish Prison*.
	Returns to New York in December.
1942	Permanently abandons university studies in favor of painting. Resides primarily in New York for the next twenty-eight years.
	Spends first summer in Provincetown, Cape Cod, Massachusetts.
1943	Makes first collages.
	Spends second summer in Provincetown.
	Visits Mexico.
1944	First mature one-artist exhibition at Peggy Guggenheim's Art of This Century Gallery, New York.
	Spends summer in East Hampton, Long Island, New York.
1945	Signs five-year exclusive contract with Samuel Kootz Gallery, New York.
	Teaches during the summer at Black Mountain College, North Carolina.
	Moves to East Hampton, Long Island, New York.
1946	Meets Mark Rothko in East Hampton.

Robert Motherwell in Greenwich Village, New York City, 1945

1948	Uses for the first time the image that comes to be known as the *Elegy to the Spanish Republic* motif.
	Together with Rothko, William Baziotes and David Hare, founds an informal loft school called "The Subject of Artists." Barnett Newman joins them early in 1949. The school closes in May 1949.
1949	Paints *Granada*, first large painting in the *Elegy to the Spanish Republic* series.
	Divorced from Maria Emilia Ferreira y Moyers.
1950	Marries Betty Little.
	Meets David Smith.
	Appointed to graduate faculty at Hunter College, New York, where he teaches until 1958.
1951	During the summer, teaches again at Black Mountain College.
1953	Daughter Jeannie born.
	Begins to spend summers regularly in Provincetown, which he continues to do until the present.
1955	Daughter Lise is born.
1957	Sidney Janis Gallery, New York, becomes his exclusive dealer.
1958	Marries Helen Frankenthaler. The two spend the summer in Spain and France, mainly in Saint-Jean-de-Luz, where he begins the *Iberia* series of black paintings.
1960	Spends the summer in Alassio, Italy. *Summertime in Italy* series begun on the Italian Riviera.
1961	Begins to make prints at Tatyana Grosman's Universal Limited Art Editions Studio, West Islip, Long Island, New York.

	Retrospective exhibition included in VI Bienal de Arte, São Paulo, Brazil.
1963	Marlborough-Gerson Gallery, New York, becomes his exclusive dealer.
1965	During six weeks in April and May creates the *Lyric Suite*, 565 "automatic" paintings in ink on Japanese rice paper.
	David Smith, the artist's closest friend, dies.
	Visits Paris, Venice, Dubrovnik, Athens, the Greek Islands, and London with his family during the summer.
	Given a retrospective exhibition at The Museum of Modern Art, New York. Exhibition travels to museums in Amsterdam, London, Brussels, Essen and Turin, during 1965–66.
1966	Executes the mural *New England Elegy* for the John F. Kennedy Federal Office Building, Boston.
1967	Begins *Open* series.
1968	Usual summer in Provincetown. Mark Rothko rents a summer place nearby.
1969	Elected member of the National Institute of Arts and Letters.
	Separates from Helen Frankenthaler.
	Moves to Greenwich, Connecticut, where he now lives, thirty miles from New York City.
1970	Mark Rothko commits suicide.
1972	Marries photographer Renate Ponsold.
	Given a collage retrospective at The Museum of Fine Arts, Houston.

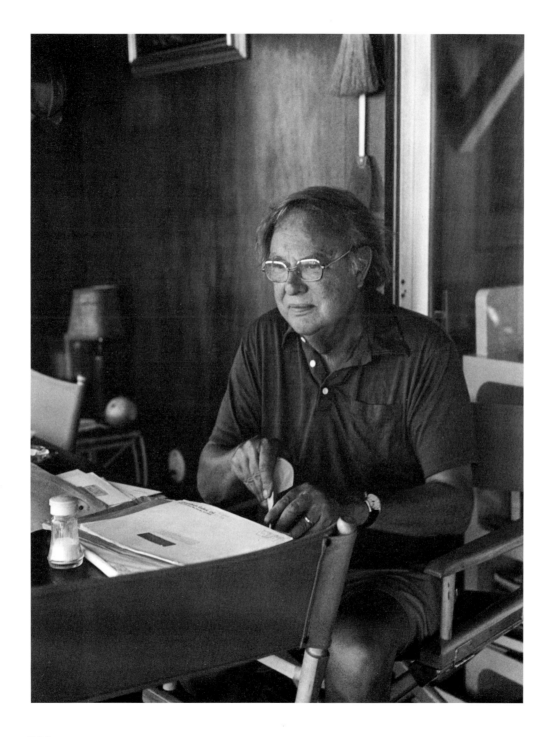

Completes etchings for Rafael Alberti's *A la pintura*, published by Universal Limited Art Editions.

Lawrence Rubin becomes his main dealer (and subsequently heads M. Knoedler & Co., New York).

Kenneth Tyler becomes his major collaborator in lithography.

Paints the first canvas of the series *In Plato's Cave*.

1973 Begins making prints on his own etching press, in Greenwich, with Catherine Mousley, as he still does.

Begins series of 6-foot-high collages.

1974 Severe illness and radical surgery.

1975 Retrospective exhibition in Mexico City.

1976 Retrospective exhibitions in Dusseldorf and Stockholm.

1977 Retrospective exhibitions in Vienna, Paris, and Edinburgh.

Begins mural commissioned by the National Gallery of Art, Washington, D.C.

1978 Retrospective exhibition in London.

Receives Grande Médaille de Vermeil de la Ville de Paris.

1979 Major exhibition on the subject of the artist and black at the William Benton Museum of Art, University of Connecticut, Storrs.

1980 Retrospective exhibitions in Barcelona and Madrid.

Receives Medal of Merit from the University of Salamanca, Spain.

Graphics retrospective organized under the auspices of American Federation of Arts, held at The Museum of Modern Art. *The Painter and the Printer: Robert Motherwell's Graphics 1943–1980* published on the occasion of this traveling exhibition.

1981 Receives the Gold Medal from the Pennsylvania Academy of Fine Arts.

Receives the Skowhegan Award for Printmaking 1981 at the Plaza Hotel, New York.

1981–82 Visiting Professor of Art, Brown University, Providence, Rhode Island.

1982 Summer. Begins printmaking in newly constructed print workshop in Provincetown with Catherine Mousley.

October 30. Keynote speaker at celebration of the 150th Anniversary of the Yale University Art Gallery, New Haven, Connecticut.

November. Dedication of the Motherwell Gallery (in perpetuity) at the Bavarian State Museum of Modern Art, Haus der Kunst, Munich, W. Germany.

Revised edition of *Robert Motherwell*, by H. H. Arnason, published by Harry N. Abrams, New York.

1983 Receives the Gold Medal of Honor 1983 at the National Arts Club, New York.

Completes *El Negro*, a *livre de peintre* for a poem by Rafael Alberti, after two years in collaboration with Kenneth Tyler.

Participant in "Kafka Unorthodox," 100th Anniversary Celebration at the Cooper Union, New York. March 18–19.

Selected Exhibitions

Concerning exhibitions of the artist's prints and graphics, only major showings have been included in the following pages. For a more complete listing, see Stephanie Terenzio, *The Painter and the Printer: Robert Motherwell's Graphics 1943–1980*, published by the American Federation of Arts, 1980.

One-Artist Exhibitions

1939 Raymond Duncan Gallery, Paris, France.

1944 Art of This Century, New York. October–November 11. Catalogue; preface by James Johnson Sweeney.

1946 Samuel Kootz Gallery, New York. January 2–19. Other one-artist shows at this gallery: April 28–May 17, 1947; May 10–29, 1948; October 4–22, 1949; November 14–December 4, 1954; April 1–19, 1952; April 6–25, 1953.

Fine Arts Club of Chicago, Chicago, Illinois. February 7–27. Catalogue; text by James Johnson Sweeney.

1951 Whitney Museum of American Art, New York. *Scotchlite.*

1952 Allen Memorial Art Museum, Oberlin College, Oberlin, Ohio. April 15–May 10. Catalogue in *Allen Memorial Art Museum Bulletin* (Oberlin, Ohio), vol. 9, no. 3, Spring 1952, pp. 110–112.

1957 Sidney Janis Gallery, New York. May 13–June 8. Other one-artist shows at this gallery: March 9–April 4, 1958; April 10–May 6, 1961; December 4–29, 1962.

1959 Bennington College, Bennington, Vermont. *Motherwell: First Retrospective Exhibition.* April 24–May 23. Catalogue; text by Eugene C. Goossen.

1962 Pasadena Art Museum, Pasadena, California. *Robert Motherwell: A Retrospective Exhibition.* February 18–March 11. Catalogue; texts by Thomas W. Leavitt, Frank O'Hara, Sam Hunter, Barbara Guest, Robert Motherwell.

1963 Smith College Museum of Art, Northampton, Massachusetts. January 10–28.

Hayden Gallery, Massachusetts Institute of Technology, Cambridge, Massachusetts. February 11–March 3.

1965 The Phillips Collection, Washington, D.C. *Collages by Robert Motherwell: A Loan Exhibition.* January 2–February 15. Catalogue; text by Sam Hunter.

The Museum of Modern Art, New York. October 1–November 28. Major retrospective exhibition selected by Frank O'Hara. Shown in 1966 at Stedelijk Museum, Amsterdam; Whitechapel Art Gallery, London; Palais des Beaux Arts, Brussels; Museum Folkwang, Essen; Galleria Civica d'Arte Moderna, Turin. Catalogue; texts by Frank O'Hara, Robert Motherwell, Kynaston McShine, Bernard Karpel.

Robert Motherwell: Works on Paper, organized by the Circulating Exhibitions Department of The Museum of Modern Art, New York. Shown in 18 cities throughout the United States including Baltimore, San Francisco, Houston.

1967 San Francisco Museum of Art, San Francisco, California. February 22–March 19.

1968 San Francisco Museum of Art, San Francisco, California. October 1–November 3.

Whitney Museum of American Art, New York. *Robert Motherwell: Collages.* October 8–November 17.

1969 Marlborough-Gerson Gallery, New York. *Robert Motherwell: "Open" Series 1967–1969.* May 13–June 7.

The Museum of Modern Art, New York. *Robert Motherwell: Lyric Suite.* September 8–October 13.

The Toledo Museum of Art, Toledo, Ohio. November 2–December 7.

1970 Stanford University Museum and Art Gallery, Palo Alto, California. April 10–May 3.

1970–71 David Mirvish Gallery, Toronto, Ontario, Canada. December 5, 1970–January 5, 1971. Other one-artist shows at this gallery: March 24–April 21, 1973; April 12–May 7, 1975.

1971 Galerie im Erker, St. Gallen, Switzerland. June 12–August 28. Catalogue.

1972 Walker Art Center, Minneapolis, Minnesota. June 15–August 6. Catalogue.

Lawrence Rubin Gallery, New York. October 21–November 2.

The Metropolitan Museum of Art, New York. *Robert Motherwell's "A la pintura": The Genesis of a Book.* October 24–December 3. Catalogue; texts by John McKendry, Diane Kelder, Robert Motherwell.

1972–73 The Museum of Fine Arts, Houston, Texas. *The Collages of Robert Motherwell: A Retrospective Exhibition.* November 15, 1972–January 14, 1973. Catalogue; texts by Philippe de Montebello, E. A. Carmean, Jr., Robert Motherwell. Traveled to the Cleveland Museum of Art, February 6–25, Wadsworth Atheneum, Hartford, Connecticut, March 14–April 22, Museum of Fine Arts, Boston, May 10–June 24.

1973 The Art Museum, Princeton University, Princeton, New Jersey. January 5–February 17. Catalogue.

John Berggruen Gallery, San Francisco, California. April–May 5. Other one-artist show at this gallery: May 21–June 28, 1975.

1974 Albright-Knox Art Gallery, Buffalo, New York. *Robert Motherwell: "A la pintura" and Four Related Paintings.* March 1–May 27.

Knoedler Contemporary Art, New York. April 6–25.

Galerie André Emmerich, Zurich, Switzerland. October 12–November 16. Catalogue. Other one-artist show at this gallery: April 2–May 24, 1977.

1974–75 Otis Art Institute, Los Angeles, California. *Robert Motherwell in California Collections.* November 26, 1974–January 12, 1975. Catalogue.

1975 Knoedler Contemporary Art, New York. January 4–February 1.

Museo de Arte Moderna, Mexico City, Mexico. *Robert Motherwell: Retrospectiva del gran pintor norteamericano.* April–May. Catalogue; text (in Spanish) by Dore Ashton.

ACE, Los Angeles, California. Closed August 23.

1976 Knoedler Contemporary Art, New York. *Robert Motherwell: Selected Prints 1961–1974.* January 10–February 11.

Janie C. Lee Gallery, Houston, Texas. *Robert Motherwell: A la pintura.* April 10–May 15.

Städtische Kunsthalle, Dusseldorf, W. Germany. September 3–October 10. Retrospective exhibition. Catalogue; texts by Jürgen Harten, Robert C. Hobbs, Robert Motherwell. Traveled to: Kulturhuset, Stockholm, November 12, 1976–January 9, 1977; Museum des 20. Jahrhunderts, Vienna, March 8–April 11, 1977.

1976–77 Brooke Alexander, Inc., New York. *Robert Motherwell: monotypes, 1974–1976.* December 4, 1976–January 4, 1977. Catalogue.

1977 Musée d'Art Moderne de la Ville de Paris, Paris, France. *Robert Motherwell: Choix de Peintures et de Collages 1941–1977.* June 20–September 30. Catalogue. A smaller version of this exhibition traveled to the Royal Scottish Academy, Edinburgh, October 15–November 27.

1978 Royal Academy of Arts, London, England. January 14–March 19. Retrospective exhibition. Catalogue; text by Norman Rosenthal and Terence Maloon.

Knoedler and Co., London, England. January 16–February 18.

M. Knoedler & Co., New York. April 22–May 29. Catalogue.

1979 The William Benton Museum of Art, University of Connecticut, Storrs, Connecticut. *Robert Motherwell & Black,* March 19–June 3. Catalogue; texts by Stephanie Terenzio and Robert Motherwell.

Edwin A. Ulrich Museum of Art, Wichita State University, Wichita, Kansas. October 31–November 25.

Janie C. Lee Gallery, Houston, Texas. *Robert Motherwell: Drawings; A Retrospective, 1941 to the Present.* November 1–December 31. Catalogue; text by Jack D. Flam.

Galerie Veith Turske, Cologne, W. Germany.

1980 Fundación Juan March, Madrid, Spain. April–May. Retrospective exhibition. Shown at Centre Cultural de la Caixa de Pensions, Barcelona (February–April) before traveling to Madrid. Catalogue.

The Museum of Modern Art, New York. *The Painter and the Printer: Robert Motherwell's Graphics 1943–1980.* October 30–December 16. Organized by The American Federation of Arts. Catalogue; text and interviews by Stephanie Terenzio; catalogue raisonné edited by Dorothy C. Belknap; note by Robert Motherwell. Traveled.

1981 M. Knoedler & Co., New York. *Robert Motherwell and Black,* February 13–March 12.

Galerie Veith Turske, Cologne, W. Germany.

1982 M. Knoedler & Co., New York. February 20–March 11.

1983 M. Knoedler & Co., New York. *El Negro,* exhibition of *livre de peintre,* March 16–31.

M. Knoedler, Zurich, Switzerland. May.

Group Exhibitions

1942 Whitelaw Reid Mansion, New York. *First Papers of Surrealism.* October 14–November 7. Organized by André Breton and Marcel Duchamp for the Coordinating Council of French Relief Societies.

1945–46 Whitney Museum of American Art, New York. *Annual Exhibition of Contemporary American Painting.* November 27, 1945–January 10, 1946. Also included: 1946–49, 1951–54, 1956, 1958–59, 1965–67, 1969, 1973. Catalogues.

1946 The Museum of Modern Art, New York. *Fourteen Americans.* September 10–December 8. Catalogue; edited by Dorothy C. Miller.

1947 Galerie Maeght, Paris, France. *Introduction à la Peinture Américaine.*

1949 Samuel Kootz Gallery, New York. *The Intrasubjectives.* September–October.

1950 Samuel Kootz Gallery, New York. *Black or White: Paintings by European and American Artists.* February 28–March 20. Catalogue.

Samuel Kootz Gallery, New York. *The Muralist and the Modern Architect.* October 3–23. Catalogue.

1951 Frank Perls Gallery, Beverly Hills, California. *Seventeen Modern American Painters.* January 11–February 7. Catalogue; preface by Robert Motherwell.

The Museum of Modern Art, New York. *Abstract Painting and Sculpture in America.* January 23–March 25. Catalogue; text by Andrew C. Ritchie.

1951–52 University of Minnesota, Minneapolis, Minnesota. *Forty American Painters, 1941–1950.* November 8, 1951–January 6, 1952.

1952 Carnegie Institute of Technology, Pittsburgh, Pennsylvania. *Carnegie International Exhibition.* October 16–December 14. Also included: 1955, 1958, 1961, 1964, 1967.

1953 Walker Art Center, Minneapolis, Minnesota. *Four Abstract Painters.* Closed March 15.

1953–54 Museu de Arte Moderna, São Paulo, Brazil. *II Bienal de São Paulo.* December 8, 1953–February 8, 1954.

1954 The Solomon R. Guggenheim Museum, New York. *Younger American Painters: A Selection.* April 27–September 30.

Yale University Art Gallery, New Haven, Connecticut. *Object and Image in Modern Art and Poetry.* April 20–June 14. Catalogue.

Städtisches Museum, Schloss Morsbroich, Leverkusen, W. Germany. *Internationale Sezession 1954.*

Contemporary Arts Museum, Houston, Texas. *Four Americans From the Real to the Abstract.* Catalogue.

1955 Whitney Museum of American Art, New York. *The New Decade: Thirty-five American Painters and Sculptors.* May 10–August 7. Traveled.

1958 *The New American Painting: As Shown in Eight European Countries 1958–59.* Organized by the International Program of The Museum of Modern Art, New York, under the auspices of the International Council at The Museum of Modern Art, New York. Catalogue. Shown in Basel, Milan, Madrid, Berlin, Amsterdam, Brussels, Paris, London.

1958–59 American Pavilion, Universal and International Exhibition, World's Fair, Brussels, Belgium. *Seventeen Contemporary American Painters.* December 15, 1958–January 17, 1959.

1959 The Museum of Fine Arts, Houston, Texas. *New York and Paris: Painting in the Fifties.* Closed February 8.

Kassel, W. Germany. *Documenta II: Kunst Nach 1945.* July 11–October 11.

Sokolniki Park, Moscow, U.S.S.R. *American Painting and Sculpture.* July 25–September 5. Catalogue; text by Lloyd Goodrich. Also shown at Whitney Museum of American Art, New York, October 28–November 15.

1960 The Columbus Gallery of Fine Arts, Columbus, Ohio. *Contemporary American Painting.* January 14–February 18. Catalogue.

Walker Art Center, Minneapolis, Minnesota. *Sixty American Painters, 1960: Abstract Expressionist Painting of the Fifties.* April 3–May 8.

Sidney Janis Gallery, New York. *Nine American Painters.* April 4–23. Catalogue.

Robert Motherwell's house
in Greenwich, Connecticut

Cleveland Museum of Art, Cleveland, Ohio. *Paths of Abstract Art*. October 4–November 13. Catalogue; text by Edward B. Henning.

1961 Museu de Arte Moderna, São Paulo, Brazil. *VI Bienal do Museu de Arte Moderna*, September 10–December 31. Exhibition from the United States organized by the International Council of The Museum of Modern Art, New York. Catalogue; text on Robert Motherwell by Frank O'Hara.

The Museum of Modern Art, New York. *The Art of Assemblage*. October 2–November 12. Traveled.

The Solomon R. Guggenheim Museum, New York. *American Abstract Expressionists and Imagists*. October 13–December 31. Catalogue; text by H. H. Arnason.

Modern American Drawings, organized by The Museum of Modern Art, New York. Shown in Spoleto, Jerusalem, Athens, Helsinki, Göteborg, Paris, London, Bonn.

1961–62 Museo de Bellas Artes, Caracas, Venezuela. *Abstract Drawings and Watercolors: USA*. December 15, 1961–January 1, 1962. Organized by The Museum of Modern Art, New York. Traveled throughout South America.

1962 Wadsworth Atheneum, Hartford, Connecticut. *Continuity and Change*. April 11–May 27.

World's Fair Art Pavilion, World's Fair, Seattle, Washington. *Art Since 1950*. April 21–October 21.

1963–64 Museu de Arte Moderna, São Paulo, Brazil. *VII Bienal de São Paulo*. November 1963–January 1964.

1964 Tate Gallery, London, England. *Painting and Sculpture of a Decade: 1954–1964*. April 22–June 28.

Whitney Museum of American Art, New York. *Between the Fairs—Twenty-Five Years of American Art, 1939–1964.* June 24–September 23.

The Solomon R. Guggenheim Museum, New York. *American Drawings.* September 17–October 25. Catalogue.

The Solomon R. Guggenheim Museum, New York. *Guggenheim International Award.* January–March. Catalogue; introduction by Lawrence Alloway.

1965 Institute of Contemporary Art, University of Pennsylvania, Philadelphia, Pennsylvania, *1943–1953: The Decisive Years.* January 14–March 1. Catalogue; text by Samuel Adams Green.

Los Angeles County Museum of Art, Los Angeles, California. *New York School: The First Generation: Paintings of the 1940s and 1950s.* July 16–August 1. Catalogue, text by Maurice Tuchman.

American Collages, organized for circulation by The Museum of Modern Art, New York. Shown 1965–67 at various American and European museums.

1966 Cleveland Museum of Art, Cleveland, Ohio. *Fifty Years of American Art: 1916–1966.* June 15–July 31. Catalogue; text by Edward B. Henning.

1968 The Museum of Modern Art, New York. *Dada, Surrealism and Their Heritage.* March 27–June 9. Catalogue.

Museo Universitario de Ciencias y Arte, Mexico City, Mexico. *Sobre Papel: Obras de Arshile Gorky y Robert Motherwell.* May–June. Organized by The Museum of Modern Art, New York, for circulation in South America. Catalogue.

XXXIV Biennale di Venezia, Venice, Italy. *Linee della ricerca contemporanea.* June 22–October 20.

1969 National Museum of Modern Art, Tokyo, Japan. *Contemporary Art: Dialogue Between the East and the West.* June 12–August 17.

The Museum of Modern Art, New York. *The New American Painting and Sculpture: The First Generation.* June 18–October 5. Catalogue.

1969–70 The Metropolitan Museum of Art, New York. *New York Painting and Sculpture: 1940–1970.* October 18, 1969–February 1, 1970. Catalogue; text by Henry Geldzahler.

1970 Fondation Maeght, St. Paul-de-Vence, France. *L'Art Vivant aux Etats-Unis.* July 16–September 30, Catalogue; text by Dore Ashton.

1971 The Museum of Modern Art, New York. *The Artist as Adversary: Works From the Museum Collections.* July 1–September 27.

1972 Museum of Fine Arts, Boston, Massachusetts. *Abstract Painting in the 70s: A Selection.* April 14–May 21. Catalogue.

Edmonton Art Gallery, Edmonton, Alberta, Canada. *Masters of the Sixties.*

1973 Seattle Art Museum Pavilion, Seattle, Washington. *American Art: Third Quarter Century.* August 22–October 14. Catalogue; text by Jan van der Marck.

1973–74 National Gallery of Art, Washington, D.C. *American Art at Mid-Century I.* October 22, 1973–January 6, 1974. Catalogue; introduction by William C. Seitz.

1974 Whitney Museum of American Art, New York. *Frank O'Hara, A Poet Among Painters.* February 21–March 17.

Virginia Museum of Fine Arts, Richmond, Virginia. *Twelve American Painters.* September 30–October 27. Catalogue.

1974–75 Städtische Kunsthalle, Dusseldorf, W. Germany. *Surrealität-Bildrealität 1924–1974*. December 30, 1974–February 2, 1975. Catalogue.

1975 Denver Art Museum, Denver, Colorado. *The Virginia and Bagley Wright Collection: American Art Since 1960*. February 1–March 16. Catalogue.

Corcoran Gallery of Art, Washington, D.C. *34th Biennial of Contemporary American Painting*. February 22–April 6. Catalogue.

Whitney Museum of American Art, Downtown Branch, New York. *Subjects of the Artists: New York Painting 1941–1947*. April 22–May 28.

1975–76 Edmonton Art Gallery, Edmonton, Alberta, Canada. *The Collective Unconscious*. December 5, 1975–January 18, 1976. Catalogue.

1976 The Solomon R. Guggenheim Museum, New York. *Twentieth Century American Drawing: Three Avant-Garde Generations*. January 23–March 21. Catalogue.

1977 Musée National d'Art Moderne, Paris, France. *Paris-New York*. June 1–September 19. Catalogue.

New York State Museum, Albany, New York. *New York: The State of the Art*. October 8–November 27. Catalogue.

1978 Herbert F. Johnson Museum of Art, Cornell University, Ithaca, New York. *Abstract Expressionism: The Formative Years*. March 29–May 14. Catalogue; introduction by Thomas W. Leavitt and Tom Armstrong; texts by Robert C. Hobbs and Gail Levin. Traveled to Seibu Museum of Art, Tokyo, June 17–July 12, and the Whitney Museum of American Art, New York, October 5–December 3.

1978–79 National Gallery of Art, Washington, D.C. *American Art at Mid-Century: The Subjects of the Artist*. June 1, 1978–January 14, 1979. Catalogue; foreword by J. Carter Brown; text on Robert Motherwell by E. A. Carmean, Jr.

1979 Montgomery Art Gallery, Pomona College, Claremont, California. *Black and White Are Colors: Paintings of the 1950s–1970s*. January 28–March 7. Catalogue; text by David S. Rubin and D. Steadman. Paintings of the 1950s and 1960s shown at the Montgomery Art Gallery; paintings of the 1970s shown at Lang Art Gallery, Scripps College, Claremont.

Montclair Art Museum, Montclair, New Jersey. *Collage: American Masters*. March 25–June 24.

Museo de Arte Contemporaneo de Caracas, Caracas, Venezuela. *David Smith/Robert Motherwell*. May. Catalogue; preface by Sofia Imber; text by Dore Ashton (in Spanish and English).

Pace Gallery, New York. *Five Action Painters of the 50s: Willem de Kooning, Franz Kline, Lee Krasner, Robert Motherwell, Jackson Pollock*. September 21–October 13. Catalogue; text by Harold Rosenberg.

1979–80 Corcoran Gallery of Art, Washington, D.C. *Gesture on Paper*. December 28, 1979–February 24, 1980.

1980 The Brooklyn Museum, New York. *American Drawings in Black and White: 1970–1980*. August 2–October 5.

Cleveland Museum of Art, Cleveland, Ohio. *Cleveland Collects Modern Art*. September 10–October 26.

William Benton Museum of Art, University of Connecticut, Storrs, Connecticut. *The Pollock Years: 1946–1956: Seventeen Abstract Artists of East Hampton*. October 11–November 16.

1981 Nassau County Museum of Fine Art, Roslyn, New York. *The Abstract Expressionists and Their Precursors.* January 18–March 22. Catalogue; texts by Max Kozloff, Dore Ashton, Constance Schwartz.

National Gallery of Art, Washington, D.C. *Contemporary American Prints and Drawings, 1940–1980.* March 22–July 19.

C.D.S. Gallery, New York. *Artists Choose Artists.* April 15–June 12.

Milwaukee Art Museum, Milwaukee, Wisconsin. *Center Ring: The Artist.* May.

M. Knoedler & Co., New York. *Easthampton/New York*, benefit exhibition. June 10–19.

Edinburgh International Festival, Edinburgh, Scotland. *American Abstract Expressionists.* Organized by the International Council of The Museum of Modern Art, New York, in conjunction with the Scottish Arts Council. Summer.

Robert Elkon Gallery, New York. *Robert Elkon: Two Decades.* September 26–November 4.

B. R. Kornblatt Gallery, Washington, D.C. *Eleven Paintings and Two Sculptures From the Sixties.* November 7–December 10.

The Art Museum and Galleries, California State University, Long Beach, California. *Renate Ponsold/Robert Motherwell: Apropos Robinson Jeffers.* October 5–November 1. Traveled to the Art Museum of South Texas, Corpus Christi, Texas, and The Friends of Photography, Carmel, California.

Artistas Modernos Enquanto Illustradores. Organized by the International Program of The Museum of Modern Art, New York, under the auspices of the International Council at The Museum of Modern Art, New York. Catalogue; text by Riva Castleman. Traveled throughout Brazil.

1981–82 The American Academy in Rome, Rome, Italy. *Works by American Artists in Roman Collections.* December 10, 1981–January 8, 1982.

1982 Marisa del Re Gallery, New York. *Selected Works on Paper.* March 2–April 3.

The Solomon R. Guggenheim Museum, New York. *The New York School: Four Decades.* July 1–August 22.

Long Point Gallery, Provincetown, Massachusetts. *Grey Days.* July.

Marisa del Re Gallery, New York. *The Season in Review.* Summer exhibition.

Stamford Museum and Nature Center, Stamford, Connecticut. *Abstract Expressionism Lives.* September 19–November 7.

Robert Elkon Gallery, New York. *Twentieth Century Masters.* October 2–November 11.

Marisa del Re Gallery, New York. *Seven American Abstract Masters.* November 9–December 18.

1982–83 Marisa del Re Gallery, New York. *Small Works by Major Artists.* December 14, 1982–January 22, 1983.

1983 Greenwich Library, Hurlbutt Gallery, Greenwich, Connecticut. *Twentieth Century Masters of the Illustrated Book.* January 16–March 6. Selected by Walter Bareiss.

Wadsworth Atheneum, Hartford, Connecticut. *Connecticut Painters 7+7+7.* January.

Selected Bibliography

By the Artist

1942 "Notes on Mondrian and Chirico." *VVV* (New York), no. 1, June 1942, pp. 59–61.

1944 "The Modern Painter's World." *Dyn* (Mexico City), vol. 1. no. 6, November 1944, pp. 9–14. Lecture originally given at Mount Holyoke College, August 10, 1944.

The Documents of Modern Art series, writings by outstanding figures in art and literature, often translated into English from European texts. Published by Wittenborn, Schultz, New York (later George Wittenborn, Inc.), 1944–55. Robert Motherwell was the director of this series of 14 books, selecting and editing the texts and writing introductions or prefatory notes for:

I. Guillaume Apollinaire, *The Cubist Painters: Aesthetic Meditations*, 1944 (2nd edition, 1949; 3rd edition, 1962).

II. Piet Mondrian, *Plastic Art and Pure Plastic Art*, 1945.

III. Hans Arp, *On My Way: Poetry and Essays 1912–1947*, 1948.

IV. Max Ernst, *Beyond Painting and Other Writings by the Artist and His Friends*, 1948.

V. Daniel-Henry Kahnweiler, *The Rise of Cubism*, 1949, edition revised, n.d.

VI. Marcel Raymond, *From Baudelaire to Surrealism*, 1949.

VII. Georges Duthuit, *The Fauvist Painters*, 1950.

VIII. Robert Motherwell (ed.), *The Dada Painters and Poets: An Anthology*, 1951.

"Painters' Objects." *Partisan Review* (New York), vol. 11, no. 1. Winter 1944, pp. 93–97.

1945 "Henry Moore." *New Republic* (New York), vol. 113, no. 17, October 22, 1945, p. 538.

1946 "Beyond the Aesthetic." *Design* (Columbus, Ohio), vol. 47, no. 8, April 1946, pp. 14–15.

1948 "A Tour of the Sublime." *Tiger's Eye* (Westport, Connecticut), vol. 1, no. 6, December 15, 1948, pp. 46–48.

1950 "For David Smith 1950." *David Smith*. New York: Willard Gallery, 1950.

1951 "Introduction to the Illustrations," (with Ad Reinhardt) in Robert Motherwell and Ad Reinhardt (eds.), *Modern Artists in America*. New York: Wittenborn, Schultz, Inc., 1951, p. 40.

"The Public and the Modern Artist." *Catholic Art Quarterly*, vol. 14, Easter 1951, pp. 80–81.

"The Rise and Continuity of Abstract Art." Lecture at the Fogg Art Museum, Harvard University, Cambridge, Massachusetts, 1951. Published in *Arts and Architecture* (Los Angeles), vol. 68, no. 9, September 1951, pp. 20–21.

"What Abstract Art Means to Me." *Museum of Modern Art Bulletin*, vol. 18, no. 3, Spring 1951, pp. 12–13. Robert Motherwell's statements at the symposium "What Modern Art Means to Me," The Museum of Modern Art, New York, February 5, 1951. Reprinted with modified text in *Art Digest* (New York), vol. 25, no. 10, February 15, 1951, pp. 12, 27–28.

1953 "Is the French Avant Garde Overrated?" *Art Digest* (New York), vol. 27, September 1953, p. 13. A symposium with Ralston Crawford, Clement Greenberg, Jack Tworkov, and Motherwell.

1954 "Painter and the Audience." *Perspectives, U.S.A.*, (New York), no. 9, 1954, pp. 107–112.

1955 "A Painting Must Make Human Contact." *New Decade*. New York: Whitney Museum of American Art and Macmillan, 1955. Reprinted in Eric Protter (ed.), *Painters on Painting*, New York: Grosset & Dunlap, 1963, p. 250.

1957 Notes in John I. H. Baur, *Bradley Walker Tomlin*. New York: Whitney Museum of American Art, 1957, pp. 11–12.

1959 "The Significance of Miró." *Art News* (New York), vol. 58, no. 4, May 1959, pp. 32–33, 65–67.

1964 "The Motherwell Collection." *Vogue* (New York), vol. 143, no. 2, January 15, 1964, pp. 88–91, 118.

1965 "Editor's Letters." *Art News* (New York), vol. 64, no. 8, December 1965, p. 6. This item, in response to the article by Natalie Edgar, *Art News*, October 1965, contains important corrections about biographical errors, and about his artistic biography in general.

"A Major American Sculptor, David Smith." *Vogue* (New York), vol. 145, no. 3, February 1965, pp. 135–139, 190–191.

1967 "Jackson Pollock: An Artists' Symposium, Part I." *Art News* (New York), vol. 66, no. 2, April 1967, pp. 29–30, 64–67.

"Letter to the Editor." *Art International* (Lugano), vol. 11, no. 8, October 20, 1967, p. 38. A rebuttal to a letter from Barnett Newman, *Art International*, September 1967.

1968 *The Documents of 20th-Century Art* series, writings by noted artists, critics and historians. Published by Viking Press, New York, 1968–80. Robert Motherwell was the General Editor of the series, with Arthur A. Cohen as Managing Editor, and Bernard Karpel as Documentary Editor. The series was taken over in 1980 by G. K. Hall, Boston. Robert Motherwell continues as General Editor, with Jack D. Flam as Associate General Editor. The series includes prefaces by Robert Motherwell in:

I. Pierre Cabanne, *Dialogues with Marcel Duchamp*, 1971.

II. Daniel-Henry Kahnweiler with Francis Cremieux, *My Galleries and Painters*, 1971.

1969 "Addenda to The Museum of Modern Art Lyric Suite Questionnaire—from Memory . . . with Possible Chronological Slips." *The Museum of Modern Art Newsletter*, Fall 1969, n.p.

Statement in *Art Now: New York* (New York), vol. 1, no. 5. May 1969.

1970 "The Humanism of Abstraction." Lecture at St. Paul's School, Concord, New Hampshire, 1970. Published in *Tracks: A Journal of Artist's Writings* (New York), vol. 1, no. 1, November, 1974, pp. 10–16.

1971 "David Smith—Erinnerungen." in *Robert Motherwell: Bilder und Collagen 1967–1970*. St. Gallen, Switzerland: Galerie im Erker, 1971. Taken from manuscript of Motherwell's contributions to John Gruen, *The Party Is Over: Reminiscences of the Fifties—New York's Artists, Writers, Musicians, and Their Friends*. New York: Viking Press, 1972.

1972 Introduction in Eugène Delacroix, *The Journal of Eugène Delacroix*. New York: Viking Press, Compass Edition, 1972.

1976 "Correspondance." Letter to Marcelin Pleynet, *Art Press* (Paris), no. 22, January–February 1976, p. 2.

1977 "Parisian Artists in Exile: 1939–45," in *Paris-New York*. Paris: Musée National d'Art Moderne, 1977.

1978 Introduction to *Emerson Woelffer: Paintings and Collages*. New York: Gruenebaum Gallery, 1978. Reprinted as "Emerson Woelffer: A Born Painter" *Art News* (New York), vol. 7, no. 2, February 1978, pp. 80–81.

"Provincetown and Days Lumberyard: A Memoir," in *Days Lumberyard Studios*, Provincetown, Massachusetts, Provincetown Art Association and Museum, 1978, pp. 14–18.

"Words of the Painter." *New York Times Book Review*, June 4, 1978, pp. 12, 42–43. Review of Jack D. Flam, *Matisse on Art*. New York: E. P. Dutton, 1978, and Jack Cowart, Jack D. Flam, Dominique Fourcade, and John Hallmark Neff, *Henri Matisse Paper Cutouts*. New York: Harry N. Abrams, 1978.

1979 "Homage to Franz Kline." *Kline: The Color Abstractions*. Washington, D.C.: Phillips Collection, 1979.

1980 "The International World of Modernist Art: 1945–1960." *Art Journal* (New York), vol. 39, no. 4, Summer 1980, pp. 270–71.

1981 "Picasso par Robert Motherwell." *Art Press* (Paris), no. 50, Summer 1981, pp. 10–11. Translated by Guy Scarpetta.

1982 "How It All Happened: Motherwell Remembers." *Art/World* (New York), February 22–March 22, 1982.

"What We Wanted to Do: Motherwell Remembers." *Art/World* (New York), March 22–April 22, 1982.

"In Memoriam: Anthony Smith." *Art Press* (Paris), no. 57, March 1982, p. 50. Memorial tribute to Anthony Smith presented at The Metropolitan Museum of Art.

"Reflections on Abstract Art." An address for the 150th anniversary of Yale University Art Gallery. To be published by Yale University.

1983 In preparation: *Collected Writings of Robert Motherwell, Documents of 20th-Century Art* series. Boston: G. K. Hall.

On the Artist

1944 Greenberg, Clement. "Art." *The Nation* (New York), vol. 159, no. 20, November 11, 1944, pp. 598–599.

Stroup, Jon. "Motherwell, Modern." *Art Digest* (New York), vol. 19, no. 3, November 1, 1944, p. 16.

1948 Kees, Weldon. "Robert Motherwell." *Magazine of Art* (Washington, D.C.), vol. 42, no. 3, March 1948, pp. 86–88.

1951 B[ird], P[aul]. "Motherwell: A Profile." *Art Digest* (New York), vol. 26, no. 1, October 1, 1951, pp. 6, 23.

1952 Fitzsimmons, James. "Illusions of Simplicity." *Art Digest* (New York), vol. 26, no. 13, April 1, 1952, p. 18.

1954 ———. "Robert Motherwell." *Design Quarterly* (Minnesota), no. 29, 1954, pp. 18–22.

1955 Greenberg, Clement. "'American Type' Painting." *Partisan Review* (New York), vol. 22, no. 2, Spring 1955, pp. 179–196.

1956 Heron, Patrick. "The Americans at the Tate Gallery." *Arts* (New York), vol. 30, no. 6, March 1956, p. 17.

1957 Ashton, Dore. "Motherwell at the Janis Gallery." *Arts and Architecture* (Los Angeles), vol. 74, no. 7, July 1957, p. 4.

1959 ———. [Motherwell at the Janis Gallery.] *Arts and Architecture* (Los Angeles), vol. 76, no. 5, May 1959, pp. 7–8.

———. "Art: Collages Are Shown in Exhibition." *New York Times* (New York), January 1, 1959, p. 29.

Goossen, Eugene C. "Robert Motherwell and the Seriousness of Subject." *Art International* (Lugano), vol. 3, nos. 1–2, January–February, 1959, pp. 33–35, 38, 51.

1960 Goldwater, Robert. "Reflections on the New York School." *Quadrum* (Brussels), no. 8, 1960, pp. 17–36.

1961 Fitzsimmons, James (ed.). "United States Representation, VI São Paulo Bienal." *Art International* (Lugano), vol. 5, no. 10, Christmas 1961, pp. 62–63.

Kroll, Jack. "American Painting and the Concentric Spiral." *Art News* (New York), vol. 60, no. 7, November 1961, pp. 34–37, 66 ff. Title of article printed incorrectly in magazine.

Rosenberg, Harold. "Art in Orbit," *Art News* (New York), vol. 60, no. 6, October 1961, pp. 22–25, 54, 57.

Sandler, Irving H. "Robert Motherwell." *Art International* (Lugano), vol. 5, nos. 5–6, June–August, 1961, pp. 43–44.

1962 Nordland, Gerald. "From Dirge to Jeer." *Arts* (New York), vol. 36, no. 5, February 1962, p. 50.

O'Doherty, Brian. "Art: Robert Motherwell: Objective Works in Introspection Are Displayed at Sidney Janis Gallery." *New York Times* (New York), December 6, 1962, p. 52.

"Deepest Identity." *Newsweek* (New York), December 10, 1962, p. 94.

1963 Ashton, Dore. "Motherwell at the Janis Gallery." *Arts and Architecture* (Los Angeles), vol. 80, no. 2, February 1963, p. 8.

———. "Motherwell Loves and Believes." *Studio* (London), vol. 165, no. 839, March 1963, pp. 116–117.

1964 ———. "Robert Motherwell, Passion and Transfiguration." *Studio* (London), vol. 167, no. 851, March 1964, pp. 100–105.

1965 Claus, Jürgen. "Robert Motherwell: Grundtypen seines Werkes." *Das Kunstwerk* (Baden-Baden), vol. 18, no. 8, February 1965, pp. 3–9.

Edgar, Natalie. "The Satisfaction of Robert Motherwell." *Art News* (New York), vol. 64, no. 6, October 1965, pp. 38–41, 65–66. See artist's response in *Art News*, vol. 64, no. 8, December 1965, p. 6.

Greenberg, Clement. "America Takes the Lead, 1945–1965." *Art in America* (New York), vol. 59, no. 4, August–September 1965, pp. 108–129.

Kaufman, Betty, "Motherwell Retrospective." *Commonweal* (New York), vol. 83, no. 12, December 24, 1965, pp. 383–384.

Kozloff, Max. "An Interview with Robert Motherwell." *Artforum* (San Francisco), vol. 4, no. 1, September 1965, pp. 33–37.

———. "Motherwell." *The Nation* (New York), vol. 201, no. 12, October 18, 1965, pp. 256–258.

Lippard, Lucy R. "New York Letter: Miró and Motherwell." *Art International* (Lugano), vol. 9, nos. 9–10, December 1965, pp. 33–35.

O'Hara, Frank. "The Grand Manner of Motherwell." *Vogue* (New York), vol. 146, no. 6, October 1, 1965, pp. 206–209, 263–265.

———. "Robert Motherwell: Museum of Modern Art." *Art In America* (New York), vol. 53, no. 5, October–November 1965, pp. 80–81.

Robertson, Bryan. "Robert Motherwell v. American and European Culture." *Times* (London), October 19, 1965, p. 16.

Tillim, Sydney. "Motherwell, the Echo of Protest." *Artforum* (San Francisco), vol. 4, no. 4, December 1965, pp. 34–36.

"What a Gesture!" *Newsweek* (New York), October 11, 1965, pp. 98–99.

1966 Arnason, H. H. "On Robert Motherwell and His Early Work." *Art International* (Lugano), vol. 10, no. 1, January 1966, pp. 17–35.

———. "Robert Motherwell: The Years 1948 to 1965." *Art International* (Lugano), vol. 10, no. 4, April 1966, pp. 19–45.

Bowen, Denis. "Robert Motherwell at the Whitechapel." *Arts Review* (London), vol. 18, no. 6, April 2, 1966, p. 132.

Robertson, Bryan. "From a Notebook on Robert Motherwell." *Studio International* (London), vol. 171, no. 875, March 1966, pp. 89–93.

———. "Robert Motherwell." *Studio International* (London), vol. 172, no. 883, November 1966, supplement, pp. 8–9.

1967 Frankenstein, Alfred. "Elegies, Anguish, and Lyric Suites." *San Francisco Sunday Examiner and Chronicle* (San Francisco), March 5, 1967, pp. 26–27.

Hare, David. "Communication." *Art News* (New York), vol. 66, no. 8, December 1967, pp. 8, 10.

1967 Supovitz, Marjory. "Robert Motherwell's New England Elegy." *Harvard Art Review* (Cambridge, Massachusetts), vol. 2, no. 2, Spring–Summer 1967, pp. 21–24.

1968 Kozloff, Max. "Robert Motherwell." *Renderings: Critical Essays on a Century of Modern Art.* New York: Simon and Schuster, 1968.

Kramer, Hilton. "Robert Motherwell: The Art of Collage." *New York Times* (New York), October 13, 1968, Section D, p. 37.

1969 Arnason, H. H. "Motherwell: The Wall and the Window." *Art News* (New York), vol. 68, no. 4, Summer 1969, pp. 48–52, 61, 62, 64, 66, 68.

Kramer, Hilton. "Between Past and Present." *New York Times* (New York), May 25, 1969, Section 2, p. 41.

———. "30 Years of the New York School." *New York Times Magazine* (New York), October 12, 1969, pp. 28–30.

Krauss, Rosalind. "Robert Motherwell's New Paintings." *Artforum* (New York), vol. 7, no. 9, May 1969, pp. 26–28.

Rose, Barbara. "Openness and Robert Motherwell, 'an Infallible Eye'." *Vogue* (New York), vol. 154, no. 2, August 1, 1969, p. 62.

Simon, Rita. "Robert Motherwell 'Open' Series at Marlborough-Gerson." *Arts Magazine* (New York), vol. 43, no. 8, Summer 1969, pp. 34–35.

1971 Lebeer, I. "Robert Motherwell: Entretien." *Chroniques de l'Art Vivant* (Paris), no. 22, July–August 1971, pp. 10–12.

1972 Allen, Henry. "Motherwell: Palate-Pleasing." *Washington Post* (Washington, D.C.), November 8, 1972, p. 3.

Forgey, Benjamin. "Motherwell's Miracle." *Evening Star* (Washington, D.C.), November 17, 1972, p. B-1.

Hughes, Robert. "A Sense of Exuberance." *Time* (New York), July 17, 1972, pp. 54–56.

Kelder, Diane. "Motherwell's 'A la pintura'." *Art in America* (New York), vol. 60, no. 5, September–October, 1972, pp. 100–101.

Kramer, Hilton. "Art: Aquatint Commentary on Poems." *New York Times* (New York), November 11, 1972, p. 29.

Rose, Barbara. "Robert Motherwell: Young Old Master." *Vogue* (New York), vol. 160, no. 8, November 1, 1972, p. 54.

Siegal, Jeanne. "Robert Motherwell: Rubin." *Art News* (New York), vol. 71, no. 8, December 1972, pp. 11–12.

Welish, Marjorie. "Bridging the Generations." *Art International* (Lugano), vol. 16, no. 10, December 1972. pp. 44–47.

1973 Kramer, Hilton. "The Folklore of Modern Painting." *New York Times* (New York), January 14, 1973, Section D, p. 23.

Masheck, Joseph. "Robert Motherwell: Lawrence Rubin Gallery." *Artforum* (New York), vol. 11, no. 5, January 1973, p. 91.

Schwartz, Sanford. "New York Letter." *Art International* (Lugano), vol. 17, no. 1, January 1973, pp. 68–72.

Volboudt, Pierre. "Perspectives de Robert Motherwell." *XX^e Siècle* (Paris), vol. 5, no. 40, June 1973, pp. 83–86.

———. "La ruée vers l'espace: Motherwell." *XX^e Siècle* (Paris), vol. 5, no. 40, June 1973, pp. 80–81.

1974 Derfner, Phyllis. "New York Letter." *Art International* (Lugano), vol. 18, no. 6, Summer 1974, pp. 46–51.

Herrera, Hayden. "Robert Motherwell: Knoedler Contemporary Art." *Art News* (New York), vol. 73, no. 6, Summer 1974, pp. 112–113.

Hess, Thomas. "Vanity Fare." *New York* (New York), April 29, 1974, pp. 68–69.

Kramer, Hilton. "Art: Motherwell's Tall Collages." *New York Times* (New York), April 13, 1974, p. 21.

Raynor, Vivien. "A Talk with Robert Motherwell." *Art News* (New York), vol. 73, no. 4, April 1974, pp. 50–52.

"Robert Motherwell in California Collections." *Artweek* (Oakland, California), vol. 5, no. 44, December 21, 1974, pp. 1,16.

1975 Dunham, Judith L. "Motherwell and Twombly." *Artweek* (Oakland, California), vol. 6, no. 24, June 14, 1975, pp. 1–2.

Ellenzweig, Allen. "Robert Motherwell." *Arts Magazine* (New York), vol. 49, no. 7, March 1975, p. 21.

Kaplan, Patricia. "Robert Motherwell: Knoedler Contemporary Art." *Art News* (New York), vol. 74, no. 3, March 1975, pp. 106–107.

O'Hara, Frank. "Robert Motherwell," *Art Chronicles: 1954–1966.* New York: George Braziller, 1975.

1976 Andre, Michael. "Robert Motherwell: Knoedler." *Art News* (New York), vol. 75, no. 4, April 1976, p. 119.

View from Robert Motherwell's studio
in Greenwich, January 1983

Arnason, H. H. "Robert Motherwell: 1966–1976." *Art International* (Lugano), vol. 20, nos. 8–9, October–November 1976, pp. 9–25, 55–56.

Carmean, E. A., Jr. "Robert Motherwell's Spanish Elegies." *Arts Magazine* (New York), vol. 50, no. 10, June 1976, pp. 94–97.

Ellenzweig, Allen. "Robert Motherwell: Knoedler Contemporary Arts." *Arts Magazine* (New York), vol. 50, no. 7, March 1976, p. 22.

Glueck, Grace. "Motherwell, at 61, Puts 'Eternal' Quality into Art." *New York Times* (New York), February 3, 1976, pp. 33, 52.

Kramer, Hilton. "Diverse Pictorial Eloquence of Motherwell." *New York Times* (New York), January 17, 1976, p. 21.

Perrone, Jeff. "Robert Motherwell: Knoedler Contemporary Art." *Artforum* (New York), vol. 14, no. 8, April 1976, p. 70.

Ratcliff, Carter. "New York Letter." *Art International* (Lugano), vol. 20, nos. 3–4, March–April 1976, pp. 67–75.

1977 Arnason, H. H. *Robert Motherwell*. New York: Harry N. Abrams, 1977.

Cohen, Arthur A. "The Motherwell Atelier." *Vogue* (New York) vol. 167, no. 3, March 1977, pp. 230–233, 256.

Hughes, Robert. "Paris' Prodigal Son Returns." *Time* (New York), July 18, 1977, pp. 50–51.

Hunter, Sam. "Motherwell on a Wide Screen." *Art News* (New York), vol. 76, no. 10, December 1977, pp. 128–129.

Kramer, Hilton. "An American in Paris." *New York Times Magazine* (New York), June 19, 1977, pp. 16–17, 22, 24, 31.

1978 Burr, James. "The Immediacy of America." *Apollo* (London), vol. 107, no. 191, January 1978, p. 64.

Feaver, William. "Degrees of Anger." *Art News* (New York), vol. 77, no. 4, April 1978, p. 134.

Fineberg, Jonathan. "Death and Maternal Love: Psychological Speculations on Robert Motherwell's Art." *Artforum* (New York), vol. 17, no. 1, September 1978, pp. 52–57.

Frackman, Noel. "Robert Motherwell: Knoedler." *Arts Magazine* (New York), vol. 66, no. 2, March–April 1978, pp. 29, 31.

Hess, Thomas B. "Sketch for a Portrait of the Art Historian Among Artists." *Social Research* (Camden, New Jersey), vol. 45, no. 1, Spring 1978, pp. 6–14.

Macmillan, Duncan. "Robert Motherwell." *Art Monthly* (London), no. 14, February 1978, pp. 4–6.

Maloon, Terence. "Robert Motherwell." *Artscribe* (London), no. 11, April 1978, pp. 16–22.

Quantrill, Malcolm. "London." *Art International* (Lugano), vol. 22, no. 3, March 1978, pp. 47–48.

Hobbs, Robert C. "Possibilities." *Art Criticism* (New York), vol. 1, no. 2, 1979, pp. 96–103.

Morrin, Peter. "Robert Motherwell." *Arts Magazine* (New York), vol. 54, no. 1, September 1979, p. 13.

Raynor, Vivien. "Motherwell Fuses Color and Expression." *New York Times* (New York), April 15, 1979, Section CN, p. 14.

1980 Ashton, Dore. "Robert Motherwell." *Flash Art* (Milan), no. 100, November 1980, pp. 4–8.

Carmean, E. A., Jr. (ed.). *Robert Motherwell: The Reconciliation Elegy*. Geneva and New York: Skira/Rizzoli, 1980.

Catoir, Barbara. "Artist as a Walking Eye: Fragen an Robert Motherwell." *Pantheon* (Munich), vol. 38, July–September 1980, pp. 281–290.

Russell, John. "Art: Modern Museum Stages Motherwell Show." *New York Times* (New York), October 31, 1980, Section C, p. 22.

1981 Abel, Lionel. "The Surrealists in New York." *Commentary* (New York), vol. 72, no. 4, 1981, pp. 44–54.

Baro, Gene. "Robert Motherwell." *Art International* (Lugano), vol. 24, nos. 9–10, August–September 1981, pp. 117–118.

Carmean, E. A., Jr. "Robert Motherwell: The Anchovies for the Spanish Olives." *October* (Cambridge, Massachusetts), no. 16, Spring 1981, pp. 90–91.

Firestone, Evan R., "Color in Abstract Expressionism: Sources and Background for Meaning." *Arts Magazine* (New York), vol. 55, no. 7, March 1981, pp. 140, 143.

Glueck, Grace. "Motherwell Turns Down Post on U.S. Arts Panel." *New York Times* (New York), May 20, 1981, Section 3, p. 25.

Henry, Gerrit. "Robert Motherwell: Knoedler." *Art News* (New York), vol. 80, no. 6, Summer 1981, pp. 236, 238.

Mattison, Robert S. "Two Decades of Graphic Art by Robert Motherwell." *Print Collector's Newsletter* (New York), vol. 11, no. 6, January/February 1981, pp. 197–201.

Newman, David. "Robert Motherwell and Black." *Arts Magazine* (New York), vol. 55, no. 10, June 1981, p. 25.

Wolff, Theodore F. "Artists Motherwell and Marin: Two American Giants to be Reckoned With." *Christian Science Monitor* (Boston), March 5, 1981.

"Art: Contemporary Collage." *Architectural Digest* (Los Angeles), vol. 39, no. 5, May 1982, p. 104.

Art Present (Paris), no. 9, Summer–Autumn 1981. Issue dedicated to Robert Motherwell.

"Izdavanje I Stampanje Grafika U Americi." *Pregled* (Sarajevo, Yugoslavia), no. 211, pp. 10–11.

"Maturing of Abstract Art Was a Big Step." *Daily Journal* (Caracas), March 5, 1981.

Poems and articles dedicated to Robert Motherwell by Octavio Paz, Rafael Alberti and Marcelin Pleynet. *Separata* (Seville), nos. 5–6, Spring 1981, pp. 1–28.

"Printer and Photographer Published: Robert Motherwell, Black Gesture on Copper Ground (1981)." *Print Collector's Newsletter* (New York), vol. 12, no. 3, July/August 1981, p. 83.

1982 Arnason, H. H. *Robert Motherwell*. New York: Harry N. Abrams, 1982. Revised edition.

Brenson, Michael. "Motherwell in Munich." *New York Times* (New York), September 10, 1982, Section C, p. 13.

Duthy, Robin. "The Investment File: Robert Motherwell." *Connoisseur* (London and New York), vol. 209, no. 839, January 1982, p. 51.

Firestone, Evan R. "James Joyce and the First Generation New York School." *Arts Magazine* (New York), vol. 56, no. 10, June 1982, pp. 116–121.

Gardner, Paul. "Will Success Spoil Bob and Jim, Louise and Larry?" *Art News* (New York), vol. 81, no. 9, November 1982, pp. 102–109.

Glueck, Grace. "Art in Public Places Stirs Widening Debate." *New York Times* (New York), May 23, 1982, p. 30.

Hall, Carla. "Artscope." *Washington Post* (Washington), October 6, 1982.

Kingsley, April. "Art on the Beach: Provincetown People and Places." *Art Express* (Providence, Rhode Island), March–April 1981, pp. 44–50.

Lewis, Jo Ann. "Robert Motherwell's Enthralling Cacophony." *Washington Post* (Washington), September 7, 1982.

Mattison, Robert S. "The Emperor of China: Symbols of Power and Vulnerability in the Art of Robert Motherwell During the 1940s." *Art International* (Lugano), vol. 25, nos. 9–10, November–December 1982.

Patton, Phil. "Robert Motherwell: The Mellowing of an Angry Young Man." *Art News* (New York), vol. 81, no. 3, March 1982, pp. 70–76.

Raynor, Vivien. "Stanford Museum Review." *New York Times* (New York), October 10, 1982.

Wolff, Theodore F. "The Many Masks of Modern Art." *Christian Science Monitor* (Boston), January 5, 1982.

"Bilder Von Motherwell Für München Angekauft." *Suddeutsche Zeitung* (Munich), November 1982.

1983 Van Hook, L. Bailey. "Robert Motherwell's Mallarmé's Swan." *Arts Magazine* (New York), vol. 57, no. 5, January 1983, pp. 102–106.

Acknowledgments

First and foremost, I would like to extend my gratitude to Robert Motherwell, without whose tireless cooperation and patience with seemingly endless detail, this exhibition would not have been possible. He has also been most generous as a lender. To work with him and to be exposed to his artistic vision and intellectual and inquisitive nature has been a great privilege. Our interaction has been a wonderful and stimulating experience for me. For this, above all, I am grateful to him and wish to express my deep appreciation.

During my visits to the artist's studio and home, I always enjoyed Renate Ponsold's warm hospitality and friendship. Joan Banach, Robert Motherwell's curator, was instrumental to this project. She responded to my every request and handled a myriad of details with efficiency and great devotion to the artist. I thank her for her invaluable help. I am also grateful to Mel Paskell for making our working sessions in Greenwich so productive.

Organizing an exhibition of this scope requires diligence and keen interest on the part of many individuals. This publication is the result of the dedicated efforts of several people—in particular Dore Ashton and Jack D. Flam, whose pertinent and insightful essays are important contributions to the scholarship on Robert Motherwell. I am grateful to Josephine Novak for her fastidious editing, which has contributed enormously to the quality of the book; to Robert Jensen for his sensitivity and skill in the design of this publication and to Mark Magowan of Abbeville Press for his enthusiasm and cooperation in the production of this publication.

On behalf of the Albright-Knox Art Gallery, I express my gratitude to the lenders for their generosity and commitment in sharing Motherwell's art with the public for an extended period. Without their support and cooperation, an exhibition of this scope would have been impossible.

The support of the National Endowment for the Arts and the IBM Corporation has been most generous.

We are grateful for the cooperation of the directors of the museums participating in the tour of this exhibition: Dr. Earl A. Powell III, Director, Los Angeles County Museum of Art; Henry T. Hopkins, Director, San Francisco Museum of Modern Art; Arnold Jolles, Director, Seattle Art Museum; Michael Botwinick, Director, Corcoran Gallery of Art, Washington, D.C., and Diane Waldman, Deputy Director, The Solomon R. Guggenheim Museum, New York.

The dedicated assistance and extraordinary help of the following individuals were also essential: Donna Freberg, Toronto, Canada; Ann Freedman, Director of Contemporary Art, M. Knoedler & Co., Inc., New York; Edward B. Henning, Chief Curator of Modern Art, Cleveland Museum of Art; Katherine Church Holland, Research/Collections and Registration Director, San Francisco Museum of Modern Art; Janie C. Lee, Houston, Texas; Jane Livingston, Associate Director, Corcoran Gallery of Art, Washington, D.C.; George W. Neubert, Associate Director for Art, San Francisco Museum of Modern Art; William E. O'Reilly, Salander-O'Reilly Galleries, New York; Brenda Richardson, Assistant Director for Art, The Baltimore Museum of Art; Cora Rosevear, Assistant Curator, Department of Painting and Sculpture, The Museum of Modern Art, New York; Lawrence Rubin, M. Knoedler & Co., Inc., New York; Dr. David W. Steadman, Director, The Chrysler Museum, Norfolk, Virginia; Cathy Card Sterling, Administrative Officer, Corcoran Gallery of Art, Washington, D.C.; Susan Taylor, Curatorial Assistant, The Solomon R. Guggenheim Museum, New York. To all of these, I would like to express my special gratitude.

A large part of the credit for the exhibition is due to the enthusiastic and able staff of the Albright-Knox Art Gallery: Francis C. Ashley, Comptroller; Mary Bell, Assistant Librarian; Bette Blum, Coordinator of Public Relations; Lenore Godin, Gallery Shop Manager; Georgette Hasiotis, Editor of Publications; Ida Koch, Curatorial Secretary; John Kushner, Building Superintendent, and his team of installers; Annette Masling, Librarian; Alba Priore, Assistant Registrar; Serena Rattazzi, Assistant to the Director for Administration; Marianne Spencer, formerly Curatorial Secretary; Leta K. Stathacos, Coordinator of Marketing Services; Marie Tarrio, Secretary; Mary Tornabene, Secretary to the Director; Sarah Ulen, Registrar. Their help has been invaluable.

During his tenure as Director of the Albright-Knox Art Gallery and especially throughout the lengthy organization of this exhibition, I have enjoyed the support of Robert T. Buck, Director of the Brooklyn Museum. I am grateful to him for his expert advice, for his diplomacy, and for his sustained enthusiasm.

Douglas G. Schultz
Chief Curator, Albright-Knox Art Gallery

Lenders to the Exhibition

H. H. Arnason, New York
Douglas S. Cramer, Los Angeles, California
Thos. Marc Futter
Donn Golden
The IBM Corporation
William C. Janss
Richard E. and Jane M. Lang, Medina, Washington
Norman and Frances Lear
Martin Z. Margulies, Coconut Grove, Florida
Anne Mirvish, Toronto, Canada
Mr. and Mrs. David Mirvish, Toronto, Canada
Robert Motherwell, Greenwich, Connecticut
Mr. and Mrs. Gifford Phillips
Mr. and Mrs. Bagley Wright
Private collection; courtesy Salander-O'Reilly Galleries, New York
Private collections

Albright-Knox Art Gallery, Buffalo, New York
Art Gallery of Ontario, Toronto, Canada
The Baltimore Museum of Art, Baltimore, Maryland
The Chrysler Museum, Norfolk, Virginia
 On loan from the collection of Walter P. Chrysler, Jr.
Cleveland Museum of Art, Cleveland, Ohio
The Museum of Fine Arts, Houston, Texas
The Museum of Modern Art, New York
National Museum of American Art,
 Smithsonian Institution, Washington, D.C.
Norton Gallery & School of Art, West Palm Beach, Florida
The Phillips Collection, Washington, D.C.
San Francisco Museum of Modern Art, San Francisco, California
Smith College Museum of Art, Northampton, Massachusetts
Whitney Museum of American Art, New York

M. Knoedler & Co., New York
Janie C. Lee Gallery, Houston, Texas

Photographic Credits

Robert Motherwell in Provincetown,
working at printing press

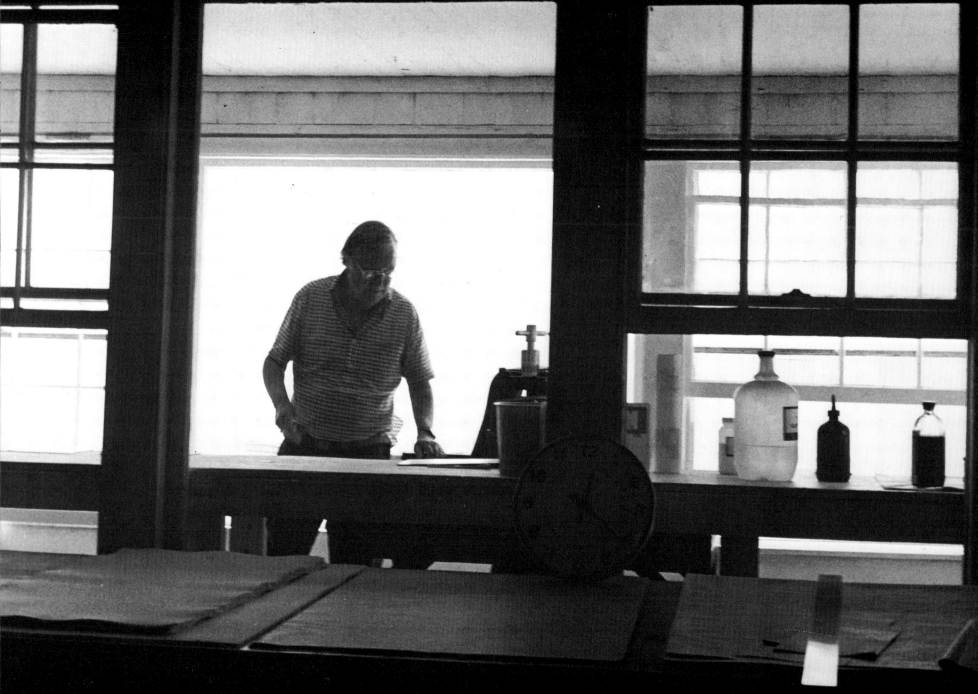

Index of Illustrations